In the Black Fantastic

In the Black Fantastic

Ekow Eshun

The MIT Press | Cambridge, Massachusetts

This book was published on the occasion of the exhibition *In the Black Fantastic* at the Hayward Gallery, London (29 June–18 September 2022).

The book's introduction sets out the themes for the exhibition, establishes a historical context for the concept of the 'Black fantastic', and showcases works by the participating artists:

The chapters that follow expand and elaborate upon the contents of the exhibition. Exploring key themes of invocation, migration and liberation, images are sequenced outside of the normal conventions of chronology, media or genre. Instead, audacious juxtapositions aim to show the connections that can be made across art forms and time, conjuring the speculative, freeform spirit of the 'Black fantastic'.

Foreword

In the Black Fantastic adds a brilliant and timely new chapter to the Hayward Gallery's long tradition of presenting groundbreaking group exhibitions that respond to and illuminate pivotal themes and tendencies in contemporary art. It highlights an important, and under-acknowledged, area of current artistic production – namely, the work of Black artists who make use of fantastical genres and motifs to address racism and social injustice, and also to invoke alternative social scenarios. By inventively recycling and reconfiguring elements of folklore, myth, science fiction, spiritual traditions, ceremonial pageantry and the legacies of Afrofuturism, the artists in this exhibition reimagine the ways in which we represent the past as well as the future, while also engaging with the challenges and conflicts of the present. The fantastical element in their work, in other words, has nothing to do with escapism; on the contrary, it is a means of inviting us to consider other possible ways of being in the world, and to confront the phantasmic character of social constructions of 'race', including the dehumanizing myths, caricatures and mythical stereotypes that feed racist cultures.

At a moment when Black artists are vividly exploring the fantastic across a variety of media, from award-winning novelists working in science fiction and fantasy to the evolution of Black horror and the rise of Black superheroes in television and cinema, *In the Black Fantastic* provides a timely and invaluable survey of how this cultural turn has been developed by some of the outstanding visual artists of our time. It focuses on cogent and imaginative artworks that are often lyrical, rather than literal, in their approach. They can also be bracingly critical, yet instead of suggesting simple answers or conclusions, the participating artists challenge conventional thinking in a spirit of open-ended questioning. Whether taking the form of paintings, photographs, videos, sculptures or installations, their works create multi-dimensional aesthetic experiences that leave space for each viewer's own individual responses. And as they probe charged subjects related to racial oppression and social injustice, many of the works in this exhibition simultaneously affirm Black and postcolonial narratives of the speculative and the spiritual as invaluable sources of cultural knowledge, insight and artistic inspiration.

All of us at the Hayward Gallery are indebted to curator and author Ekow Eshun, who brought his keen intelligence, imagination and energy to bear on this project. Fuelled by his astute understanding of his subject, he has forged an engaging and thought-provoking exhibition, while also producing illuminating and informative essays for this book that explore a broader historical framework. We are also grateful to Michelle Commander and Kameelah Martin for their original and perceptive contributions to this volume.

Ambitious international exhibitions like this require support from many partners and colleagues. I wish to extend our profound thanks to Gagosian Gallery for their support of *In the Black Fantastic*. In addition, it would not have been possible to realize this exhibition without the generosity of the many lenders involved, including individual collectors, institutions, galleries and the participating artists themselves. We extend to all our sincere appreciation for making these artworks available to the public.

A number of individuals on the Hayward curatorial team contributed to this project, and in particular our thanks go to Thomas Sutton, Phoebe Cripps and Debbie Meniru for their indispensable work in realizing the exhibition. I also wish to thank Hayward Installation Manager Juliane Heynert and Senior Technicians Nick Davies and Chloe Brooks for their careful planning and skilful installation of the exhibition; Hayward Registrar Stephanie Busson for capably overseeing the transport and care of the artworks; and Alison Maun for adroitly handling all insurance matters. As always, I remain especially appreciative of the support of Southbank Centre's Board of Governors, our CEO Elaine Bedell and Arts Council England.

Our gratitude also extends to our colleagues and collaborators at Kunsthal Rotterdam, including Director Marianne Splint, Business Director Herman van Karnebeek, and Curator Shehera Grot, whose initial enthusiasm and support played a crucial role in facilitating the exhibition tour. In addition, our thanks go to Registrar Klaas Witsen Elias; Assistant Curator David Snels; Sabine Parmentier and Anna Kerkhoff for Marketing and Communications; Hylke Bijker, Ron Barneveld, Gert-Jan Knoll and Jan van Vliet for their work on the technical operations; Bas van der Kruk, Frieda Baldewsing and Ninelotte Dijk for education and outreach; and Mathilde Stuyling de Lange and Sabiha Taner from the Development team.

Finally, all of us extend our heartfelt thanks to the incredibly talented and trailblazing artists in this exhibition: Nick Cave, Sedrick Chisom, Ellen Gallagher, Hew Locke, Wangechi Mutu, Rashaad Newsome, Chris Ofili, Tabita Rezaire, Cauleen Smith, Lina Iris Viktor and Kara Walker. We are forever grateful for the opportunity to present their compelling, vibrant and transformative artworks to new audiences in the United Kingdom.

Ralph Rugoff
Director, Hayward Gallery

Introduction

The Art of the Black Fantastic

I. A WAY OF SEEING

As its ominous title suggests, *Slave Ship (Slavers Throwing Overboard the Dead and Dying, Typhoon Coming On)* (1840) by J. M. W. Turner, depicts a scene of horror. A ship struggles in the midst of a squall. Giant waves assail the deck. The sky is blood red. Fish, their eyes glinting and pointed teeth bared, feed on the corpse of a woman. Submerged hands reach out of the water, chains still clasped to their wrists. Turner's painting is based on the infamous case of the *Zong*, a British ship whose captain, in 1781, had thrown overboard 132 sick and dying enslaved African people so that he could collect insurance money only available for those 'lost at sea'.

Slave Ship is also among the artistic source material for Ellen Gallagher's series of paintings *Ecstatic Draught of Fishes* (2019– ongoing; see fig. 1 and p. 35). But where Turner's picture focuses its 'moral power and poetic vision' on events aboard the *Zong*, Gallagher goes beneath the waves.[1] Her paintings detail an underwater ecosystem in which marine creatures and delicate flora, rendered in aqueous colours, are intertwined with Black Atlantis fable and the legacy of slavery and colonialism. In these works, and also in Gallagher's complementary series, *Watery Ecstatic* (2001–ongoing; see p. 34), a history, a mythos, an oceanography, coalesces into view.

In Derek Walcott's 'The Sea is History', the Atlantic seabed is a burial ground for lives lost during the slave trade: 'Exodus. / Bone soldered by coral to bone, / mosaics / mantled by the benediction of the shark's shadow.' But the same poem closes on an affirmatory note, envisaging the water as the site of life starting anew: 'and in the salt chuckle of rocks / with their sea pools, there was the sound / like a rumour without any echo / of History, really beginning.'[2] Similarly, Gallagher's paintings wrestle with the grotesqueness of the Middle Passage and find in its legacy the space to imagine new configurations of Black life and resistance. On the sea floor,

amid nautilus shells and corals, and the memory of the shackled and the drowned, we find elegant, alien, female creatures whose appearance is modelled by Gallagher on sculpted Fang figurines from Central Africa.

Their presence references the Black oceanic myth created by Drexciya, the enigmatic 1990s Detroit techno duo. The group's songs imagine a submarine realm populated by the offspring of pregnant African women thrown overboard from slave ships like the *Zong*. The women's foetuses learned to breathe through the embryonic fluid of their mother's womb and were born adapted to life underwater. Gallagher's figures might be the descendants of these infants. With their proud bearing, they are glorious proof of how Black life might have flourished in Africa without the depredations of slavery.

The synthesis of historical fact and lyrical fiction in Gallagher's paintings is indicative of a turn to the speculative and the mythic in the work of a number of Black contemporary artists. In the arresting evocations of race and collective memory conjured by Kara Walker,

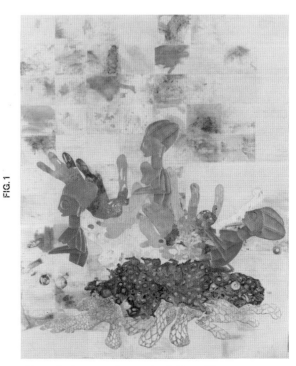

FIG. 1

Ellen Gallagher, *Ecstatic Draught of Fishes*, 2021

Wangechi Mutu, Nick Cave and the other artists featured here, we see a similar merging of the spiritual, the supernatural and the science fictional. Describing how she wrote the masterly *Beloved*, Toni Morrison talked of wanting 'to strike out for new territory'.[3] The goal, as she saw it, was to explore the texture of Black life while eschewing the conventions of racialized thinking, with its hierarchies of white superiority and Black brutishness. She sought 'not to [reinforce] already established reality' but to occupy a space of strange and compelling imagining rich with unique 'metaphorical and imagistic associations'[4] that was 'historically true in essence, but not strictly factual'.[5]

Morrison's 'new territory' is a site that an increasing number of Black artists have made their own. It is a domain that we might call the 'Black fantastic'.[6] By this I mean works of speculative fiction that draw from history and myth to conjure new visions of African diasporic culture and identity. I take speculative fiction in this context to mean artworks that are non-mimetic in form, and that affirm 'the existence of ethnic traditions of science and spirituality' as a means to firstly 'interrogate normative notions about reality' and, secondly, subvert 'the Western dichotomy between the real and unreal, natural and supernatural, scientific and unscientific'.[7] And I reference writer Rosemary Jackson's description of the fantastic as a form that reaches beyond the boundaries of realism and dispenses with 'rigid distinctions between animate and inanimate objects, self and other, life and death'. The fantastic, observes Jackson, undoes and reconfigures the 'cultural order' of society and represents the unspoken desire for change. It involves 'inverting elements of this world, recombining its constitutive features in new relations to produce something strange, unfamiliar and apparently "new", absolutely "other" and different'.[8]

To this definition, we can add that the Black fantastic begins from an understanding of race as a socially constructed fiction rather than a scientific truth, albeit one that maintains a determining sway over popular perceptions of the world. It also operates with a scepticism about Western narratives of progress and modernity, predicated as they are on the historical subjugation of people of colour. For the great minds of the Enlightenment in the eighteenth century, order and rationality were strictly Western accomplishments. The rest of the world sat at the opposite end of a binary formulation: civilized–primitive, modern–traditional, scientific–superstitious. 'In Negro life', wrote Georg W. F. Hegel, 'consciousness has not yet attained to the realization of any substantial objective existence.' African people are representative of 'natural man in his completely wild and untamed state'.[9] Immanuel Kant concurred: 'The Negro can be disciplined and cultivated but is never genuinely civilized. He falls of his own accord into savagery.'[10] For proponents of scientific racism in the nineteenth century like Louis Agassiz, Black people were not 'of the same blood' as Europeans. They belonged, rather, to a 'degraded and degenerate' subspecies of their own and could not be categorized as fully human.[11]

The intertwined history of Western thought and racial othering has profoundly shaped the lived experience of Black people through to modern times. In 1903, W. E. B. Du Bois, the great analyst of race, coined the term 'double consciousness' to describe the 'peculiar sensation' of living as a Black person physically within, and psychologically outside, white society. He referred to this 'sense of always looking at one's self through the eyes of others, of measuring one's soul by the tape of a world that looks on in amused contempt and pity'.[12] For Du Bois, double consciousness was the defining criterion of Blackness. It was the bitter proof that we would always be excluded from the main body of society, doomed to spend our lives in embodied alienation.

And yet in addition to the pain and vulnerability inherent to the concept, double consciousness can also be described as a gift of sorts. It confers the ability to view the world with a nuance and complexity less readily accessible to those not obliged to undertake a daily reckoning with their own personhood.

Despite the constraints of endemic bigotry, double consciousness is a prompt for Black people to imagine ourselves on our own terms, with all the fierce dreaming we might summon to that task. As the writer Jayna Brown puts it, 'Unburdened by investments in belonging to a system created to exclude us in the first place, we develop marvelous modes of being in and perceiving the universe.'[13] Instead of the West's 'stifling vision of reality – with its correlates of "truth," "facts," and "power"', the Black fantastic looks to self-fashioned fictions, mythic worlds, African-originated knowledge systems and spiritual practices, as a means of liberation.[14]

For example, Tabita Rezaire's *Ultra Wet – Recapitulation* (2017; see fig. 2 and pp. 44–45) embraces 'spiritual and technological understandings of pre-colonial Africa and ancient indigenous ways of life'. Projected onto the four faces of a pyramid, the work's imagery travels from scenes of South African traditional healers and the landscape of Egypt to discourses on African epistemologies drawn from the stars. At the same time, Rezaire critiques Western binaries of 'mxn-womxn, feminine-masculine, good-bad, right-wrong, light-dark, strong-weak, life-death'. Invoking ancient Africa becomes a means of reaching beyond such dualities towards a future unfettered by patriarchal power or norms of gender. 'What lies outside of exploitative and oppressive structures?' asks Rezaire. 'Can you see, feel, and imagine what it's like?'[15]

The Black fantastic shares commonalities with genres such as magic realism and Afrofuturism. But it also differs from them in significant ways. Magic realism operates on polarities such as 'history versus magic, the pre-colonial past versus the post-industrial present and life versus death'.[16] By contrast, the Black fantastic finds productive tension in the to and fro between the everyday and the extraordinary. And it does so without the tone of ironic detachment characteristic to magic realist novels such as Kim Scott's *Benang*.[17] The distinction is an important one.

FIG. 2

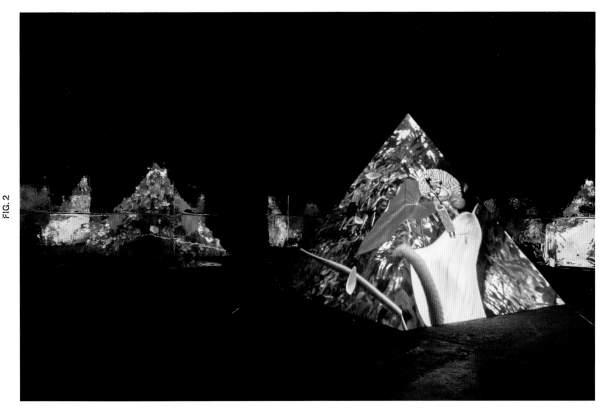

Tabita Rezaire, *Ultra Wet – Recapitulation*, 2017

It speaks to a conviction that African beliefs and cultural practices are worthy of sincere, not sardonic, consideration as sources of knowledge and creative inspiration.

Afrofuturism is a term first coined by the critic Mark Dery, in 1993. Dery defined the genre as '[s]peculative fiction that treats African-American themes and addresses African-American concerns in the context of twentieth-century technoculture – and, more generally, African-American signification that appropriates images of technology and a prosthetically enhanced future'.[18] The concept has been further refined and expanded by writers such as Greg Tate, Alondra Nelson, Ytasha L. Womack, and Kodwo Eshun with the groundbreaking *More Brilliant Than the Sun*.[19]

But aspects of Afrofuturism are also vulnerable to criticism. Pedro Bell's phallocentric album art for Parliament Funkadelic sits ill with the group's mantra of a liberated cosmic Blackness. In her 'Mundane Afrofuturist Manifesto' (2013), the artist Martine Syms laments the 'hackneyed tropes' of the genre. This 'bonfire of the Stupidities … includes, but is not exclusively limited to:

Jive-talking aliens; Jive-talking mutants; Magical negroes; Enormous self-control in light of great suffering; Great suffering as our natural state of existence; Inexplicable skill in the martial arts; Reference to Wu Tang; Reference to Sun Ra; Reference to Parliament Funkadelic and/or George Clinton; Reference to Janelle Monáe…'.[20] For writer Hope Wabuke, Afrofuturism 'lacks room to conceive of Blackness outside of the Black American diaspora *or* a Blackness independent from any relationship to whiteness, erasing the long history of Blackness that existed before the centuries of violent oppression by whiteness – and how that history creates the possibility of imagining the free Black futures that Dery deems impossible'.[21]

By contrast, the Black fantastic is less a genre or a movement than a way of seeing, shared by artists who grapple with the legacy of slavery and the inequities of racialized contemporary society by conjuring new narratives of Black possibility. For example, Chris Ofili has made gorgeously dream-like paintings that draw inspiration from Homer's *Odyssey* (see fig. 3 and pp. 42–43). The works depict Odysseus's seven years spent with the

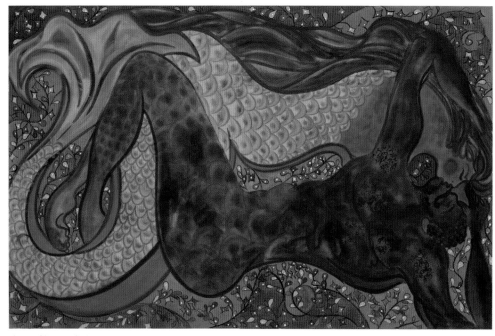

FIG. 3

Chris Ofili, *Kiss (Odysseus & Calypso)*, 2019

12

beautiful goddess Calypso on her island, a place 'full of wonder', suffused with 'the scent of citrus and of brittle pine'.[22] Ofili's paintings transport the poem's setting from the Aegean to the Caribbean. The shift is partly personal. Ofili relocated from Britain to Trinidad in 2005, and the island's verdant beauty has been a sustaining source of inspiration for him since then. In Homer's account, Calypso is demanding and manipulative. She is determined to keep Odysseus for herself even after he has become weary of her love. Ofili eschews the caricature of an angry, scorned woman. Instead, with works such as *Kiss (Odysseus & Calypso)* (2019), he depicts the pair as ardent lovers, their bodies intertwined against a backdrop of lush, kaleidoscopic colours and arabesque vines. By changing setting, Ofili also expands the poem's field of associations, putting its characters in conversation with Caribbean mythology and the history of the West Indies as a key location in Atlantic slave trade routes. Ofili's version of Odysseus has dark skin, identifying his origins within the African diaspora. Calypso, who shares her name with Trinidad's similarly titled popular music, is a mermaid. Her enchanting form summons thoughts of Mami Wata, the beguiling water deity historically venerated across the Afro-Atlantic world and often represented with the lower body of a fish.

Ofili's Odyssey also brings us, again, to Derek Walcott, whose *Omeros* offers its own sweeping, Caribbean-set interpretation of the poem. In Walcott's telling, the Middle Passage, with its pain and suffering, is its own Homeric journey of struggle and endurance. 'But they crossed, they survived. / There is the epical splendour. ... the grace born from subtraction as the hold's iron door / rolled over their eyes.'[23] *Omeros* provides a yet richer context within which to situate Ofili's lovers. By dint of their location at the physical periphery of Empire, colonies like the Caribbean islands have historically functioned as 'contact zones', sites of blurred hierarchy and power, where 'disparate cultures meet, clash, and grapple with each other'.[24] Ofili's rhapsodic lovers are testament to this boundaryless condition. Their embrace

evokes a place outside order or imperial control, where parity between colonizer and colonized, and Black and white, might be as natural as the coming together of a mortal and a god.

The wealth of references suggested by Ofili's paintings illustrates the capaciousness of the notion of the Black fantastic. The term describes how, in the scholar Michelle D. Commander's words, Black artists are 'renarrativizing master accounts, and creating and representing new worlds and alternate existences'.[25] It also carries an exhortation to envisage, as the poet Elizabeth Alexander puts it, 'a metaphysical space beyond the black public everyday', governed by the 'power and wild imagination that black people ourselves know we possess'.[26] Additionally, the Black fantastic facilitates a nuanced engagement with the complex histories of the African diaspora and its peoples. Within its framework, walking the paths of the past summons something like the 'plural and polyphonic' Portuguese term *histórias*, a word which encompasses 'both fiction and non-fiction, personal, political, economic, cultural as well as mythological narratives'.[27] Across the rest of this essay, I will trace the origins of the Black fantastic in visual art and further explore its thematic territories by reference to the work of a range of contemporary artists.

II. AN EMERGENCE

The Black fantastic as a tendency in visual art first started to flourish in the interwar period when artists based across the diaspora began to summon dreamlike evocations of Blackness based on notions of spiritual power and memories of ancient Africa.

In 1936, Aaron Douglas, the leading visual artist of the Harlem Renaissance, painted the mural *Aspiration*, for the Texas World's Fair in Dallas (fig. 4). The painting charts African American progress from the shackles of slavery to the promise of a transcendent future, depicted by a shining city on a hill. An outline

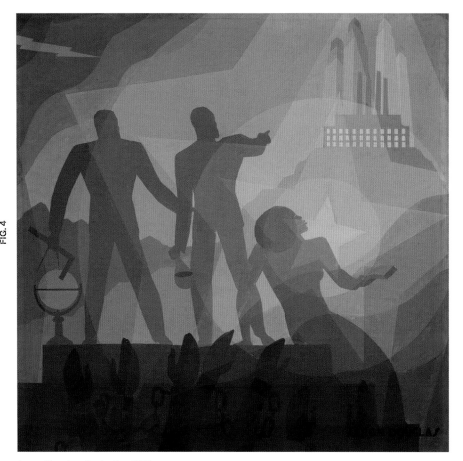

FIG. 4

Aaron Douglas, *Aspiration*, 1936

of pyramids in the mural makes a link back to ancient Egypt, suggesting past civilization as a precursor to inevitable future glory. The image of Africa that Douglas summons in *Aspiration*, as well as other pictures he made during this period, is consciously stylized and romantic. Its beauty and majesty offer a means of conceptualizing Blackness itself as a condition of dreaming, absent of white constraint. The goal, as he wrote, is to make '[n]ot white art painted black ... [but] something transcendentally material, mystically objective. Earthy. Spiritually earthy. Dynamic.'[28]

Douglas's aspirations to the 'spiritually earthy' were shared elsewhere in the diaspora. In London, the Jamaican sculptor Ronald Moody created *Midonz* (1937; fig. 5), a larger-than-life representation of a female head, carved from a single block of elm wood. Inspired by the lore of ancient Egypt, the sculpture symbolizes a powerful deity,

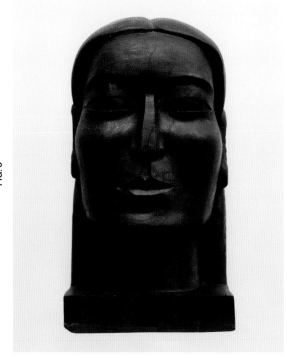

FIG. 5

Ronald Moody, *Midonz*, 1937

'one of the Great Mothers of antiquity who dominate the world of myth and legend'.[29]

In Cuba, Wifredo Lam made paintings that fuse influences from Cubism, surrealism and African cultural practice. After returning to the country of his birth from war-riven Paris, Lam was increasingly drawn to Afro-Cuban art and spiritual belief as a counter to the broken promise of progress in Europe. He frequented Santería and Vodou ceremonies, searching for the inspiration to create art that 'would spew forth hallucinating figures with the power to surprise'.[30] *The Jungle* (1943; fig. 6) shows a quartet of mystical half-human, half-animal creatures against a backdrop of dense tropical vegetation. The painting shows the influence of Lam's immersion in spiritual practices. During Vodou rituals, the *loa* or gods are said to possess a worshipper's body and movements, taking control of them like a rider does a horse. One of the figures in *The Jungle* is in the midst of a spiritual possession of this kind. As depicted by Lam, she is the *femme cheval* or 'horse-headed woman' – 'a hybrid go-between who travels between material and spiritual worlds, and journeys from the lost African past towards the uncertain future of the West'.[31]

Douglas, Moody and Lam pursued their practice separately, working without reference to one another. Nevertheless, works such as *Aspiration*, *Midonz* and *The Jungle* display a number of traits that collectively point to the emergence of the Black fantastic as an artistic sensibility. The works embrace the mystic, the numinous and the otherworldly. They reject realism and the purely authentic in favour of the dreamlike or the surreal. And they find in ideas of ancient African cultures and beliefs the inspiration to challenge Western narratives of rationality and progress.

In their evocations of an Africa rich in knowledge and spiritual power, their approach can also be said to grapple with the aftermath of the 'discovery' of African art by the European avant-garde in the early twentieth century. Modernism's engagement with Africa produced exhilarating paintings

FIG. 6

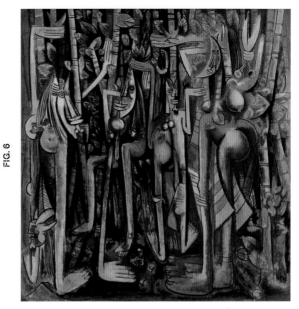

Wifredo Lam, *The Jungle*, 1943

like Picasso's *Les Demoiselles d'Avignon* (1907). But even as European artists thrilled at their encounter with *l'art nègre*, their view of African culture itself remained rooted in colonial stereotypes of the dark continent. As the scholar Patricia Leighten notes, the modernists 'embraced a deeply romanticized view of African culture (conflating many cultures into one) and considered Africa the embodiment of humankind in a precivilized state'.[32]

Here, then, we can also cite the work of the painter Loïs Mailou Jones, who spent a formative year studying in Paris in 1937, out of which she produced *Les Fétiches* (1938; see p. 244). The painting depicts five African masks set against a dark, swirling background in a style that echoes modernist Primitivism, even as it simultaneously asserts African cultural identity as an innately cosmopolitan, sophisticated condition. As Jones reflected, 'My French professors couldn't understand this painting and I had to remind them that Cubism is influenced by African art which is my heritage.'[33] The African mask was a motif that Jones would return to with striking effect later in her career. The powerfully graphic *Moon Masque* (1971; fig. 7), for example, was a result of Jones's extensive travels across the African continent in the late 1960s, a period that

inspired a series of paintings which appeared to her as 'a dream' and which combined 'the old with the new; Africa with Black America; painting with design; realism with symbolism'.[34]

Beyond art, the interwar years also saw diaspora figures in other disciplines mount a challenge to reductive views of Africanness, in the process further laying the groundwork for the Black fantastic. This was the period when the author and folklorist Zora Neale Hurston travelled the American South to document Black folktales and custom. In 1931, Hurston published 'Hoodoo in America', the first academic study of Vodou by a Black folklorist. She also journeyed further afield, to Haiti, Jamaica and Honduras, in search of indigenous cultural practices. In Haiti she was initiated into Vodou. Undergoing secret rites, she had a vision in which, as she wrote, 'I strode across the heavens with lightning flashing from under my feet, and grumbling thunder following in my wake'.[35]

In Martinique, Aimé Césaire, the poet and co-founder of négritude, and his wife,

writer and theorist Suzanne Roussi Césaire, published the literary journal *Tropiques* in 1941. With its swirling mix of modernism, Marxism, surrealism, Black consciousness, and presentation of pre-colonial African beliefs and practices, the journal aimed to trigger 'a revolution of the mind'.[36] For Lam, who had visited the Césaires in Martinique en route to Cuba, *Tropiques* was an important influence as he pursued a turn toward the magical. As editor of the journal, Roussi Césaire urged others to also liberate themselves from the restraints of a Western worldview. Embrace 'the domain of the strange, the marvelous and the fantastic', she wrote. 'Here is the freed image, dazzling and beautiful, with a beauty that could not be more unexpected and overwhelming. Here are the poet, the painter, and the artist, presiding over the metamorphoses and the inversions of the world under the sign of hallucination and madness.'[37]

III. A LIBERATION

In 1968, a group of Black painters, photographers, fashion designers and sculptors came together on the South Side of Chicago to form the collective AfriCOBRA (African Commune of Bad Relevant Artists).[38] The group's shared creative vision marks another step in the development of the Black fantastic. Like the poets and playwrights of the Black Arts Movement, such as Amiri Baraka and Larry Neal, AfriCOBRA married artistic expression with the politics of Black liberation. But where the Black Arts Movement could be didactic and liable to faux-authentic '"neo-African" essentialism', AfriCOBRA's artists pursued a spirit of openness and experimentation.[39] Instead of the social realism called for by Baraka, the group preferred the 'point exactly between absolute abstractions and absolute naturalism', where 'the real and the unreal, the objective and the non-objective, the plus and the minus meet'.[40] Their approach found expression in an exhilarating visual language. Paintings were composed of 'bright, vivid, singing cool-ade colors of orange, strawberry,

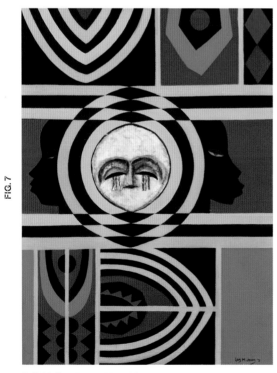

FIG. 7

Loïs Mailou Jones, *Moon Masque*, 1971

FIG. 8

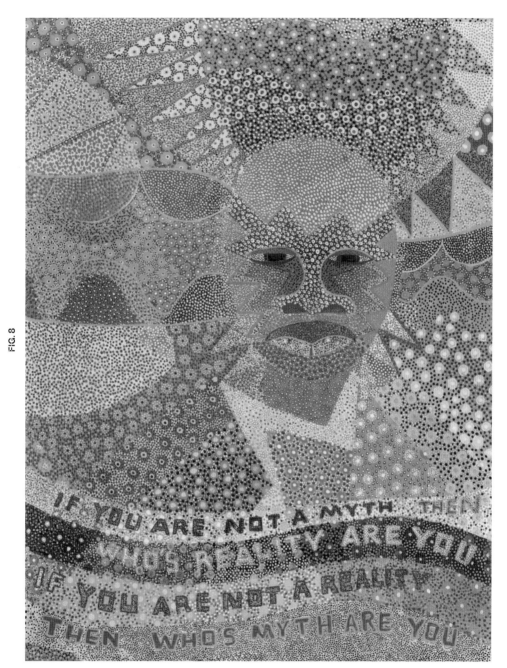

Gerald Williams, *Portrait Y*, 1970

cherry, lemon, lime and grape. Pure vivid colors of the sun and nature.'[41] Consciousness-raising slogans embedded in the pictures declared, 'Wake up', 'Don't be jivin' and 'Nation time'. *Portrait Y* (1970; fig. 8) by Gerald Williams, one of the original co-founders of AfriCOBRA, who talked of creating art that represented 'mimesis at midpoint', featured the evocative wording: 'If you are not a myth then who's reality are you. If you are not a reality then who's myth are you'. The closest parallel to such a dynamic approach to art-making, reflects writer George E. Lewis, was the 'noise', 'frenzy' and 'chaos' of free jazz,[42] an observation that finds thrilling realization in paintings such as James Phillips's *Howling Bebop Ghost* (1977; fig. 9).

Around the same time as AfriCOBRA, other Black artists were using colour to similarly expansive ends. Alma Woodsey

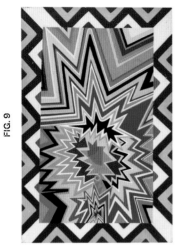

FIG. 9

James Phillips, *Howling Bebop Ghost*, 1977

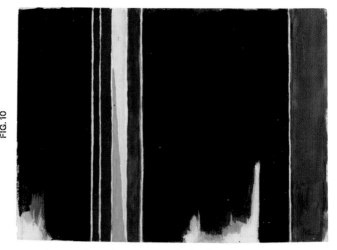

FIG. 10

Alma Woodsey Thomas, *Atmospheric Effects I*, 1970

Thomas's *Space* series was inspired by the moon landing in 1969. In dazzling shades of violet, sunshine yellow and brilliant orange, Thomas's abstract paintings such as *Atmospheric Effects I* (1970; fig. 10), *Antares* (1972) and *Celestial Fantasy* (1973) sought to evoke the wonder and mystery of the cosmos.

Looking to European old masters such as Goya, Poussin and Tintoretto, as well as the jazz of Ornette Coleman, Don Cherry and John Coltrane, Bob Thompson created works of dazzling chromatic intensity. His richly allegorical paintings are populated with enigmatic figures summoned from myth and nightmare. Rendered in dramatic scenes sumptuous with colour, *St. Matthew's Description of the End of the World* (1964; fig. 11) depicts the chaos and violence of the biblical apocalypse described in the Gospel of St Matthew. Thompson's domain of lyricism and fabulation could also encompass unsettling real life. Works like *The Hanging* (1959) and *The Execution* (1961) alluded to the lynchings of African Americans in the South, and an awareness that even the heightened reality of nightmare and fantasy might not compare with the horror of the racialized condition of everyday life.

By the early 1970s, the civil rights struggle had taken a bleak turn. Martin Luther King and Malcolm X had both been murdered. Eldridge Cleaver had fled to Algeria. Angela Davis was on the cover of *Newsweek* in handcuffs. The FBI was hounding the Black Panthers with its COINTELPRO surveillance programme. As AfriCOBRA artist Jeff Donaldson wrote, to be Black in the late 1960s was to be assailed by 'the thunder and by the lightning of the real Amerika'.[43] For AfriCOBRA, dazzling colour became a symbol of resistance. 'Coolade colors for coolade images for superreal people. Superreal images for SUPERREAL people' (see fig. 12).[44]

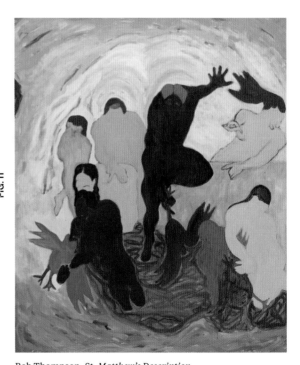

FIG. 11

Bob Thompson, *St. Matthew's Description of the End of the World*, 1964

As the Sixties gave way to the Seventies, figures across the arts produced works of similarly expansive imagining. This was the decade that saw the speculative fiction of Octavia E. Butler, Henry Dumas and Ishmael Reed (see fig. 13 and p. 266). The transcendental jazz of Sun Ra, Pharoah Sanders, Alice Coltrane and Rahsaan Roland Kirk (see fig. 14 and pp. 167, 172, 178 and 228). Movies of the supernatural, like Bill Gunn's *Ganja & Hess* (1973; see p. 73), and the wildly picaresque, such as Djibril Diop Mambéty's *Touki Bouki* (1973; see p. 118). Works which originated from a way of seeing that preferenced Black folklore, myth and imagination over dominant discourses of Western knowledge.

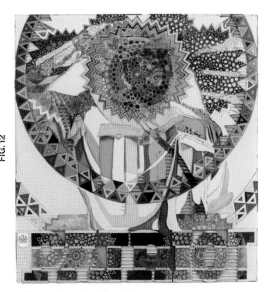

FIG. 12

Jeff Donaldson, *Patriot*, 1975

IV. SIGNIFYIN'

Shortly after midnight on 3 March 1991, Rodney King, a 25-year-old, unemployed construction worker, is pulled over by police for speeding in the San Fernando Valley of Los Angeles. According to the subsequent testimony of the first four LAPD officers at the scene, King is a monstrously threatening figure. He is 'bear-like'. He has 'superhuman strength'. He is 'like a wounded animal'. Like 'a mean dog'. To enforce 'pain compliance' on him, the officers deliver fifty-six baton blows and five kicks. King suffers broken teeth, a broken leg, a concussion, nine skull fractures, a shattered eye socket and cheekbone, injuries to both knees, and nerve damage that leaves his face partly paralysed.

King's beating stands in a long history of Black bodies defined as hostile and made subject to public sanction or extrajudicial killing. We could look back here to the more than 4,400 Black people lynched in America in the period between Reconstruction and World War II.[45] But a catalogue of contemporary examples also springs to mind, the incidents so familiar we can cite them with just a first name: George, Breonna, Michael, Sandra, Eric, Ahmaud, Tamir, Trayvon, and so many more. In America 'a black body in motion is never without consequence', observes theologian

Wallace Best. 'It is always a signifier of something, scripted and coded. And for the most part, throughout our history black bodies in motion have been deemed a threat.'[46]

For Nick Cave, watching the footage on TV of King's assault felt like a 'slap' – a painful reminder of his own vulnerability as a Black male in America.[47] In response, the artist began to make the first of his soundsuits (see figs. 15 and 16, and p. 30), which today number more than five hundred. Part sculpture, costume

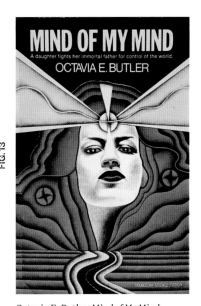

FIG. 13

Octavia E. Butler, *Mind of My Mind*
(book cover artwork by Jan Esteves), 1977

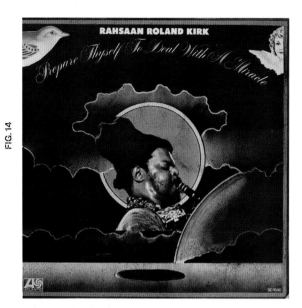

FIG. 14

Rahsaan Roland Kirk, *Prepare Thyself to Deal with a Miracle* (album cover artwork by Stanislaw Zagorski), 1973

and armour, the soundsuits are made from a dizzying array of materials, including beaded necklaces, embroidered flowers, stuffed animals, vintage toys and ceramic figurines. Named after the sounds they make when worn by performers, they conceal the identity of the wearer while encouraging movement and creating noise that reflects their materials and construction. The bright colours and elaborately decorated surfaces of the works are a rejoinder to conventional registers of racial identity. They transform the body, altering height and proportions, and turning the epidermal exterior into patterned fantasia. The vivacity of Cave's creations defies attempts to reduce the Black body to caricature, as was the case with Rodney King, or to reinforce the 'Western equation' of Blackness with 'ugliness, evil, corruption, and death'.[48] And their visibility signals an insistence on the fact that the Black body should be seen on its own terms, without apology or explanation. In this way, we might see them as a riposte to repressive strictures dating back to slavery and Jim Crow that Black people should 'know their place' in relation to white society.

Writing in 1934, Zora Neale Hurston defined 'the will to adorn' as a primary characteristic of African American expression.[49] Hurston was referring to the inventiveness of Black speech, but she could just as easily have

been describing any number of forms of Black vernacular creativity, such as fashion, interior décor, quilting, dance or body adornment. The dynamism of these practices can in many cases be traced back to customs and cultures that have been retained and shared across the Black diaspora since slavery. Consider, for example, how costumed ceremonies which originated in West Africa, such as the Egungun masquerades of Nigeria, are echoed today in exuberant festivals of dress, dance and music, like Bacchanal in Jamaica and Junkanoo in the Bahamas. And how the migration of such activities from Africa to the New World enabled Black people to maintain 'subtleties of persistence, nostalgia, practices, memories, institutions, coping strategies, and structures that provided succor and character for those in bondage'.[50]

Hew Locke's photography series *How Do You Want Me?* (2007; see fig. 17 and p. 36) similarly deploys costume and performance in order to explore questions of place, identity and history. Locke's series is made up of a set of spectacular studio portraits, with the artist himself playing the costumed role in each. The project's title refers to the question sometimes asked by subjects when posing before a photographer. In Locke's formulation, the query takes on a seditious quality. The masked, weapon-toting, ostentatiously garlanded characters in the photographs are 'inherently sinister figures – corrupt kings, generals, tyrants and bandits'.[51] Their fearsome appearance is a challenge to what the scholar Tina M. Campt calls 'constrained formats of photography', such as nineteenth-century African ethnographic imagery or apartheid passbook photos – situations in which the camera has been instrumentalized to enforce the control of the state over Black people.[52]

A complementary element of the project extends to sculpture and makes the rejection of imperial power yet more explicit. In *The Ambassadors* (2021; see fig. 18 and p. 37), a quartet of figures is mounted on horseback. They are festooned with symbols of regality and rebellion: colonial medals, six-guns, slave

pennies, Benin bronzes, portraits of Toussaint Louverture. The potential origins of all these figures, from bandits to lords, is open to supposition. Locke grew up in Guyana and we might imagine his characters being loosed on the world by the spirit of misrule that governs Caribbean carnival. Alternatively, they could have stepped out of diaspora fables of witch doctors and obeah men. Or from histories of slave rebellion and marronage. They may also have been inspired by the swagger of notorious characters from Locke's childhood. An early working title for the series was *The Harder they Come*, named after the classic 1972 Jamaican gangster movie, and Locke speaks wryly of 'famous mad-men' in Georgetown, Guyana, with names such as Law and Order, Mary Bruk

Iron and British Guiana. The lattice of allusion, reference, historical reach and aesthetic juxtaposition woven by Locke connects the project to Henry Louis Gates's notion of 'signifiyin', as a vernacular practice, deployed through strategies of 'metaphor, metonymy, synecdoche, and irony', not to mention 'marking', 'loud-talking' and 'testifying'.[53]

Rashaad Newsome's video *Stop Playing in My Face!* (2016; see fig. 19 and p. 41) also invites reflection on the power of performance and display. Newsome's video opens on a virtual recreation of the Befreiungshalle (Hall of Liberation), an ornate neoclassical monument in Bavaria, Germany. Between the colonnades of the building's dome, ballroom

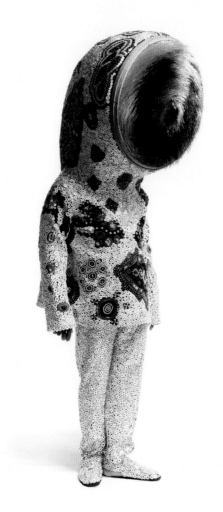

FIG. 15

Nick Cave, *Soundsuit*, 2014

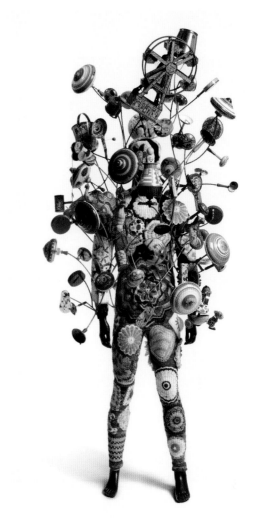

FIG. 16

Nick Cave, *Soundsuit*, 2010

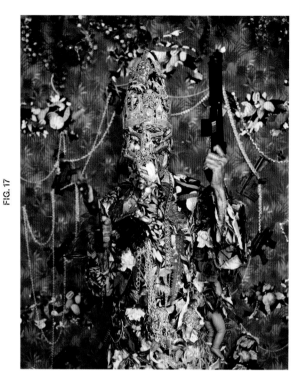

FIG. 17

Hew Locke, *Harbinger* (from *How Do You Want Me?* series), 2007

choreographer and trans activist Leiomy Maldonado, known as the 'Wonder Woman of Vogue', performs a sequence of dips and gestures. Around her, the video's animated scenography grows increasingly elaborate, eventually zooming out to reveal Maldonado as one of many facets of a giant cosmic entity composed of diamonds, pearls and floating glossy-red lips. With Maldonado at the centre of the video's dizzying collage, *Stop Playing in My Face!* explores complex intersectionalities of gender, sexuality, race and agency. Its title is taken from a phrase by Black trans YouTube personality Samantha James, who coined the term to mean, 'Don't be fake, don't mess with me.'[54] As Maldonado dances, we hear James elaborating on the phrase, while the voices of feminist academics and writers, including bell hooks and Janet Mock, are merged into a collaged dialogue about identity.

Newsome's life-size sculpture *Ansista* (2019; see p. 41) brings the complicated questions of being that are raised within the video into physical form. Posed in a Vogue dance dip, Ansista's appearance fuses African fashion with drag ballroom aesthetics. The design of the figure's head is inspired by female Pwo masks of the Chokwe peoples of Congo, and was carved from African mahogany by Ghanaian master craftsmen. Ansista's lower half is made from a life-like sex doll, complete with prosthetic vagina and silicone rubber skin. Newsome's choice of materials invites reflection on the oversexualization and fetishization of trans people. But Ansista's hybrid form also situates Newsome's enquiries into the 'radical futurity of emerging identities' within a larger body of work by artists and scholars envisaging non-heteronormative forms of being, belonging, gender and sexuality.[55] We might consider here the multiple queer identities described in Samuel R. Delany's Afrofuturist short story 'Aye, and Gomorrah', including gay voyeurs, fetishistic 'frelks' and genetically engineered 'spacers'.[56] Or queer theorist José Esteban Muñoz's resonant assertion that the 'future is queerness's domain'. Queerness, as Muñoz argued, 'is a structuring and educated mode of desiring that allows us to see and feel beyond the quagmire of the present. The here and now is a prison house. We must strive, in the face of the here and now's totalizing rendering of reality, to think and feel a *then and there*. Some will say that all we have are the pleasures of this moment, but we must never settle for that minimal transport; we must dream and enact

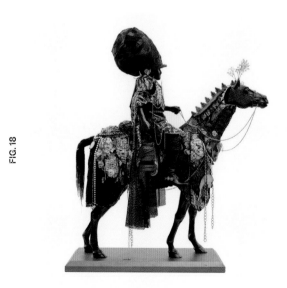

FIG. 18

Hew Locke, *Ambassador 1*, 2021

22

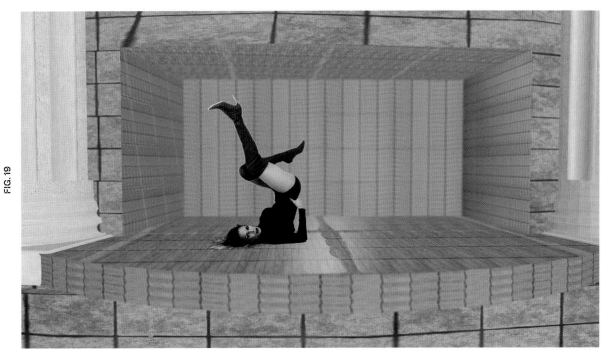

FIG. 19

Rashaad Newsome, *Stop Playing in My Face!* (still), 2016

new and better pleasures, other ways of being in the world, and ultimately new worlds.'[57]

V. MONSTROUS RACES

In the first century CE, the Roman writer Pliny the Elder described a variety of extraordinary human tribes living at the edge of the known world, including men with dogs' heads, and mouthless hairy creatures called Astomi, who had no need of food or drink. Many of the same fantastic creatures are present in the popular imaginary of the medieval period. The Hereford Mappa Mundi (*c*. 1300), the largest surviving world map from the medieval era, teems with fabulous beasts and beings. There are unicorns, minotaurs, pygmies and cyclops, and bizarre peoples like the Blemmyae, whose faces were in their chests, and the Sciopods, one-legged men who could hop at astonishing speed and used their giant foot as a parasol. According to medieval belief, such peoples could be discovered if one ventured beyond the boundaries of civilization. The English knight John Mandeville wrote of his journeys to Ethiopia, Egypt, the Middle East and India, where, alongside Sciopods and cyclops, he encountered women with precious stones for eyes, dwarves who subsisted on the aroma of apples, and men whose 'ballocks' hung to their knees. But a skein of xenophobia runs through much European travel writing of the period. The English Benedictine monk and cartographer Matthew Paris described a tribe of cannibalistic Jews living behind the Caspian mountains whose behaviour was characterized by 'hidden treachery and extraordinary deceit'.[58] He also gave an account of a feast among the 'monstrous and inhuman' Tartar people, at which the body of a young boy was roasted on a spit. Others describe barbarous cave-dwelling troglodytes from Ethiopia, who dine on lizards and kill their elderly. The 'monstrous races' represented the threat posed by the foreign and the non-white to the sanctity of European cultural identity. Their existence '"provided the ideological infrastructure" for ruminating on and understanding "other types of 'monsters,' namely Ethiopians, Jews, Muslims, and Mongols"'.[59]

The monstrous races acquire a contemporary relevance in the work of Sedrick Chisom. Chisom's *The Fugitives of The Southern*

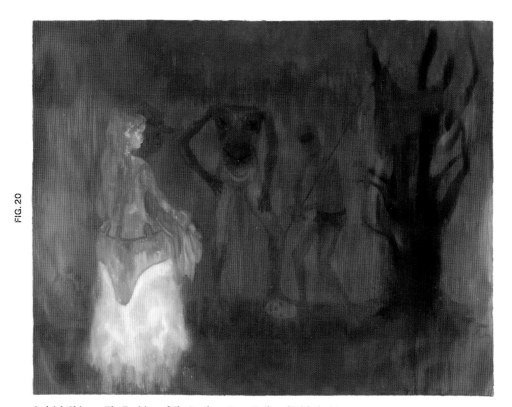

FIG. 20

Sedrick Chisom, *The Fugitives of The Southern Cross Gathered With the Monstrous Races Beneath a Juniper Tree along the Outer Realm of the Savage South*, 2021

Cross Gathered With the Monstrous Races Beneath a Juniper Tree along the Outer Realm of the Savage South (2021; fig. 20) depicts a Blemmyae, his foot resting on a human skull, clustered with a trio of men and women, one of whom holds a Confederate flag. The painting is part of an ongoing series of works that describe a dystopian future in which all people of colour have left the Earth. The planet's remaining inhabitants, all white, are divided into two opposing groups, both of whom are suffering from a disease which is altering the pigmentation of their skin. One group bears resemblance to American Civil War soldiers as well as contemporary alt-right groups. The other tribe consists of people who have already been transformed by the disease into creatures like the Blemmyae. Both groups are locked into a futile war, with the former trying to assert their superior whiteness over the latter, even as they too fall victim to the pestilence, and the planet, with its toxic orange skies, turns rotten around them.

By invoking the monstrous races of a millennium ago, Chisom offers reflection on the long history of whiteness as an ideology of domination. Here, the term 'whiteness' refers to the construction of a white racialized identity that situates the customs, culture and beliefs of white people as the standard by which all other groups are compared.[60] In medieval travel writing, we see how the non-white are rendered racially aberrant as a way 'to define the home culture as not normal but normative, not representative but defining the standard against which all other Others might be judged'.[61] Chisom's paintings extend that idea to a hallucinatory extreme. His works reveal how, in the words of philosopher George Yancy, whiteness functions as a 'parasitic' condition, an ideology that survives by creating a menacing racial other upon which it can assert sovereignty. Even with Black people departed, the planet poisoned and their bodies ravaged by a disease that is changing their skin colour, Chisom's white tribes cling to a belief in their innate racial superiority. Chisom concedes that

the narrative premise of his paintings can sound absurd, but he is nevertheless careful to base his works on existing aspects of Western history, mythology and speculative fiction.[62] References for his paintings include Mormon lore, H. P. Lovecraft's cosmic horror, and the white supremacist novel *The Turner Diaries* (1978).

Kara Walker's film, *Prince McVeigh and the Turner Blasphemies* (2021; see fig. 21 and pp. 50–51), also looks to *The Turner Diaries* as a means of exploring America's painful history of racial violence. Walker's title refers to Timothy McVeigh, the Oklahoma City bomber, and the book that was a key touchstone for him. Known as the Bible of far-right extremists in America, *The Turner Diaries* describes a violent Aryan takeover of the United States. McVeigh slept with a copy under his pillow and emulated the book's protagonist by exploding a huge truck bomb outside a federal building, killing 168 people and injuring 500 others in 1995.

Walker's film imagines a nightmarish America as seen from a white supremacist point of view, in which McVeigh is a dashing hero and acts of grotesque violence against Black people are carried out with impunity. The true nightmare, of course, is that a number of the terrifying scenes enacted by the film's cut-paper marionettes are based on real events. One scene replays the racist murder of James Byrd Jr., a 49-year-old African American man, in Texas, 1998. Three white men known to Byrd drove him to a deserted country road, beat him, chained him by the ankles to the back of their pickup truck, and dragged him so violently that his head and right arm were wrenched from his body. Byrd's dentures were found torn from his mouth. A smeared trail of blood ran a mile long. Like McVeigh, the men claimed to have been inspired by *The Turner Diaries*. At one moment in the film, an image of Donald Trump swims into view, a marker of the legitimization of white supremacist ideology that occurred under the former president.

In the miasma of hatred and horror spun by Walker, no one is innocent. Not the silhouette figures performing their unspeakable acts;

FIG. 21

Kara Walker, *Prince McVeigh and the Turner Blasphemies* (still), 2021

not us, as viewers; not the artist, whose hands – or those of a puppeteer acting on her behalf – are intermittently visible, manipulating the marionettes.

Across the length of Walker's film, scenes skip back and forth between the present day and Civil War America. The blurring of timeframe and setting may be a strategic means of underscoring how the legacies of slavery remain painfully alive today. As the writer Hilton Als has noted, Walker's films stretch and compress time because 'history – and, specifically, black history – is long, with more than its share of science-fictional elements… One minute we are enslaved, the next, writing stories about twisted dreams of power and the people they imagined we were or wanted us to be.'[63]

VI. A NEW VISION

In July 1830, Rebecca Cox Jackson, a 35-year-old free Black woman in Philadelphia, experienced a religious awakening of startling intensity. Outside a storm raged. Terrified of the thunder, Jackson prayed for death or redemption. Suddenly she felt as though 'the cloud burst' and the lightning that had been 'the messenger of death, was now the messenger of peace, joy, and consolation'.[64] Spiritually reborn, Jackson left her husband and six children to become an itinerant preacher and, eventually, the leader of her own sisterhood of Black Shaker religionists. In her spiritual autobiography, *Gifts of Power*, she also describes developing extraordinary abilities, including being able to read minds, divine the future and contact the dead.[65]

Jackson's transformation into a seer exists within a lineage of African American women who have similarly declared themselves mystics. The list runs from nineteenth-century religious visionaries like Jarena Lee, Zilpha Elaw and Sojourner Truth to the jazz artist Alice Coltrane, who largely turned away from secular music in the 1970s to open an ashram under the name Turiyasangitananda ('the Transcendental Lord's highest song of bliss'). The history of these figures who refuse 'to participate in the perceived reality of dominant consensus' is a subject of frequent enquiry for Cauleen Smith.[66] For example, her films *Pilgrim* (2017) and *Sojourner* (2018) visit sites of Black spiritual and cultural significance, such as Coltrane's ashram, in order to explore their founders' mutual project of 'black alter-world-making'.[67]

Smith's installation *Epistrophy* (2018; see p. 47) addresses similar themes of community and Afrofuturist utopia. *Epistrophy* presents an assemblage of objects on a round table, each of which has a personal significance for Smith. Items include books, seashells, bracelets, African figurines, a jar of starfish, a Magic 8-Ball and a taxidermied raven. Projected on the surrounding walls are scenes both intimate and epic in scale, from drifting clouds and trees coming into blossom to a view of the Earth seen from space. With its free-ranging set of references, *Epistrophy* marks for Smith an 'archive of associations, travels, affections, desires, questions, and longings'.[68]

The heterogeneity of the installation's materials suggests the breadth of sources and influences that Black female mystics typically drew upon to tell their stories, including folklore, poetry, the Bible, political pamphlets, the sentimental novel, and a variety of 'empowering myths'.[69] Black women like Jackson who left a conventional family life behind to become itinerant preachers at a time when opportunities for female self-determination were vanishingly scarce, were obliged to draw from 'whatever sources were available' in order to make themselves heard.[70] As writer Mae Gwendolyn Henderson has observed, such women learned to 'speak in tongues', a term Henderson uses to mean, not the religious practice of glossolalia, but the ability to negotiate between 'the multiple languages of public discourse'. 'Through the multiple voices that enunciate her complex subjectivity, she not only speaks familiarly in the discourse of the other(s) but as Other she is in contestorial dialogue with the hegemonic dominant … discourses.'[71]

FIG. 22

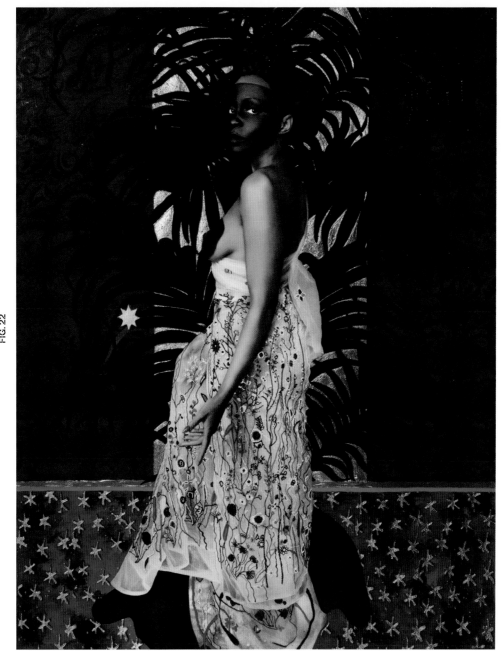

Lina Iris Viktor, *Sixth* (from *A Haven. A Hell. A Dream Deferred* series), 2018

The breadth of influences and references in Lina Iris Viktor's artworks evidences a similar tendency to 'speak in tongues'. Merging photography, performance, sculpture, painting and artisanal techniques of gilding in her practice, Viktor draws from sources including astronomy, Aboriginal dream paintings, African textiles, and West and Central African myth and cosmology. *A Haven. A Hell. A Dream Deferred* (2017–18; see fig. 22 and pp. 48–49)

is an imaginary mapping of the history of Liberia, the country of Viktor's family origins. Liberia was established in 1847 by free African Americans. But the notion of a 'return' to Africa for Black people was a problematic one from the start. Despite dreams of building a Black utopia, the American settlers created a racialized caste system built on dominance over indigenous peoples. Their new society established 'an experience of colonialism which

mirrored conventional features of European colonization'.[72] In Viktor's photographs, Liberia is both a paradise lost and a cautionary tale on the seduction of power. At the heart of the series is another mystic, Sojourner Truth, the visionary preacher, abolitionist and women's rights activist. Truth's charisma as a speaker earned her the title the 'Libyan Sibyl'. The name was a reference to the divine prophetess of Greek myth who foretold 'the coming of the day when that which is hidden shall be revealed', and probably reflected Truth's belief in a coming time of revelation and liberation. In Viktor's gilded photographs, the Classical priestess and the abolitionist activist merge into one oracular figure, whose presence foreshadows Liberia's complex history of migration and colonialism, oppression and emancipation.

Diasporic connection writ on a cosmic scale also informs Wangechi Mutu's animated video, *The End of eating Everything* (2013; see figs. 23 and 24). A grotesque, planet-sized flying monster crosses a blighted skyscape. She has a humanoid upper body and writhing tendrils for hair. Her body is covered in spinning machine parts and flailing human limbs. Clouds of toxic smoke spew from her flesh. As she journeys, the creature encounters a flock of birds. She feeds and feeds on them until, gorged beyond limit, she implodes in a cloud of smoke.

In *The End of eating Everything*, we can see a cautionary parable for the overconsumption that is pushing our planet toward catastrophe. It's tempting to think of the monster as a rapacious Medusa-figure, the signifier for a planet turned vengeful and bitter through despoliation. Yet I'd suggest the strange and haunting scenario that Mutu has conjured exhorts us to think more speculatively in picturing climate change. At the very least, we can reject masculinist metaphors of predatory woman. For example, the scholar Donna Haraway proposes that we might look more productively to the often female-centred myths of planetary care belonging to indigenous peoples around the world.

We find new ways of recognizing the interconnectedness of the planet's species and systems, writes Haraway, by invoking 'the diverse earth-wide tentacular powers and forces and collected things with names like Naga, Gaia, Tangaroa (burst from water-full Papa), Terra, Haniyasu-hime, Spider Woman, Pachamama, Oya, Gorgo, Raven, A'akuluujjusi, and many many more'.[73] Amidst these 'webs' of 'speculative fabulation, speculative feminism' we find new ways to orient ourselves through an uncertain future.

The same might be said for the notion of the Black fantastic. As deployed indifferent forms by different artists, the concept proposes that we both recognize the realities of the racialized everyday and also reach beyond its strictures, conjuring new paradigms, new visions, new possibilities with which to express the wonder and strangeness of being Black in the world.

28

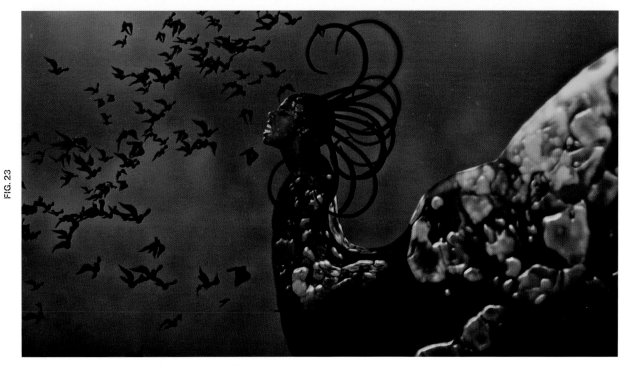

Wangechi Mutu, *The End of eating Everything* (still), 2013

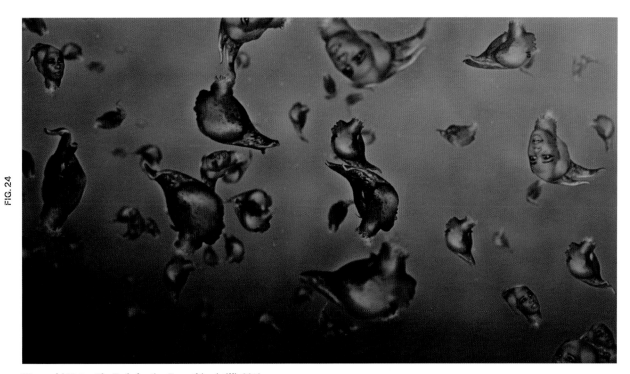

Wangechi Mutu, *The End of eating Everything* (still), 2013

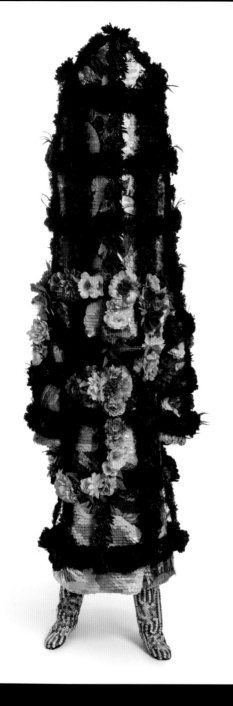

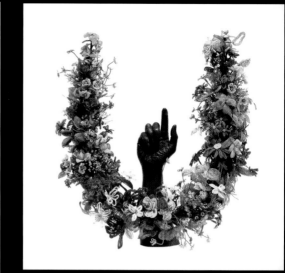

Soundsuit 8:46, 2020
Unarmed, 2016

30

31

Nick Cave's *Chaplet* series (see above) features a cast of the artist's hand or arm, in bronze, emerging from the wall, clutching a delicate garland of flowers. In contrast to the exuberance of Cave's soundsuits, the work strikes a reflective note, suggesting, in the words of critic Megan O'Grady, 'a sense of renewal, of hope and metamorphosis'.

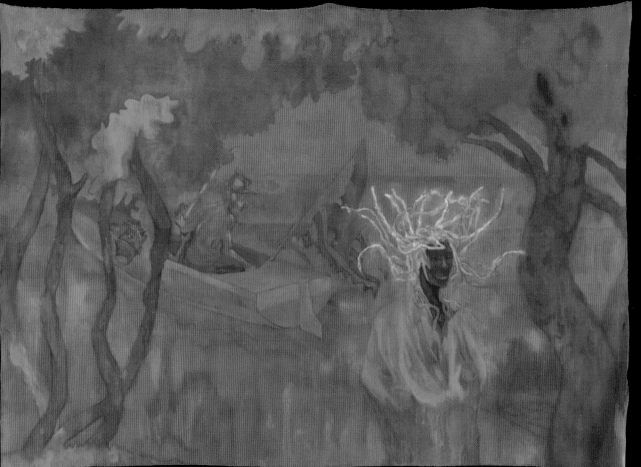

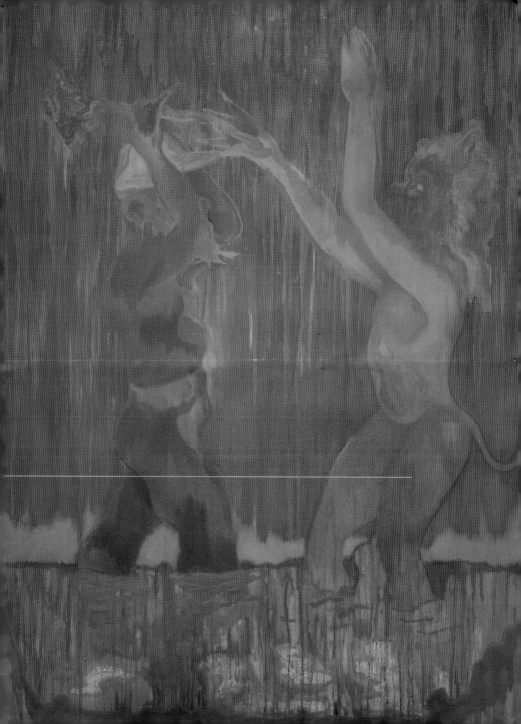

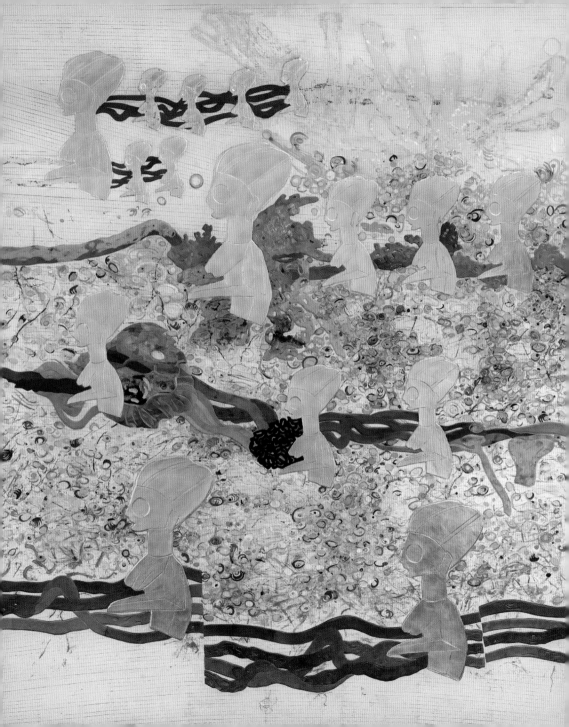

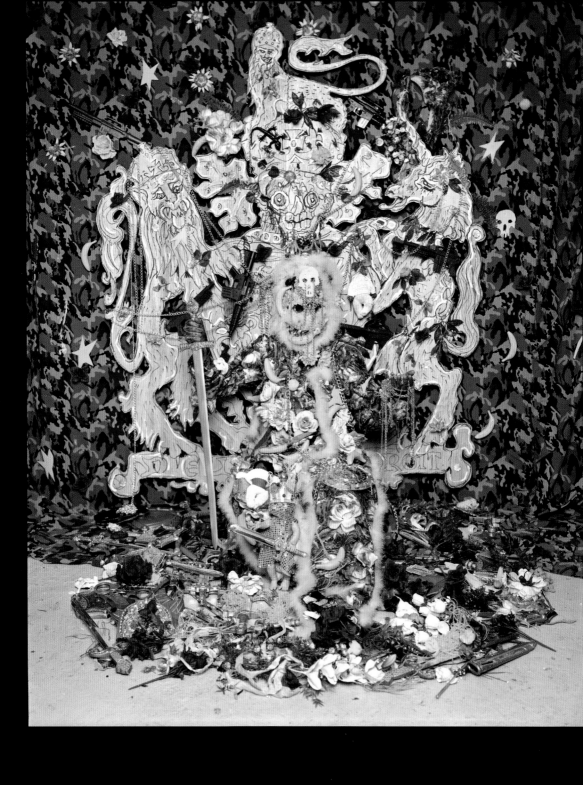

...ion (from *How Do You Want Me?* series), 2007

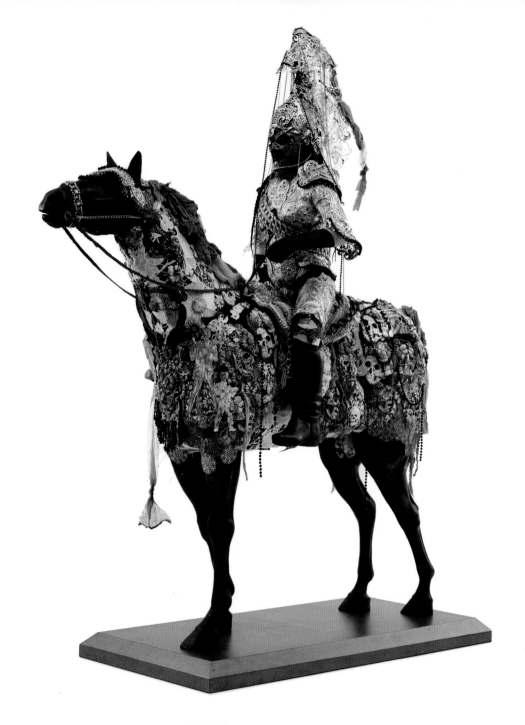

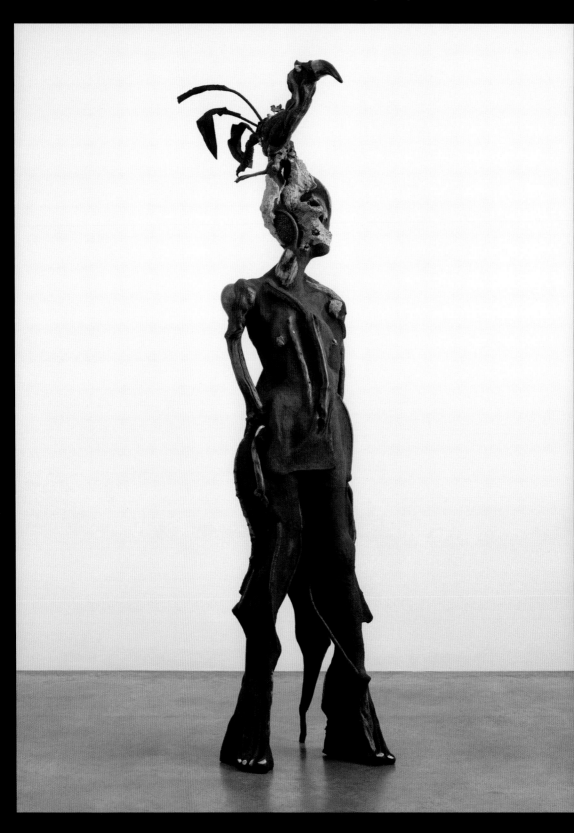

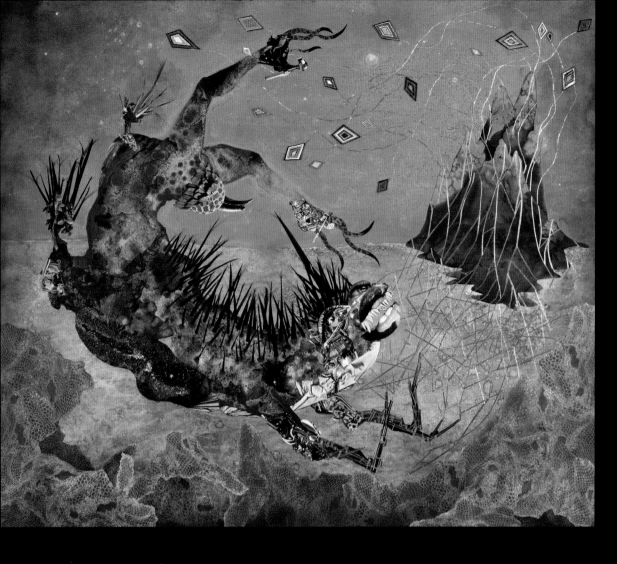

The screamer island dreamer, 2014

In sculptures such as *Sentinel V* (2021), Wangechi Mutu conjures powerful hybridized female figures from a range of diverse references, including East African myth, gender and racial politics, Western popular culture, Eastern and ancient beliefs, and autobiography. *The screamer island dreamer* (2014) is inspired by the nguva, an East African folkloric creature thought to be derived from the dugong. These mythical water women wander, restless and vicious, along the coast and are said in stories to have pulled men from their boats, drowning them in the sea.

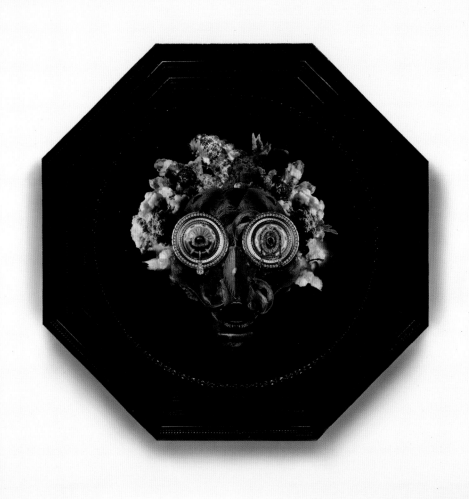

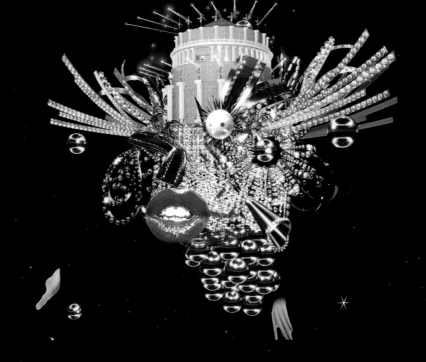

Stop Playing in My Face! (still), 2016
Ansista (installation view), 2019

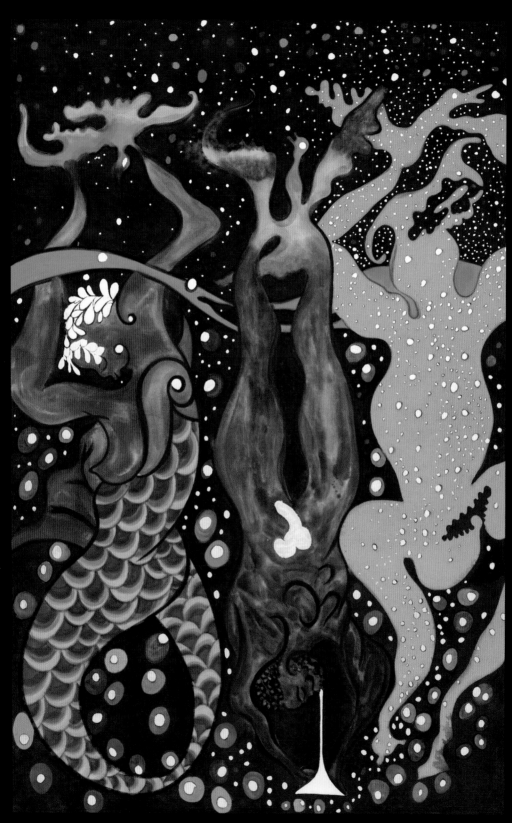

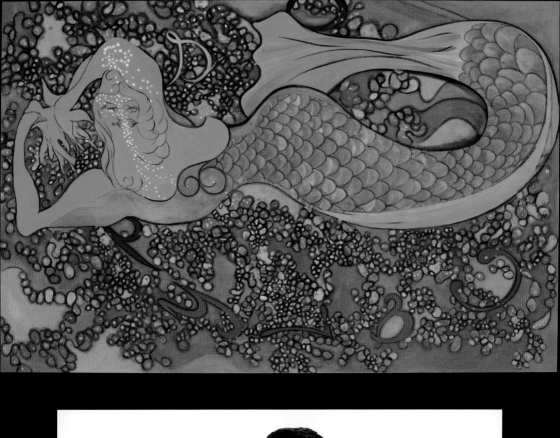

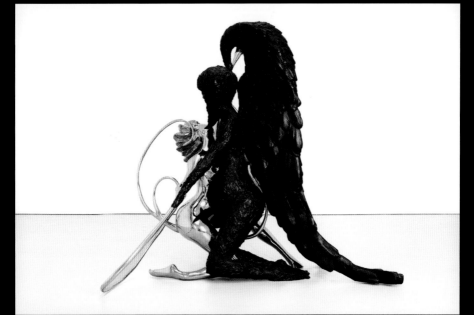

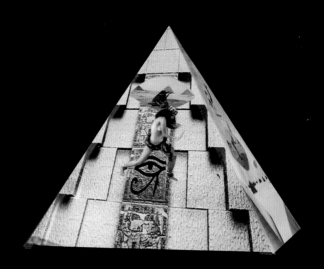

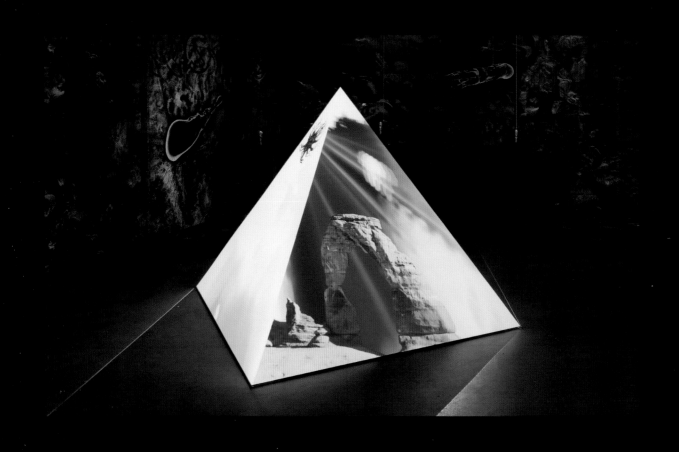

Ultra Wet – Recapitulation, 2017

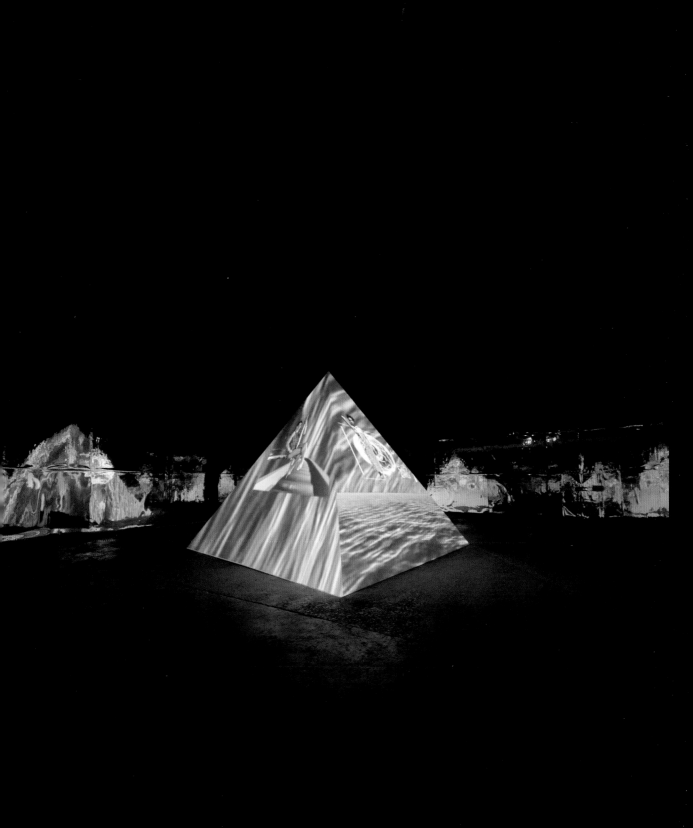

BLK FMNNST Loaner Library 1989–2019 (2019) is a set of thirty drawings of books that have inspired Cauleen Smith's interdisciplinary practice. The gouache drawings depict a range of publications, including novels by Toni Morrison, Ralph Ellison and Octavia E. Butler, and works of cultural theory by scholars such as Saidiya Hartman, Christina Sharpe and Hortense J. Spillers, as well as books on botany and natural history such as Jethro Kloss's *Back to Eden: The Classic Guide to Herbal Medicine, Natural Foods, and Home Remedies* [since 1939].

Back to Eden, 2019

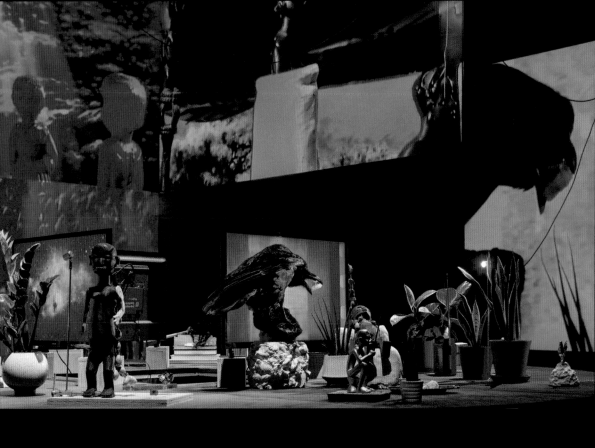

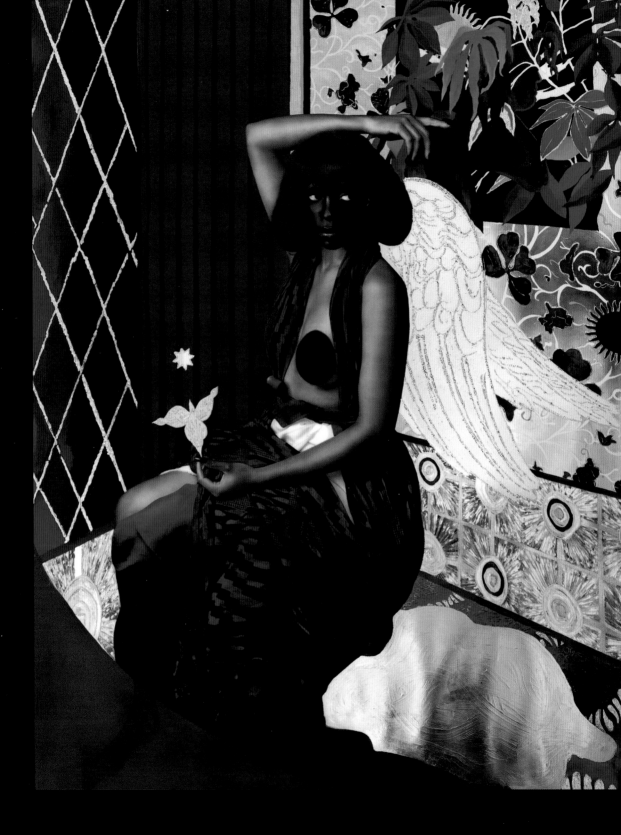

Second (from *A Haven. A Hell. A Dream Deferred* series), 2017–18

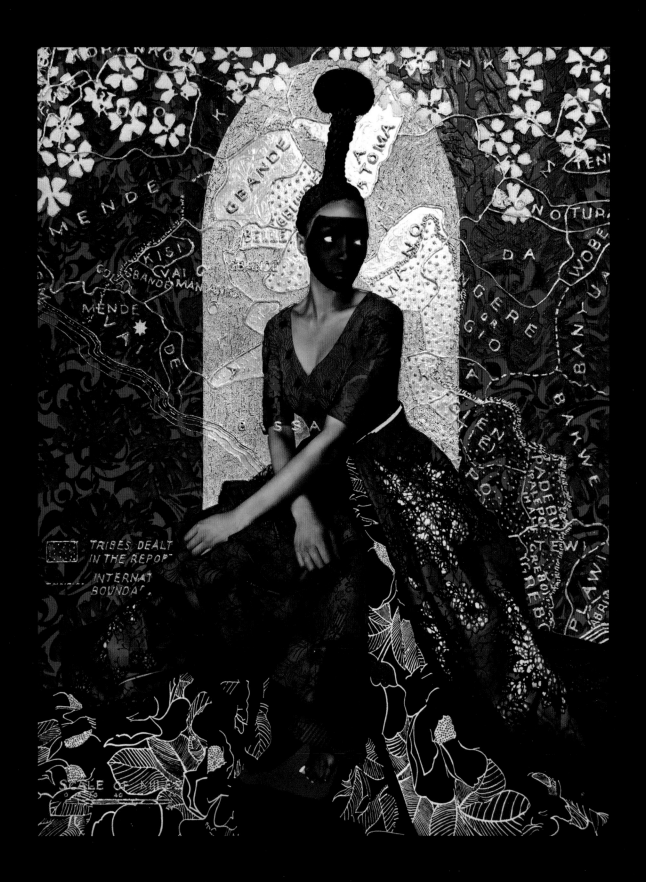

Eleventh (from *A Haven. A Hell. A Dream Deferred*
series), 2018

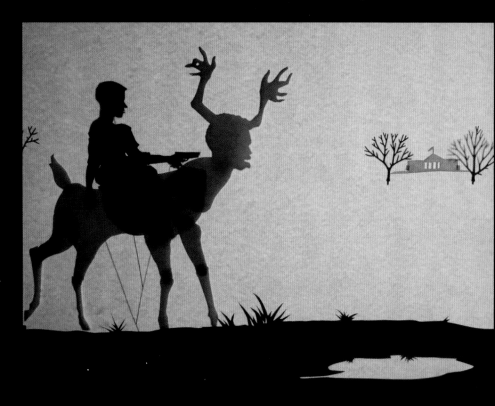

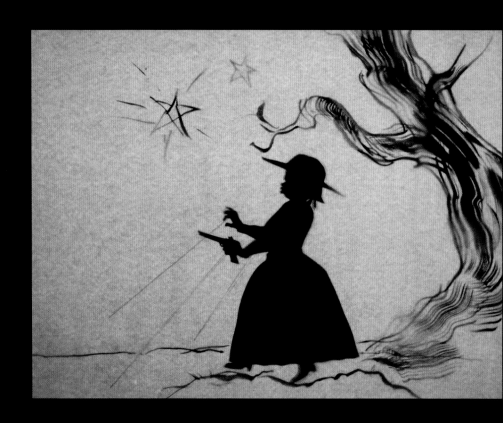

Prince McVeigh and the Turner Blasphemies (stills), 2021

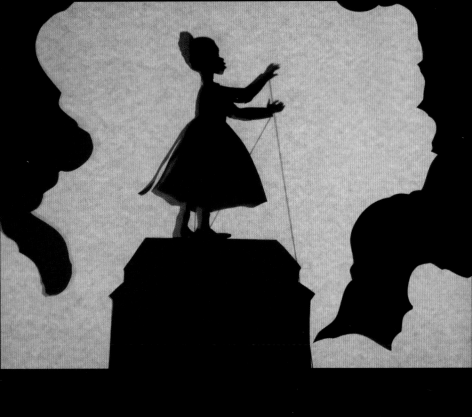

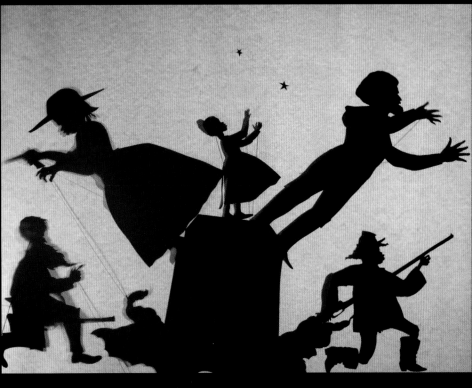

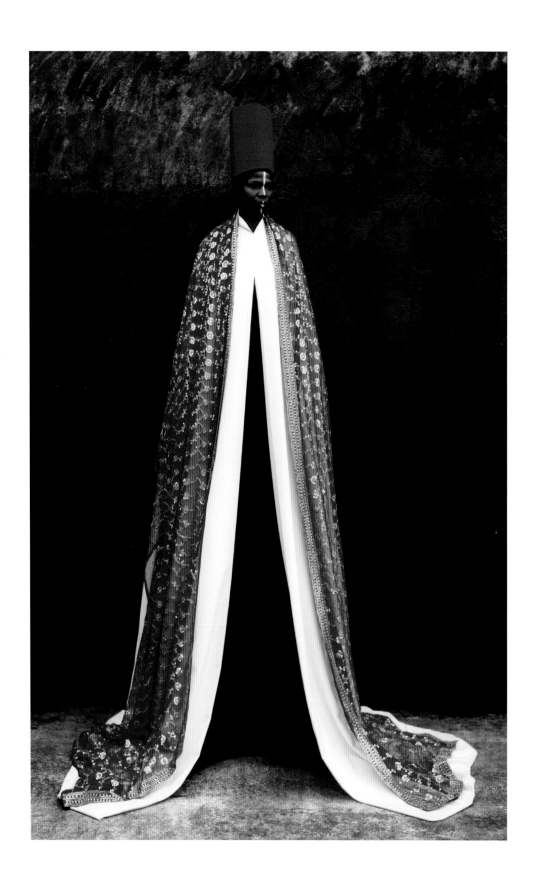

Maïmouna Guerresi, *Rhokaya*, 2010

Invocation

1

A
Summoning
of Spirits

when Black people were forcibly transported to the island to work its indigo plantations. Isolated from the mainland, the island's people have developed their own creole language, known as Gullah, and they have held onto customs and spiritual beliefs originally practised by their forebears in Africa.[1] In the film's next scene, the same woman is present. But she is now 88 years old and we see her walking out of the sea, fully dressed, at a site on the island known as Igbo Landing.

Daughters of the Dust tells the story of three generations of women in a Gullah family in 1902, as some among them prepare to leave the island and its traditions for modern life on the mainland. Events take place on a single day but the film weaves stories across time, establishing a lattice of memories that connects the family to their African ancestry across the ocean. Two voices act as narrator: Nana, the 88-year-old, who is the family matriarch and holds fast to African beliefs and rituals, and the Unborn Child, Nana's great-great-granddaughter-to-be, who appears intermittently as a spectral presence, a vision of the future of the family.

Daughters of the Dust explores legacies of slavery, survival and spiritual retention between America and Africa. The film gains additional resonance for being filmed at Igbo Landing, a location which marks 'the great divide between two continents while constituting a space of resistance of African folkways and magic rituals'.[2]

The significance of the site dates back to May 1803, when a group of enslaved Igbo-speaking Africans being shipped to the island revolted against their captors. The white crew either jumped overboard or were killed, and the power of myth. Some versions of the story have the Igbos returning to Africa by walking on the waves or along the seabed. Others describe them taking to the sky and soaring back home on air currents. The story has also been reimagined in contemporary culture. The spectacle of flying Africans drives the narrative of Toni Morrison's novel *Song of Solomon*. And the larger world of diasporic deities and healing arts inhabited by the Gullah women depicted in *Daughters of the Dust* is the inspiration for some of the most mesmerizing scenes in Beyoncé's *Lemonade*. In these fictional works, the boundary between the past and the present, the everyday world and the spirit realm, is always on the verge of dissolving. In *Lemonade*, for example, Beyoncé is submerged in a room filled with water and emerges, reborn, as a representation of the Yoruba river deity Oshun.

In works by creative figures from across the African diaspora, we see a shared tendency to elide myth and collective memory, the speculative and the supernatural, and to also imagine the flow of time as unfixed and open-ended. Here, we can cite books such as Nnedi Okorafor's 'Africanfuturism' novel, *Who Fears Death* (2010), Marlon James's 'African *Game of Thrones*' *Black Leopard, Red Wolf* (2019), and D. O. Fagunwa's wildly fantastical *Forest of a Thousand Daemons* (1938), the first full-length novel published in Yoruba. We can also mention the simultaneously devotional and profane photography of Rotimi Fani-Kayode, and films such as Haile Gerima's time-slippage slavery movie *Sankofa* (1993) and Souleymane Cissé's *Yeelen* (1987; fig. 1), a magical quest set in the medieval-period Mali Empire.

The defining characteristic of these works is not the type of stories they tell so much as

54

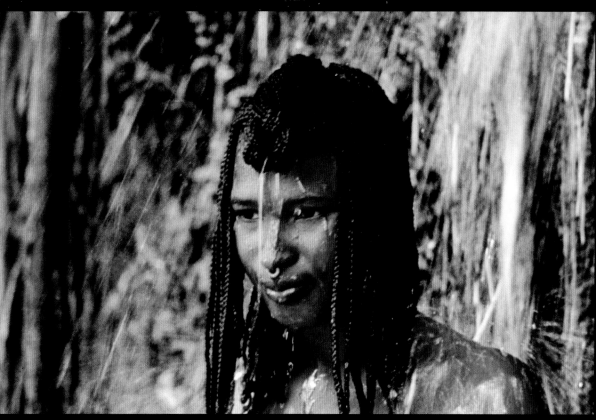

Yeelen, dir. Souleymane Cissé (still), 1987

the extraordinary tone of otherworldliness they conjure. For instance, *Atlantics* (2019) by Mati Diop begins as realist drama before giving way to strange and haunting scenes of spirit possession and supernatural resurrection. And with his 2021 TV adaptation of Colson Whitehead's *The Underground Railroad* (2016), filmmaker Barry Jenkins heightens and stretches the speculative elements of the novel, creating a beautiful, disturbing phantasmagoria that is equal parts dream, nightmare and historical reality.

Thanks to the wild popularity of superhero movies and TV shows like *Game of Thrones*, fantasy has become the dominant cultural language of our times. One of the unanticipated consequences of that trend is that it has given space for Black artists to explore Black life in ways that are more allusive

and audacious than was possible, say, in the 1990s when *Daughters of the Dust* was released. Although the film won critical acclaim, Dash was greeted with such indifference by the film industry that she has not made a movie since.

In this context, the embrace of the speculative is not the escapism we might associate with fantasy. It is an indication, rather, that a world built on racial inequity is itself fractured. For instance, the psychologically fraught tone of movies like Jordan Peele's *Us* (2019) and *Get Out* (2017) is surely a response to the horror and absurdity of a world in which Black people can be harassed, arrested or shot dead while going bird-watching, jogging or lying asleep in bed at night. Works based on myth and fable become a corrective, a sustaining force, against the irrationality of ordinary life.

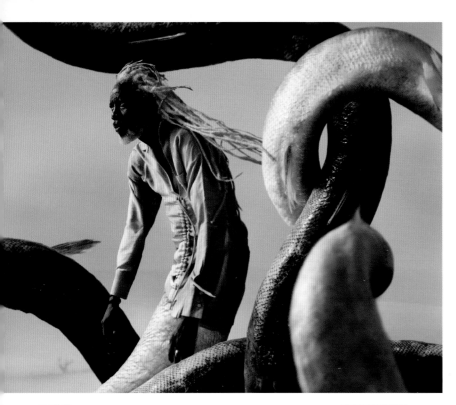

David Uzochukwu, *Uprising*, 2019
Kristin-Lee Moolman, from *Baloji* series, 2018

56

→
David Uzochukwu, *Wildfire,* 2015

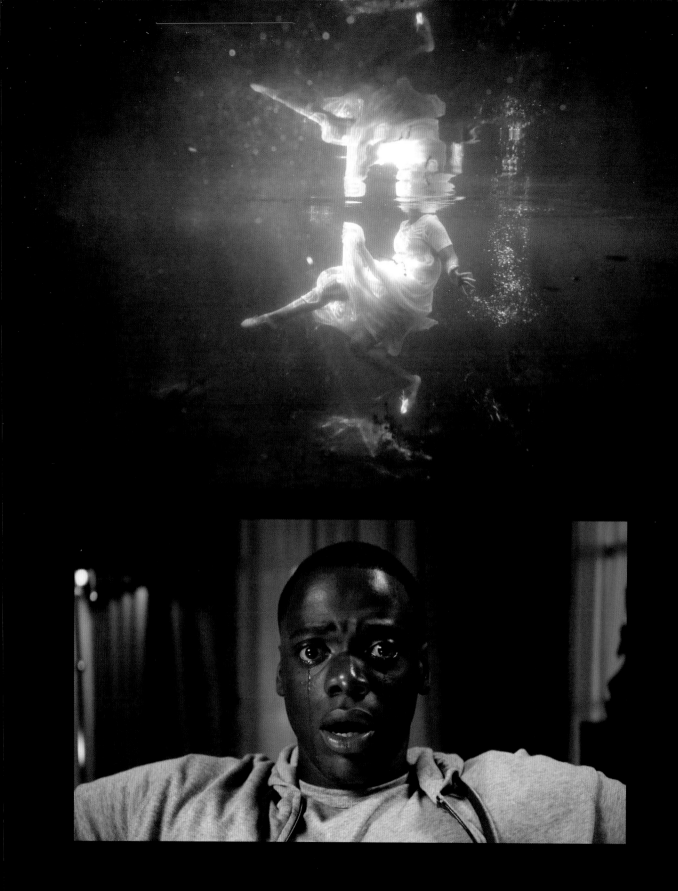

Allison Janae Hamilton, *Floridawater II*, 2019
Get Out, dir. Jordan Peele (still), 2017

58

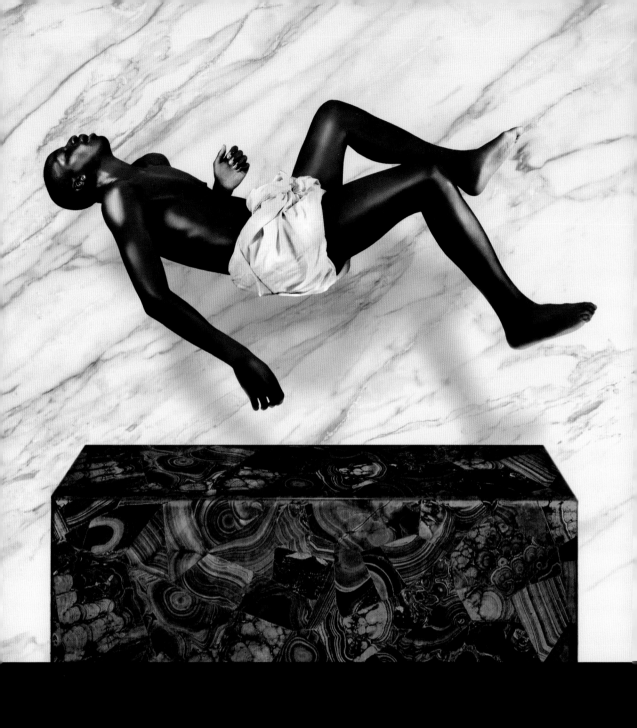

Petite Noir, *La Vie Est Belle / Life Is Beautiful*
album cover artwork by Lina Iris Viktor), 2015

INVOCATION: A SUMMONING OF SPIRITS

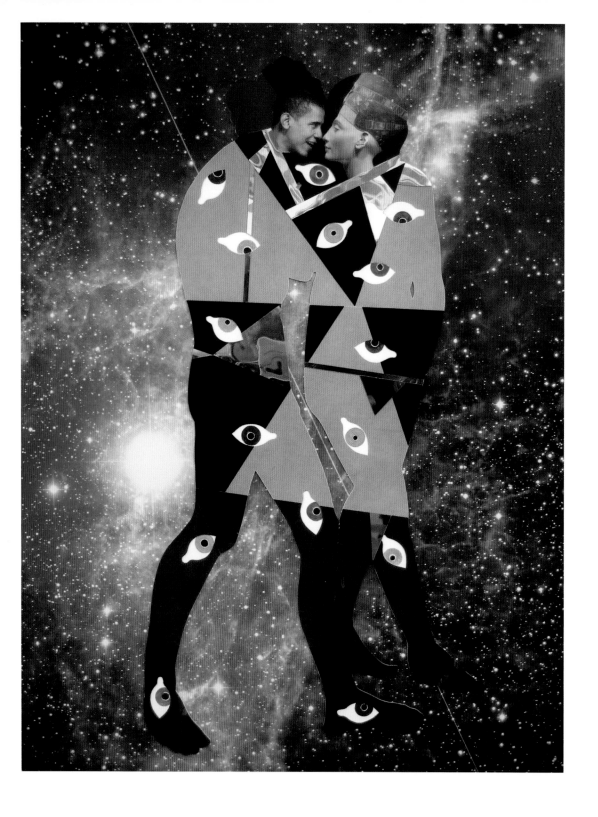

William Villalongo, *Barack and Nefertiti
in the Vela Supernova Remnant*, 2009

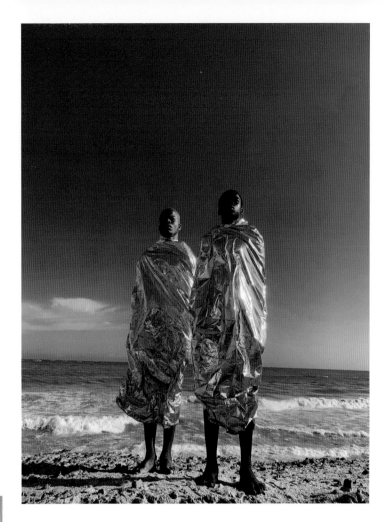

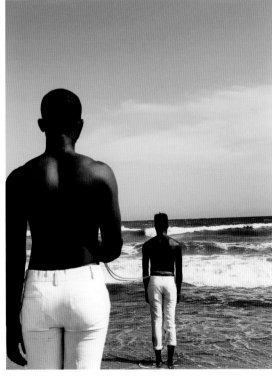

Prince Gyasi, *Mental Slavery*, 2018

Prince Gyasi, *Restoration*, 2019

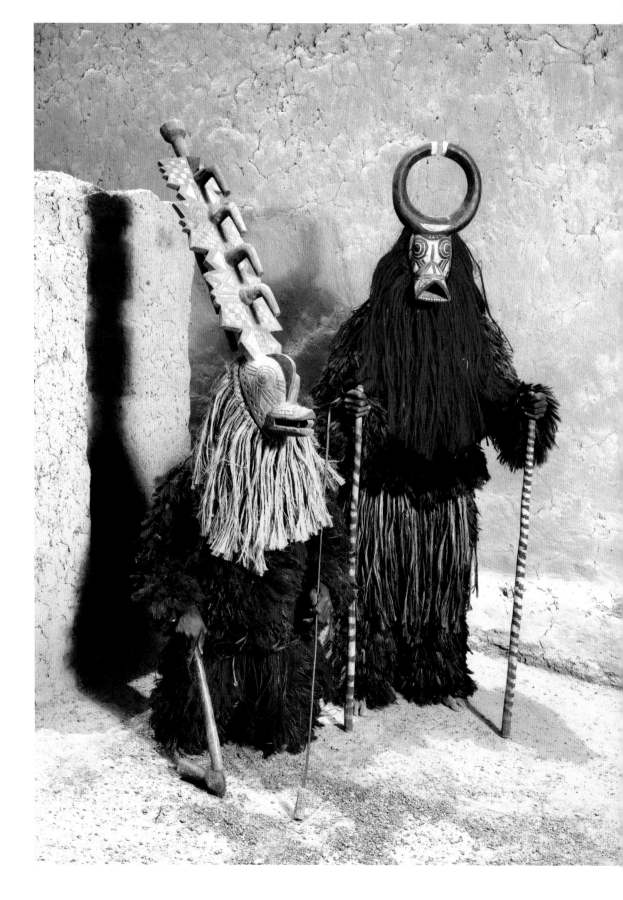

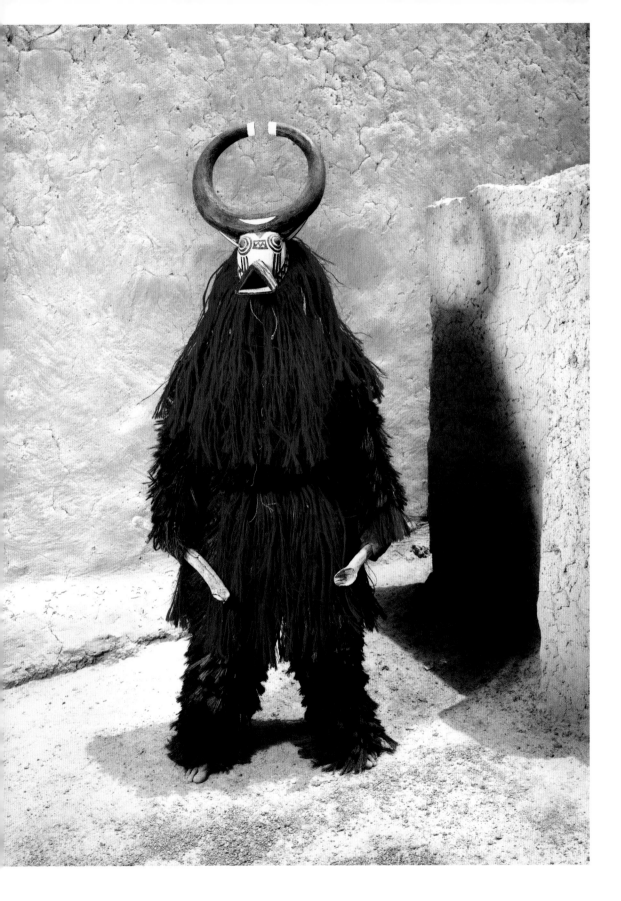

INVOCATION: A SUMMONING OF SPIRITS

Flying Lotus, *You're Dead!* (album cover
artwork by Shintaro Kago), 2014

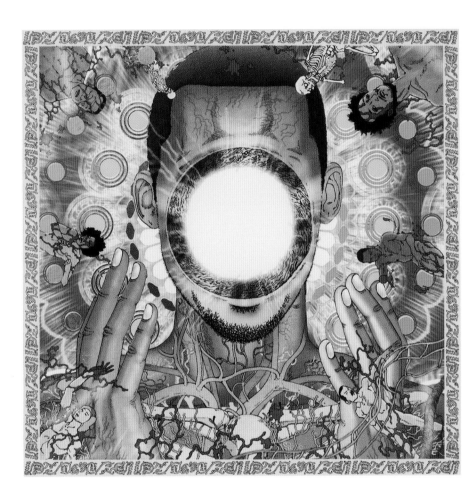

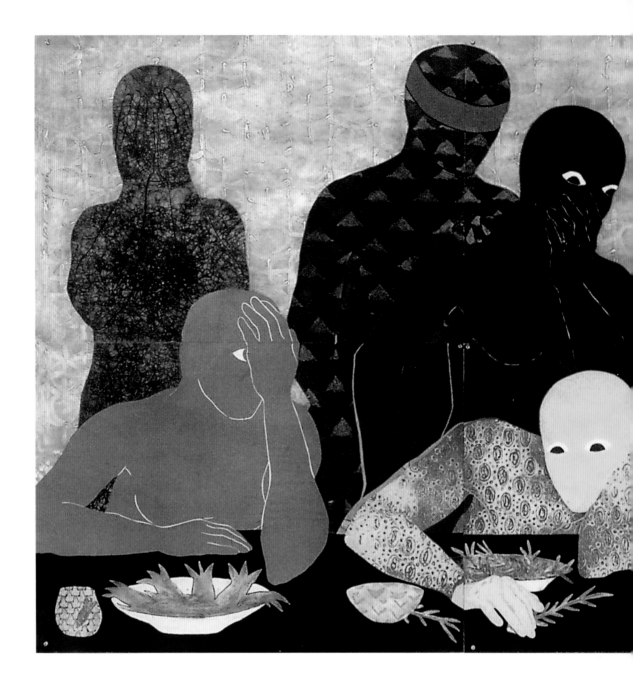

Belkis Ayón, *La cena (The supper)*, 1988

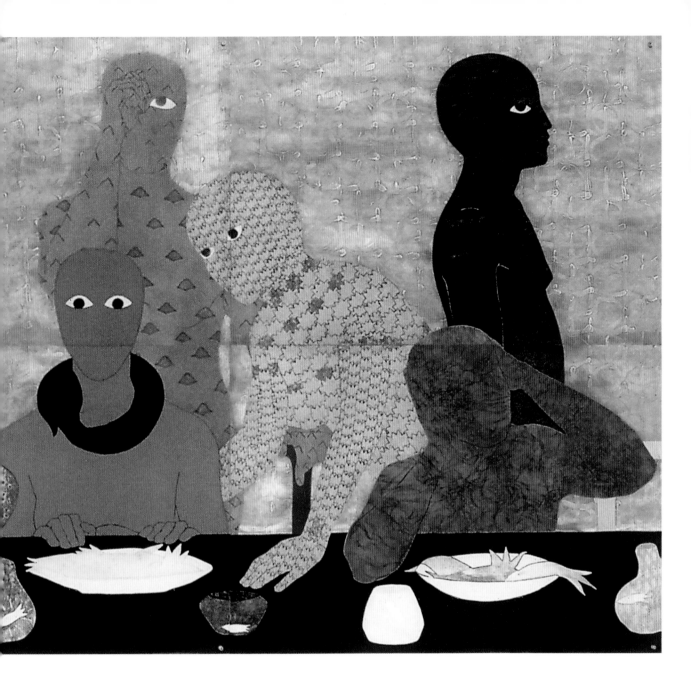

The Cuban printmaker Belkis Ayón focused much of her career on producing works that explored the mythology of La Sociedad Secreta Abakuá (The Abakuá Secret Society), an all-male Afro-Cuban religious group with a complex mythology that informed its rites and traditions. Although excluded from participation in its ceremonies, Ayón studied Abakuá closely. Sikán, the most prominent female figure in the religion's belief system, was a recurring presence in her print-based works. In *La cena (The supper)*, Sikán, in green, is seated at the centre of a table, surrounded by androgynous figures lacking facial features except eyes. The scene is thought to depict the secret initiation banquet of Abakuá, while also referencing Leonardo da Vinci's *The Last Supper*.

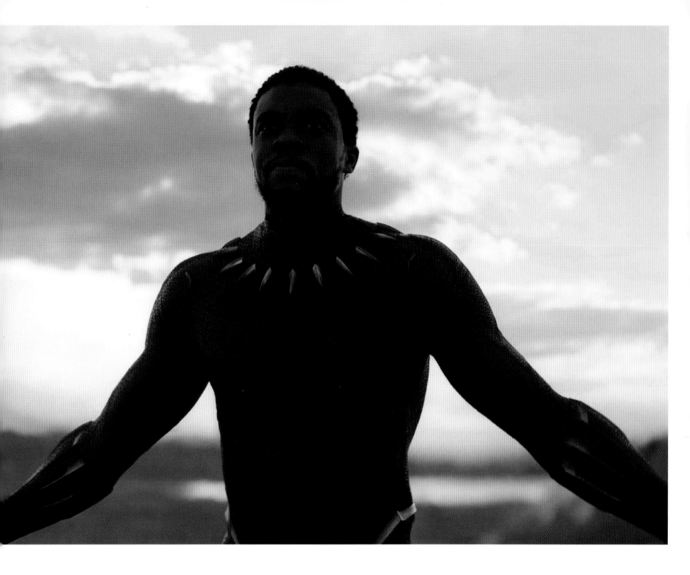

Created by Stan Lee and Jack Kirby in 1966, the Black Panther was
the first Black comic book superhero. He was also the first African one.
Over the years, the Panther's African identity has increasingly defined
him as a character. As King T'Challa, he is ruler of the secretive African
nation of Wakanda, deriving his superhuman strength, agility and
enhanced senses from his connection with Wakanda's powerful panther
god, Bast. Wakanda is also the most technologically advanced nation
on Earth, a land where science and African belief systems comfortably
co-exist. In Ryan Coogler's *Black Panther*, starring Chadwick Boseman,
the character's ability to channel the wisdom of his ancestors is central
to his strength as both a hero and a head of state.

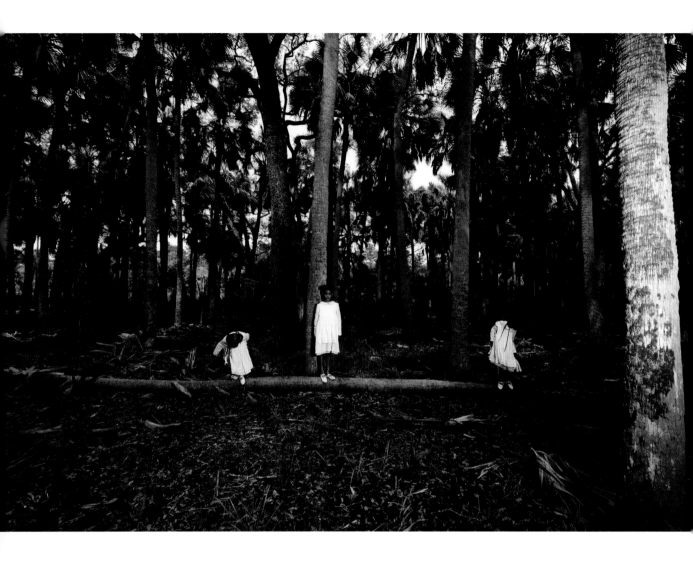

Allison Janae Hamilton, *Three girls in sabal palm forest II*, 2019

70

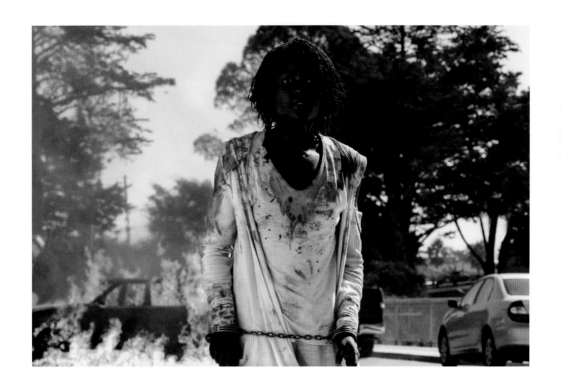

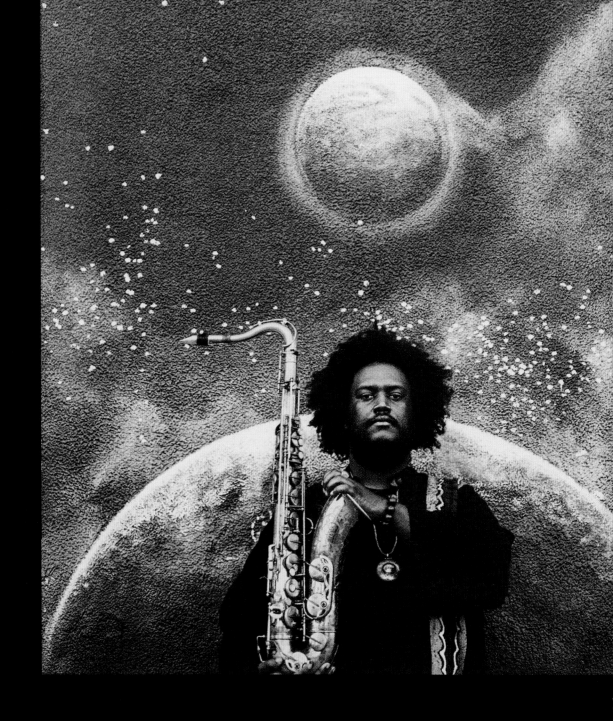

Kamasi Washington, *The Epic* (album cover photograph
by Mike Park, artwork by Patrick Henry Johnson), 2015

72

→ *Ganja & Hess*, dir. Bill Gunn (still), 1973

Nnedi Okorafor, *Binti: The Complete Trilogy*
(book cover artwork by Greg Ruth), 2020

INVOCATION: A SUMMONING OF SPIRITS

Kristin-Lee Moolman, from *Baloji* series, 2018

INVOCATION: A SUMMONING OF SPIRITS

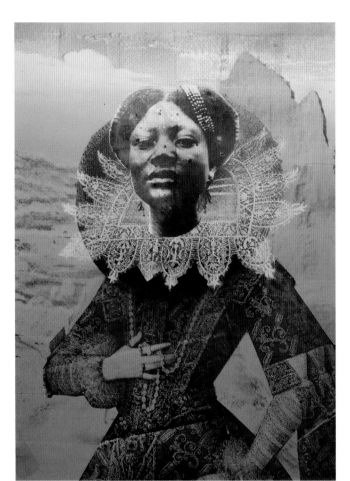
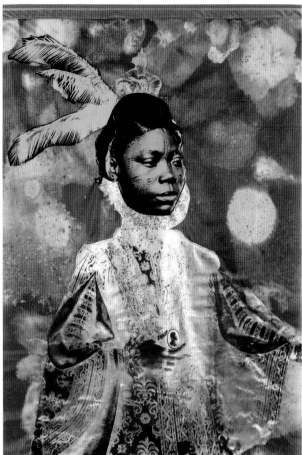

Raphaël Barontini, *Njinga*, 2021
Raphaël Barontini, *Queen Nanny*, 2021

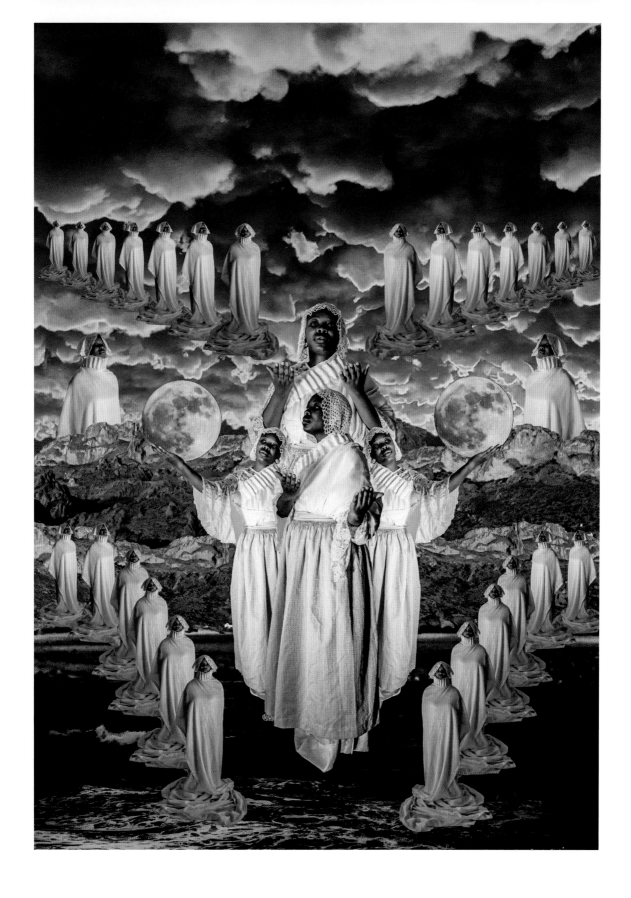

Puleng Mongale, *Indlela Ibuzwa Kwabaphambili*
(*Ask Those Who Have Gone Before*), 2020

79

INVOCATION: A SUMMONING OF SPIRITS

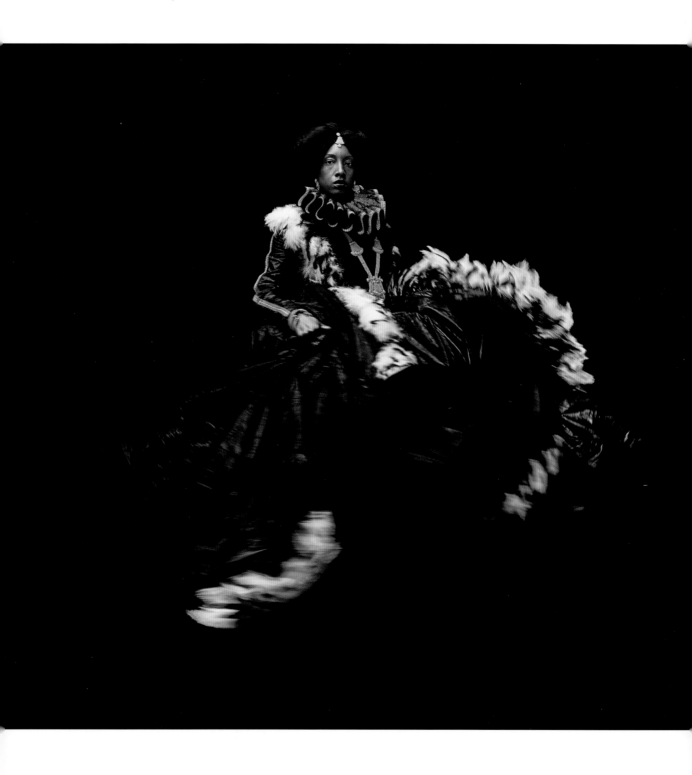

Ayana V. Jackson, *Consider the Sky and the Sea*, 2019

PART 1

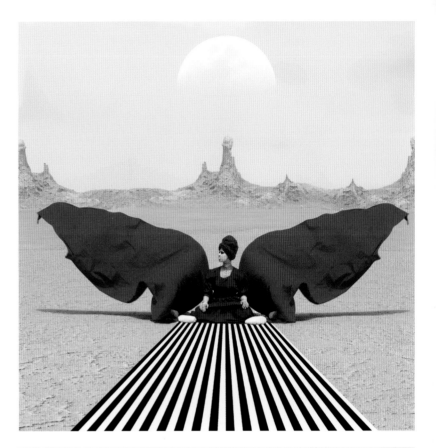

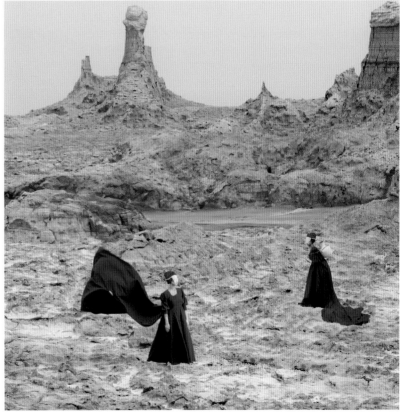

Aïda Muluneh, *Star shine, moon glow*
(from *Water Life* series), 2018

Aïda Muluneh, *Distant echoes of dreams*
(from *Water Life* series), 2018

INVOCATION: A SUMMONING OF SPIRITS

Jim Adams, *Royal Flypast (Horus flies over the artist's studio while Seth explodes in rage)*, 2019

→
Kristin-Lee Moolman, from *Baloji* series, 2018

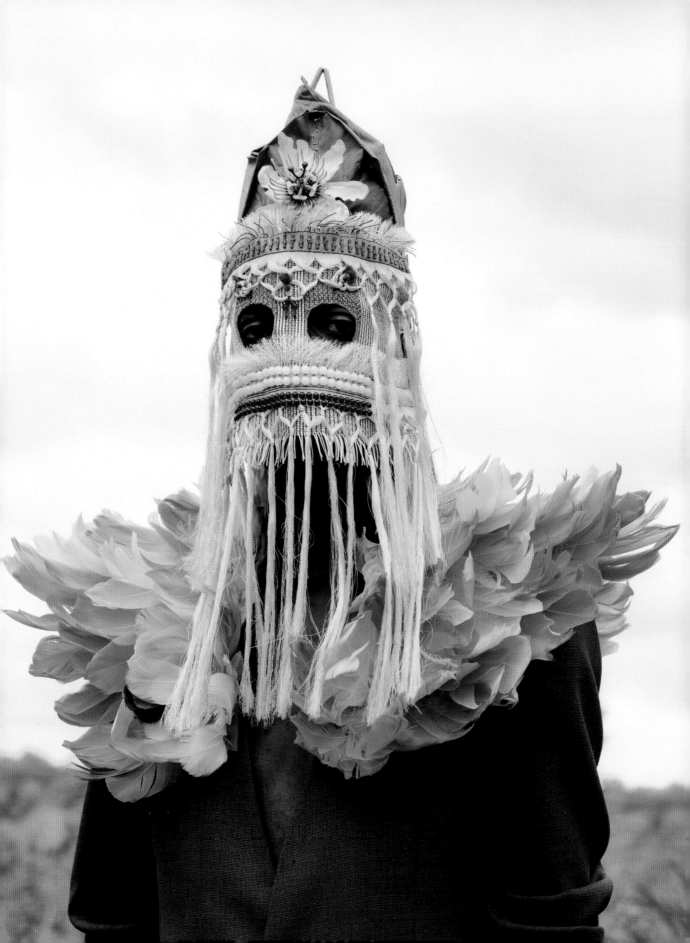

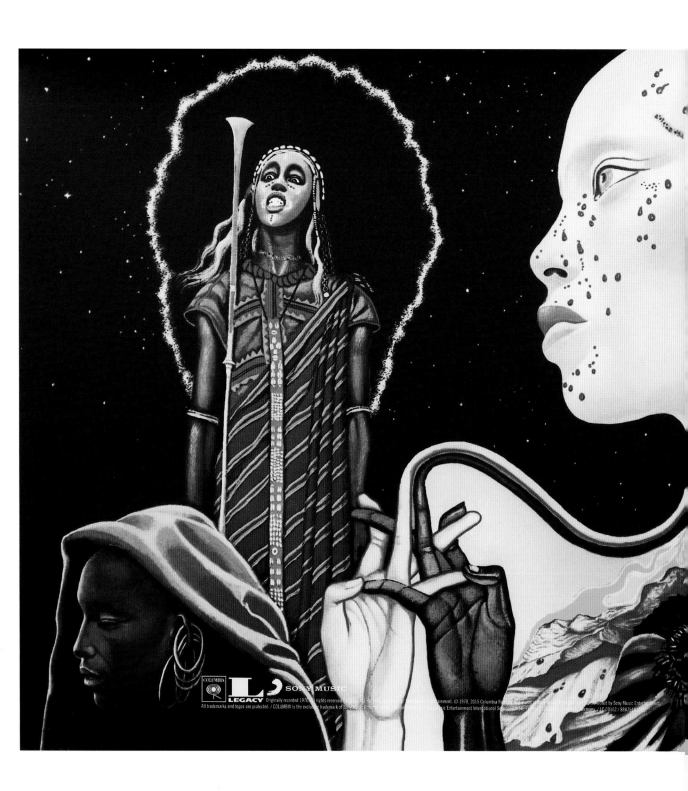

Miles Davis, *Bitches Brew* (album cover
artwork by Abdul Mati Klarwein), 1970

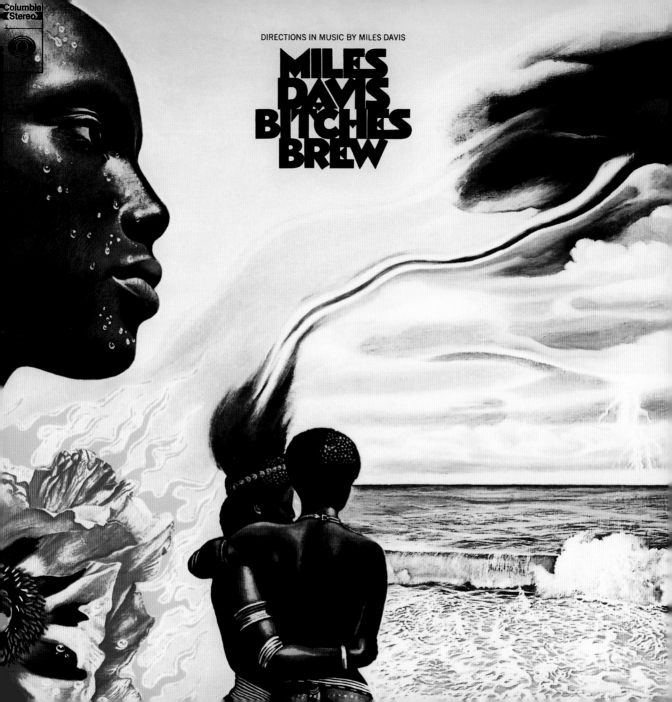

Jackie McLean, *Demon's Dance* (album cover artwork
by Abdul Mati Klarwein, design by Bob Venosa), 1970

→
Leonce Raphael Agbodjelou, *Untitled*
(from *Egungun* series), 2011

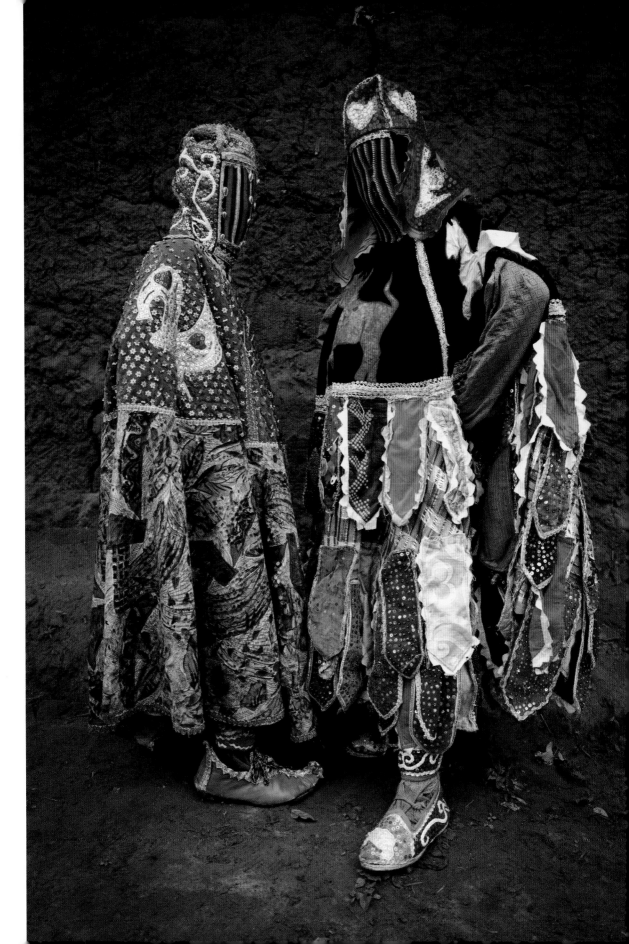

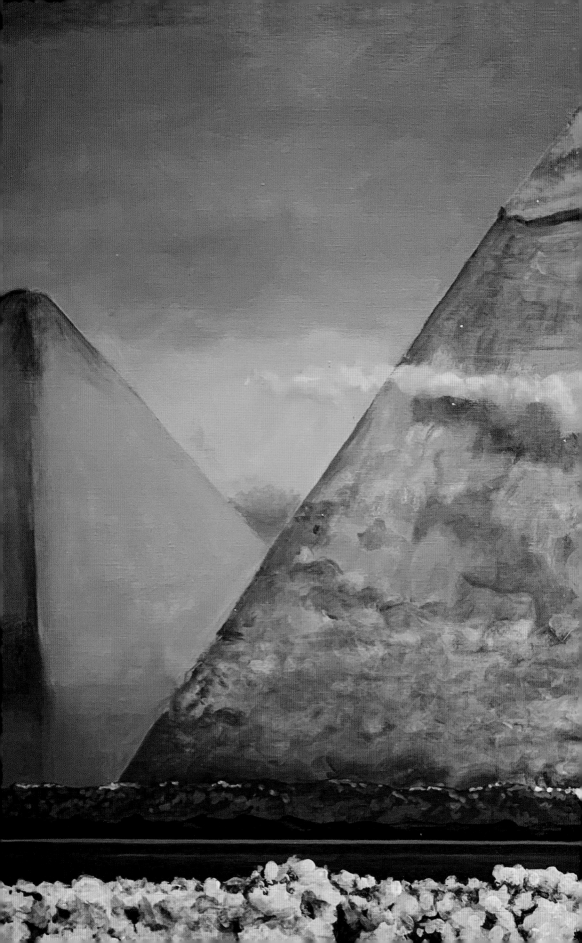

Old Slavery Seen Through Modern Eyes: Octavia E. Butler's Kindred and Haile Gerima's Sankofa

Adriano Elia

Altre Modernità (open access), Università degli Studi di Milano, February 2019, pp. 20–30 [extract: pp. 21–24]

The Role of Fiction and Cinema

It is now worth raising a couple of questions: what is the role of fiction and cinema in discussing sociopolitical issues? How can they contribute to such discussion? While it is beyond the scope of this essay to deal thoroughly with such crucial matters, we are obviously aware of the fact that fiction is a creation of imagination, hence, by definition, something unreal, a lie. Yet, as we have seen elsewhere (Elia *Formal* 139), fiction can also be a useful resource in approaching sociopolitical issues in at least two different ways.

The first one involves introducing fictional characters and narrating events mainly to make direct political statements and elicit social criticism. Early examples are W. E. B. Du Bois's novels *The Quest of the Silver Fleece* (1911) and *Dark Princess* (1928), narrating the condition of African Americans and revealing the author's political views, and later James Baldwin's outspoken first novel, *Go Tell It on the Mountain* (1953). Du Bois deliberately used speculative fiction as a further instrument of interpretation and social analysis: 'I have used fiction to interpret those historical facts which otherwise would be not clear', Du Bois wrote in the 'Postscript' to his novel *The Ordeal of Mansart* (1957). Therefore, to achieve a realistic representation of African-American life, it is paradoxical that Du Bois used imagination to reinterpret historical situations that had either been distorted or had not been

adequately considered by traditional narrations (see:
Terry in Zamir 54; Elia *W.E.B.* 177).

A different way of tackling sociopolitical matters
is offered by Afrofuturist literature and cinema, based
on science fiction and related issues such as time travel,
space age metaphors and so forth.[1] The conflation of
past, present and future allows Afrofuturist writers
and filmmakers to construct counter-histories and
imagine counterfutures reconsidering a series of
issues concerning the African-American and the Afro-
European diaspora. Both *Kindred* and *Sankofa* belong
to this second category.

With regard to the role of cinema, Kracauer has
argued that films can be used as historical sources
reflecting the mentality of a nation. In the essay
From Caligari to Hitler (1947), he noted that the analysis
of films – in his case, those made in the Weimar era
foreshadowing the rise of Nazism – makes it possible
to comprehend the social and psychological mindset
of a nation. Albeit in a different context, *Sankofa*
can also be considered as an important historical
document describing the odd connection between the
lives of slaves in the antebellum South and what their
descendants are doing in the contemporary world.

1 In 1993 Mark Dery defined
Afrofuturism as 'speculative
fiction that treats African-
American themes and addresses
African-American concerns
in the context of twentieth-
century technoculture'. For a
discussion of Afrofuturism as
an interdisciplinary cultural
movement see: Elia *Languages*.

Therefore, a third question arises: what if a contemporary woman were to experience early nineteenth-century racism as an eyewitness? Living old-fashioned slavery from a contemporary standpoint is what actually happens to the protagonists of the novel and the film. In this case, what the media of fiction and of cinema bring about is imagining and, in actual fact, *seeing*, old slavery through modern eyes. *Kindred* and *Sankofa* play as intermediaries between reality and the social sciences, generating counter-histories advancing different and unusual perspectives.

Kindred: Old Slavery, Modern Eyes

To confirm this point, it is useful to cite a passage from an interview with Butler about the making of *Kindred*. The time travel to antebellum Maryland was meant to be a narrative device obliging Dana to perceive deeply and directly the evils of slavery. As Butler put it, 'I was trying to get people to *feel* slavery' (Snider, Butler's emphasis). In order to do so, time travel is perfectly appropriate for making the contemporary reader feel almost physically the pain of being treated like a slave. The fact that an impossible event such as time travel could happen to anyone heightens the reader's sense of identification with Dana, who lives this effectively

described nightmarish experience. The conflation of past and present provides the novel with a valuable vantage point that considers in diachronic terms one's relation with old slavery and violence *per se* through a contemporary sociocultural mindset.

As we have seen, it is the story of a young mixed couple, African-American writer Dana and her white partner Kevin, living in contemporary Los Angeles. For seemingly inexplicable reasons, Dana moves in space and time and ends up in a pre-Civil War plantation in Maryland where she meets her ancestors: Rufus, the young son of a slave owner, and Alice, an African-American slave. Dana later understands that she is compelled to go back in time when Rufus is in danger and travels back to Los Angeles when she finds herself in danger. The novel is thus based upon these parallel settings: on the one hand Maryland, 1815, where Dana undergoes the dramatic experience of slavery; on the other Los Angeles, 1976, where she tries to lead a normal life with Kevin.

Butler's groundbreaking method tackled slavery and racial politics via unconventional tactics typical of science fiction, in order to discuss and examine the dynamics of antebellum slavery as well as its legacy in contemporary society. More precisely, in the case of *Kindred*, rather than science fiction Butler herself defined the novel as 'a kind of grim fantasy', because she did not explain the scientific reasons that made time travel possible: 'I don't use a time machine or

anything like that. Time travel is just a device for getting the character back to confront where she came from' (see: Snider; Kenan 496).

One of the most salient features of the novel is certainly its stylistic hybridity. Butler manages to integrate disparate types of narrations such as fantasy novel and slave narrative, a genre based upon a literary transposition of the lives of slaves. The Maryland sections of *Kindred* are by all means influenced by intense autobiographies such as *Narrative of the Life of Frederick Douglass, an American Slave* (1845) by Frederick Douglass (to whom many conferences and events are currently being dedicated on the 200th anniversary of his birth), or *Incidents in the Life of a Slave Girl* (1861) by Harriet Jacobs, which reported the sexual violence and abuse she had to suffer from her master. For this reason, *Kindred*, in particular the gripping and moving accounts of its Maryland sections, may be considered a seminal example of the so-called neo-slave narrative. Whereas the aim of the above-mentioned slave narratives (mainly autobiographies) was to denounce the horrors of slavery and support abolitionism, neo-slave narratives are contemporary novels inspired by traditional first-hand slave narratives and offering a psychological insight into the experience of slavery such as *Beloved* (1987) by Toni Morrison, who aptly described her writing as a 'literary archaeology' (Fabi 327–28; Scacchi 308–10).

We have discussed elsewhere (Elia *Languages*) the proto-Afrofuturist features in *Kindred*. What is

interesting in this context is the way in which old
slavery can be experienced through a contemporary
perspective. Seeing old slavery through modern eyes,
perceiving it in the first person, yields an even stronger
impression of its meaninglessness. The main motif
that runs through the novel is indeed the dialogic
relationship between violence and slavery. For a
twentieth-century emancipated woman like Dana,
the whippings inflicted on her become even more
absurd. In an interview, Butler pointed out that Dana's
amputation of her left arm had been deliberately
devised: 'I couldn't let her come back whole and that,
I think, really symbolizes her not coming back whole.
Antebellum slavery didn't leave people quite whole'
(Kenan 498). The truthfulness of Dana's experience
derives from the fact that she suffers from a corporeal
trauma, not just a psychological one. A similar strategy
can be detected, for example, in some scenes of the
film *The Birth of a Nation* (2016), in which the master
smashes a slave's teeth just because he refuses to eat;
or the subsequent violent whipping of Nat Turner, the
preacher who led a liberation movement in 1831 to free
African Americans in Virginia, resulting in a violent
retaliation from whites; or, even more so, the lynching
of blacks that at that time was still common practice.

These are all examples of violence just for its own
sake, that kind of violence Fanon denounced in *The
Wretched of the Earth* (1961) as actually rebounding
on the oppressor, thus uncovering his brutality and
ethical backwardness. This is a crucial point, the

boomerang effect of violence on the oppressor. *Kindred* sets before our very modern eyes what Jean Paul Sartre, commenting on the French colonialism in Algeria in his 'Preface' to the English edition of *The Wretched of the Earth*, defined as the 'strip-tease of our humanism':

> the only violence is the settler's; but soon they will make it their own; that is to say, the same violence is thrown back upon us [...] Let us look at ourselves [...] we must face that unexpected revelation, the strip-tease of our humanism. There you can see it, quite naked, and it's not a pretty sight [...] an ideology of lies, a perfect justification for pillage; its honeyed words, its affectation of sensibility were only alibis for our aggressions (Sartre 15, 21).

WORKS CITED

Butler, Octavia E. *Kindred*.
The Women's Press Limited,
[1979] 1988.

Elia, Adriano. 'Formal
Experimentation and Time Travel
as a Reconceptualization Strategy
in Anthony Joseph's *The African
Origins of UFOs*'. *Iperstoria*, 10,
2017, pp. 139–45.

——. 'The Languages of
Afrofuturism'. *Lingue e Linguaggi*,
12, 2014, pp. 83–96.

——. 'W. E. B. Du Bois's Proto-
Afrofuturist Short Fiction: *The
Comet*'. *Il Tolomeo*, 18, 2016,
pp. 173–86.

Fabi, Giulia M. 'Postfazione'.
Octavia E. Butler, *Legami di sangue*,
Le Lettere, 2005, pp. 327–41.

Kenan, Randall. 'An Interview with
Octavia E. Butler', *Callaloo*, 14, 2,
1991, pp. 495–504.

Kracauer, Siegfried. *From Caligari
to Hitler: A Psychological History of
the German Film*. Princeton U. P.,
[1947] 1974.

Sankofa. Directed by Haile Gerima,
1993.

Sartre, Jean Paul. 'Preface'. Frantz
Fanon, *The Wretched of the Earth*.
Penguin, [1961] 2001, pp. 7–26.

Scacchi, Anna. 'Madri, figlie
e antenate nel racconto
contemporaneo della
schiavitù: *Kindred* di Octavia
Butler'. *Letteratura e conflitti
generazionali. Dall'antichità
classica a oggi*, ed. Davide Susanetti
and Nuala Distilo, Carocci, 2013,
pp. 308–22.

Snider, John C. 'Interview:
Octavia E. Butler'. *SciFiDimensions*,
19 June 2004.

Terry, Jennifer. 'The Fiction of
W. E. B. Du Bois'. *The Cambridge
Companion to W. E. B. Du Bois*,
ed. Shamoon Zamir, Cambridge
University Press, 2008, pp. 48–63.

The Birth of a Nation. Directed
by Nate Parker, Fox Searchlight
Pictures, 2016.

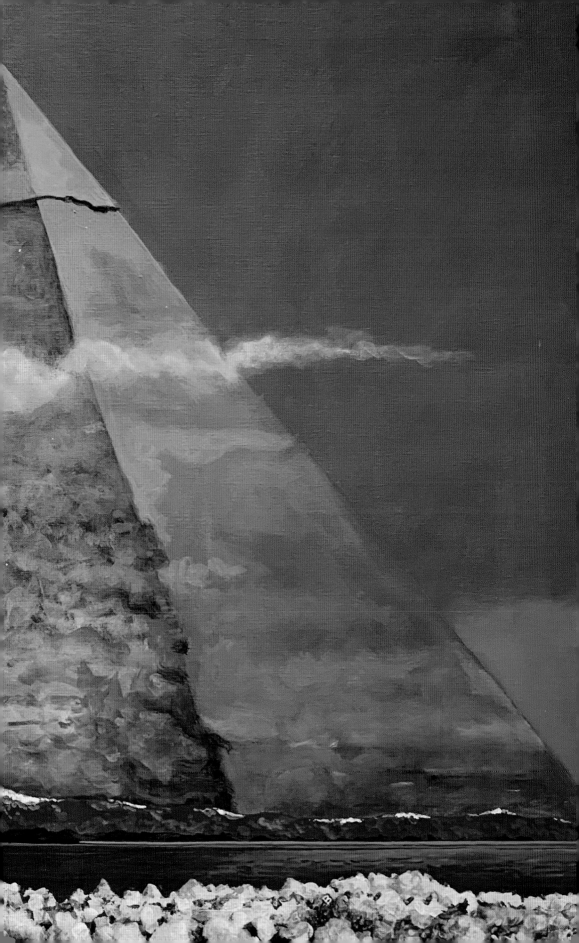

David Uzochukwu, *Shoulder*, 2019

INVOCATION: A SUMMONING OF SPIRITS

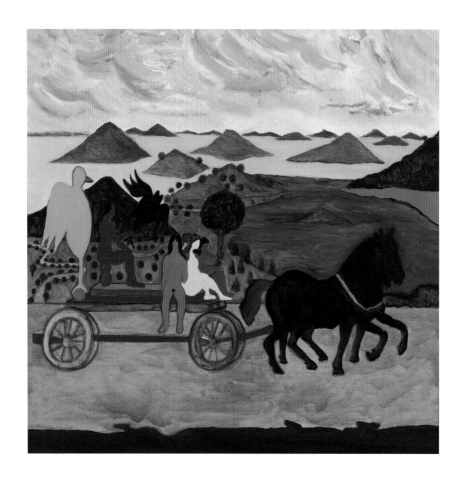

Bob Thompson, *An Allegory*, 1964

PART 1

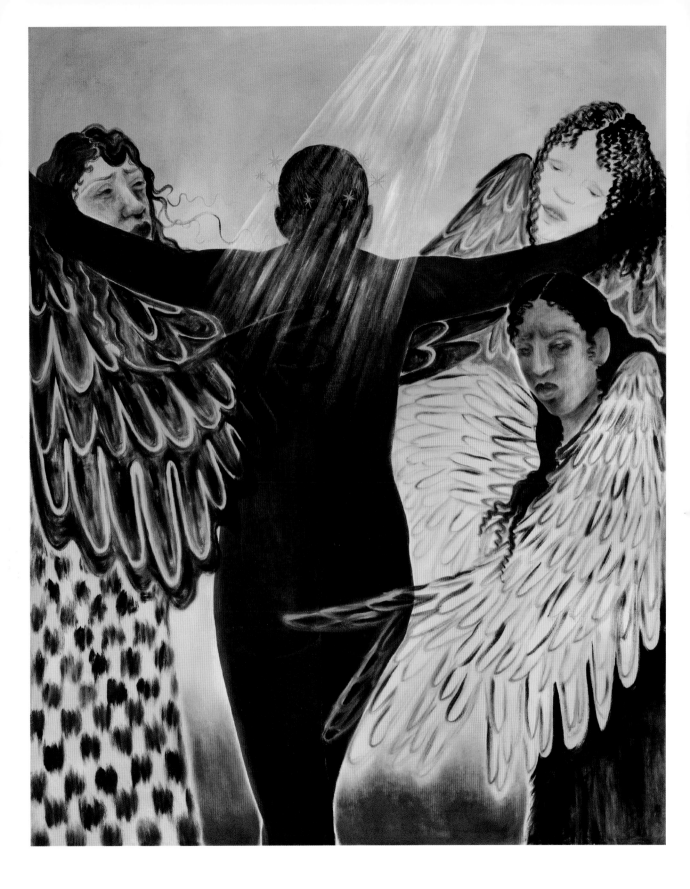

Naudline Pierre, *Take Great Care*, 2019

INVOCATION: A SUMMONING OF SPIRITS

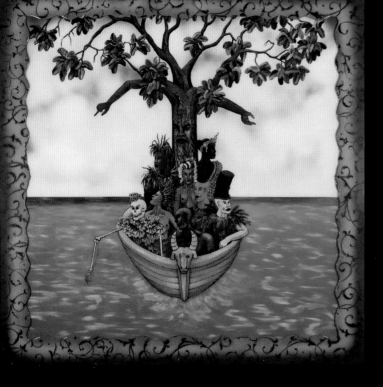

Edouard Duval-Carrié, *La Traversée*, 2016
Edouard Duval-Carrié, *Kongo Queen*, 2015

PART 1

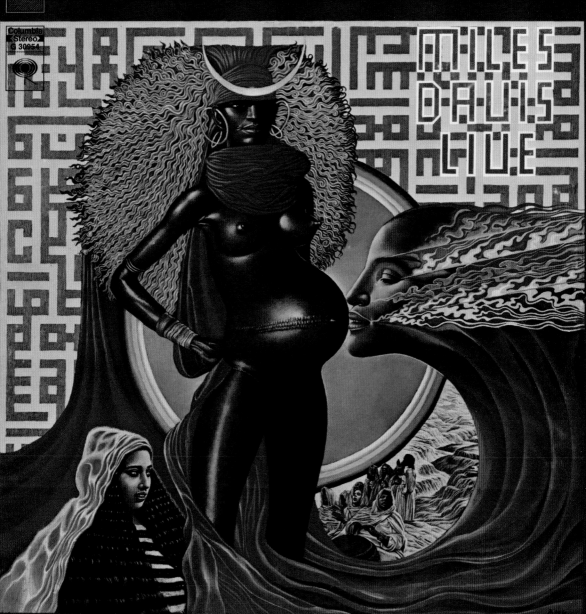

Hannsjörg Voth, *Stairway to Heaven*, Morocco, 1980–87

Rico Gatson, *Untitled (Universal Consciousness After Alice Coltrane)*, 2021

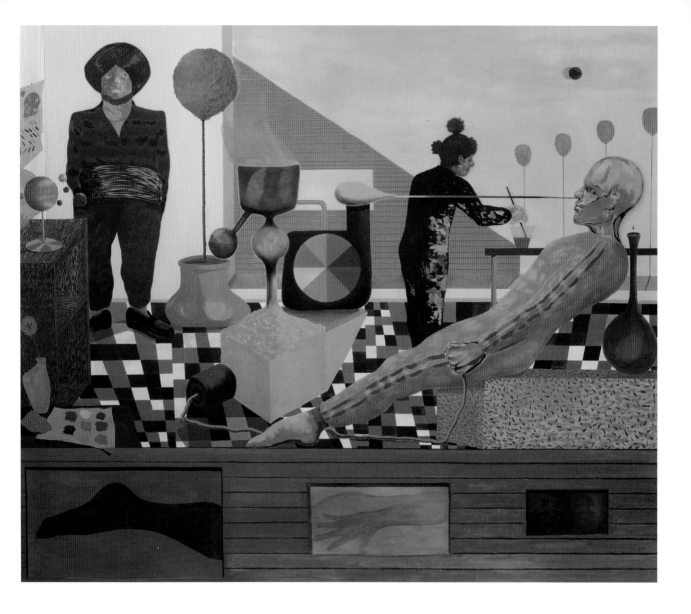

Alex Jackson, *Basic Tools for Transmutation*, 2018 PART 1

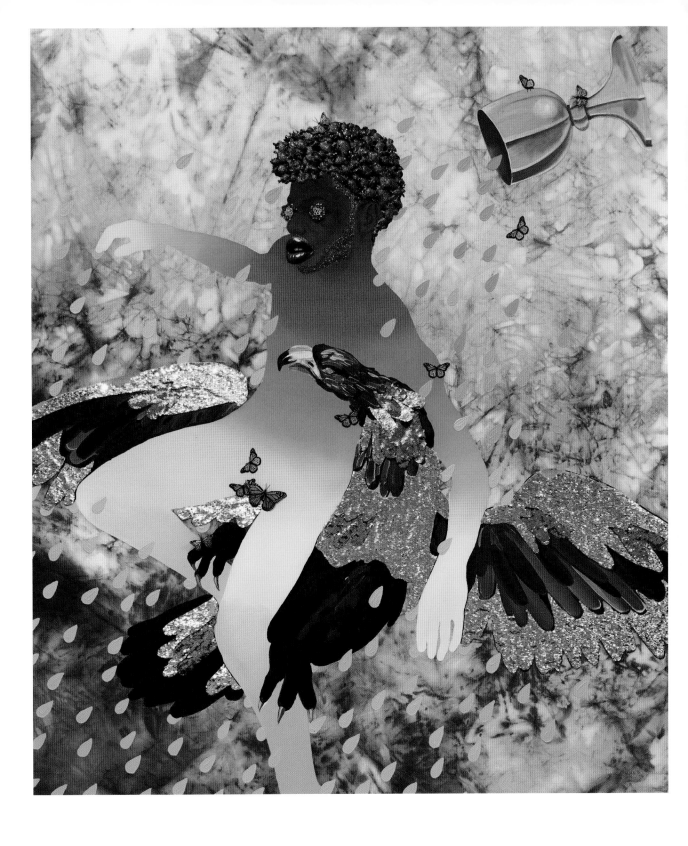

Devan Shimoyama, *The Abduction of Ganymede*, 2019

INVOCATION: A SUMMONING OF SPIRITS

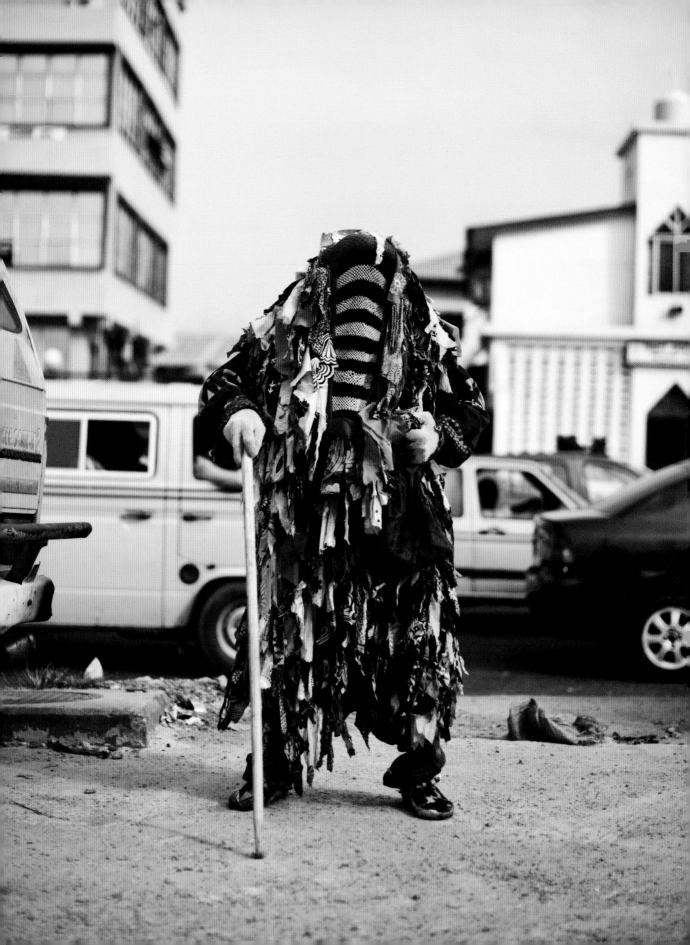

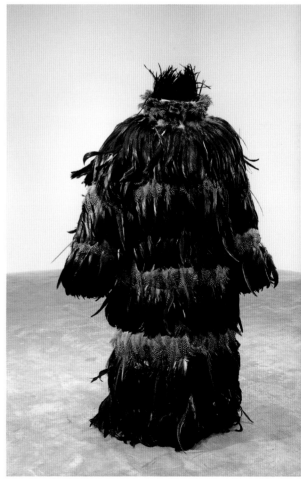

Cristina de Middel, *Okowako* (from *This is What Hatred Did* series), 2014

Cristina de Middel, *Arufin* (from *This is What Hatred Did* series), 2014

Sanford Biggers, *Ghettobird Tunic*, 2006

111 INVOCATION: A SUMMONING OF SPIRITS

Rotimi Fani-Kayode, *Nothing to lose XII*, 1989

Rotimi Fani-Kayode, *Adebiyi*, 1989

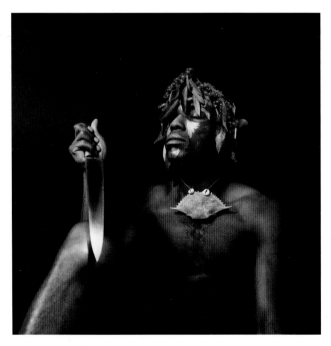

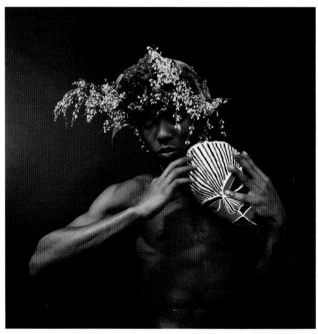

The British-based Nigerian photographer Rotimi Fani-Kayode frequently combined motifs of Yoruba culture and European iconography in his work. In *Adebiyi*, a subject holds a mask representing Eshu, the Yoruba trickster god. The picture gestures to Fani-Kayode's Nigerian heritage, but the presence of the mask also makes sardonic reference to the apparent 'discovery' of African art by European modernists in the 1900s. Where Picasso and his peers saw only the primitive in African art, Fani-Kayode suggests a lineage of sophistication and symbolism that stretches back from his work through previous generations of Nigerian cultural practice.

Rotimi Fani-Kayode, *Every Mother's Son/ Children of Suffering*, 1989

INVOCATION: A SUMMONING OF SPIRITS

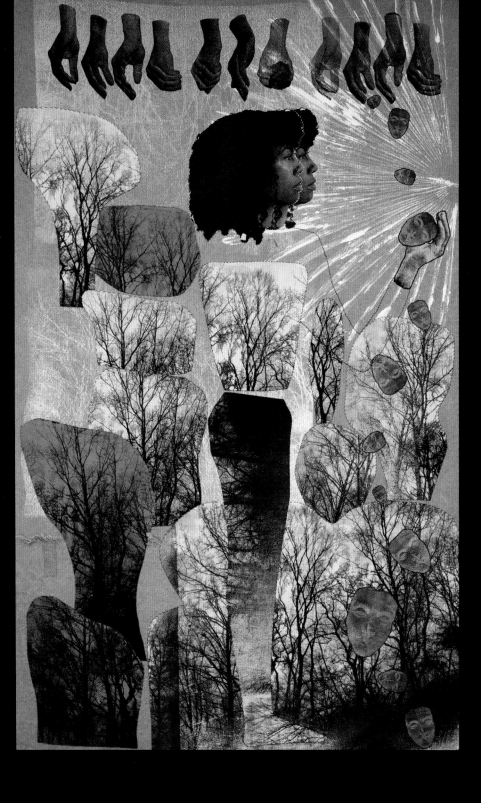

Zohra Opoku, *Re, cry out, let your heart be pleased by your
beautiful truth of this day. Enter from the under-sky, go forth
from the East, (you) whom the elders and the ancestors worship.
Make your paths pleasant for me, broaden your roads for me
(so that) I may cross the earth in the manner of (crossing) the
sky, your sunlight upon me*, 2020

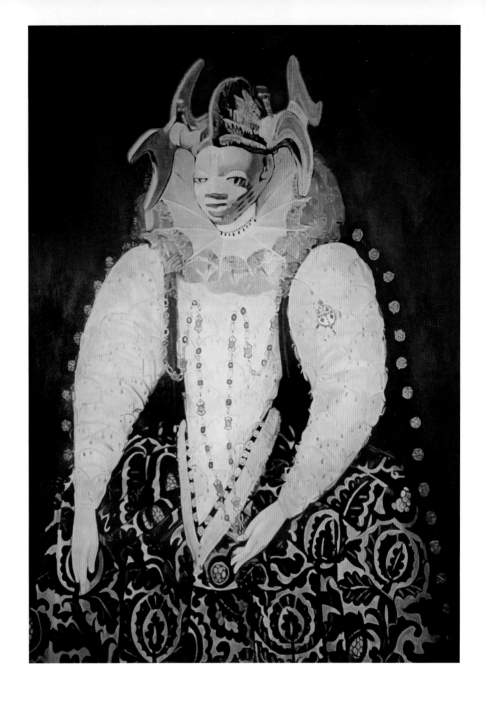

Wole Lagunju, *Belle of the Hearth*, 2014

INVOCATION: A SUMMONING OF SPIRITS

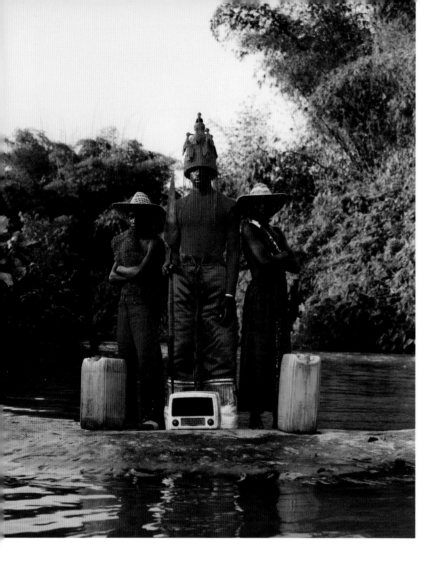

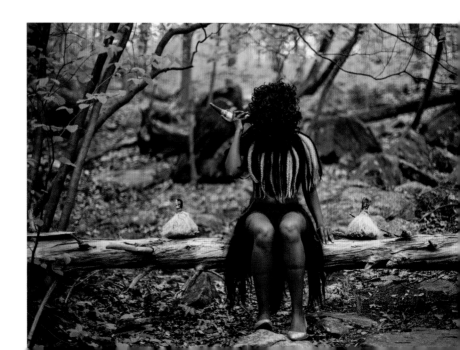

Petite Noir, *La Maison Noir / The Black House*
(album cover photograph by Kyle Weeks), 2018
Adama Delphine Fawundu, *Aligned with Sopdet,
Forest Upstate New York*, 2017

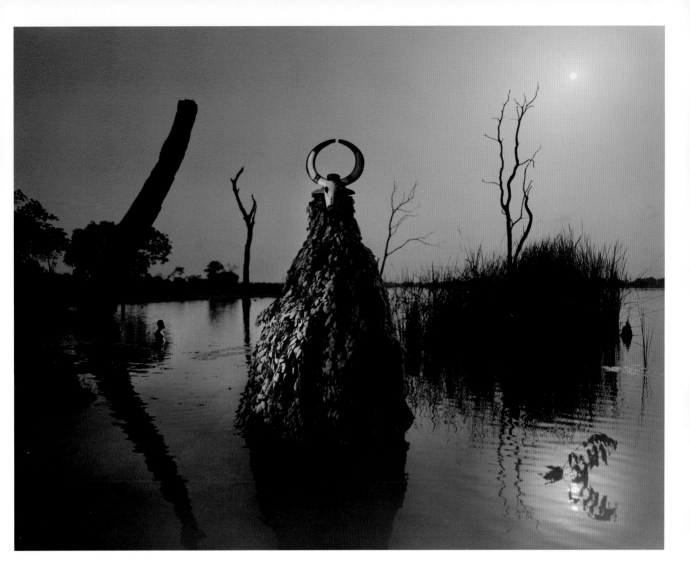

Hyenas, dir. Djibril Diop Mambéty (still), 1992
Touki Bouki, dir. Djibril Diop Mambéty (still), 1973

→ Neo-Sudanic architecture of BCEAO Tower (headquarters of the Central Bank of West African States), Bamako, Mali, designed by Raymond Thomas Farah, 1994

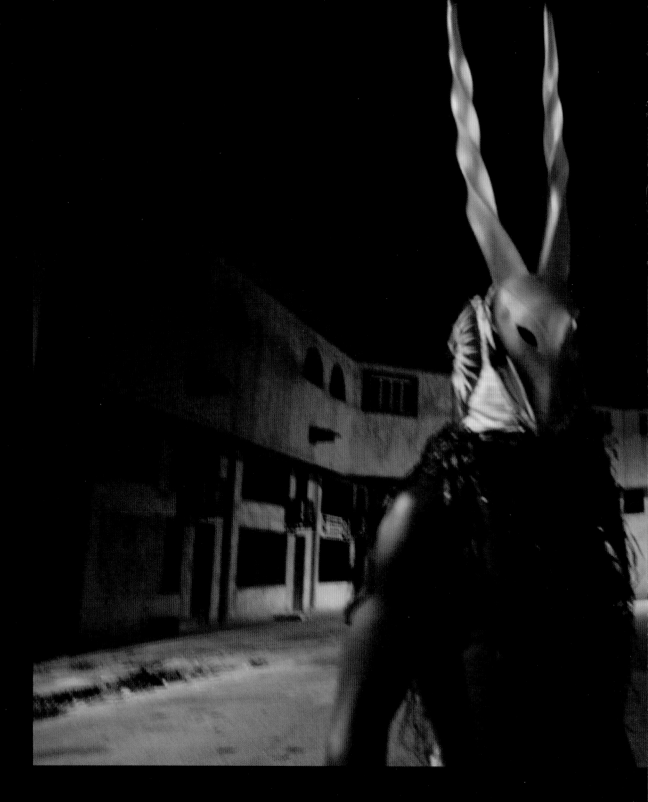

Zina Saro-Wiwa, *Holy Star Boyz: Night Watch Men*, 2018

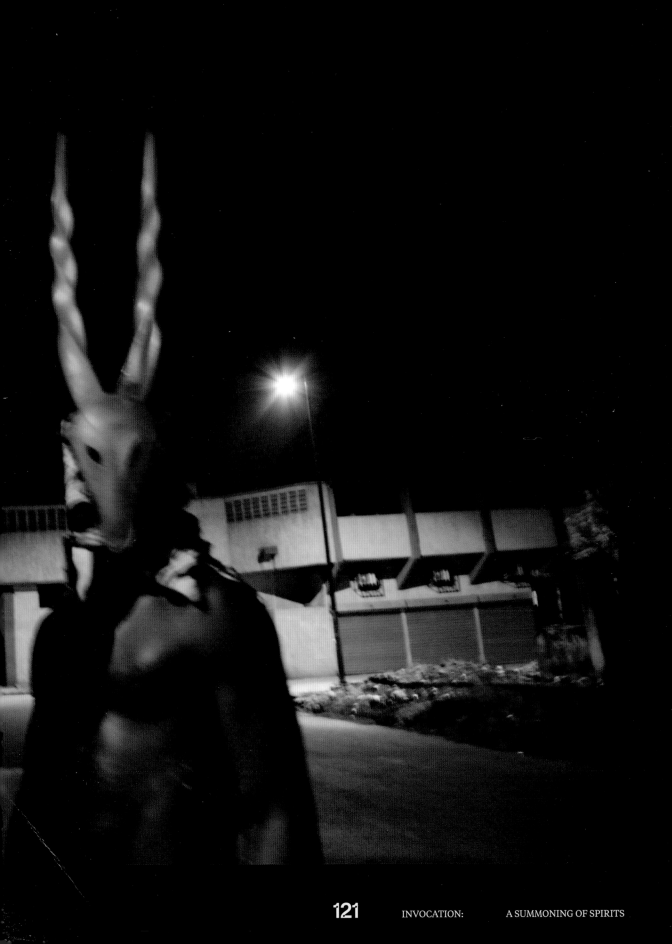

The TV drama series *Lovecraft Country* followed a young Black man, Atticus Freeman (Jonathan Majors), on a road trip across 1950s Jim Crow America in search of his missing father. Along the way, Freeman and his allies faced both the racist terrors of white America and a raft of monstrous creatures ripped from the fiction of horror writer H. P. Lovecraft. Created by Misha Green, and based on a novel of the same name by Matt Ruff, *Lovecraft Country* invited consideration of the nightmare realities of racialized America and also offered a reckoning with the legacy of Lovecraft, a hugely influential author who was also an avowed racist.

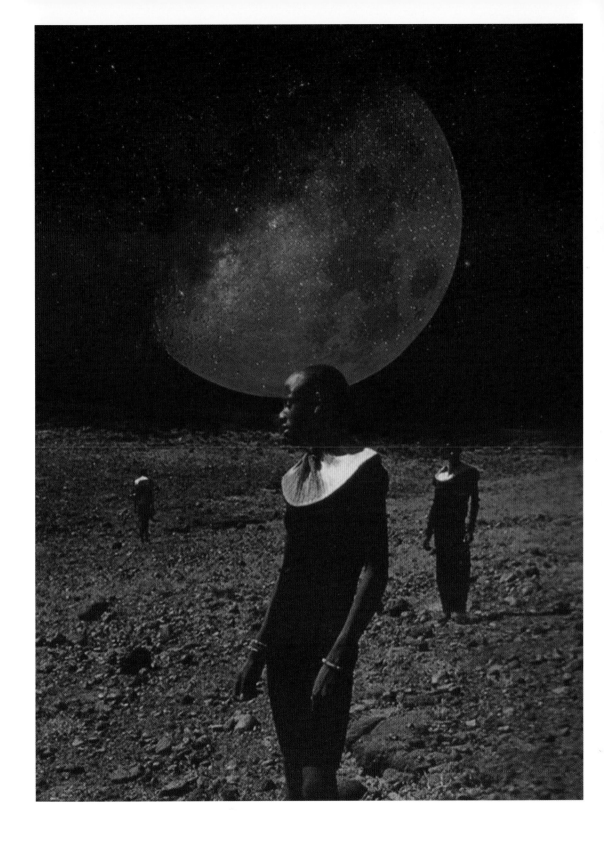

Damon Davis, *Brave New World*, 2015

INVOCATION: A SUMMONING OF SPIRITS

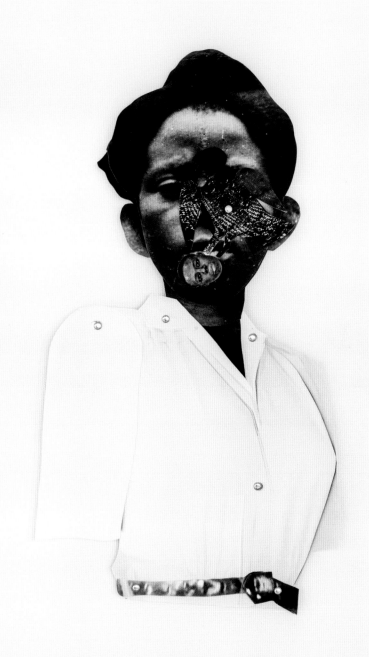

OutKast, *ATLiens* (album cover artwork by Frank Gomez,
art direction and creative concept by D. L. Warfield,
design by Nigel Sawyer and Vince Robinson), 1996

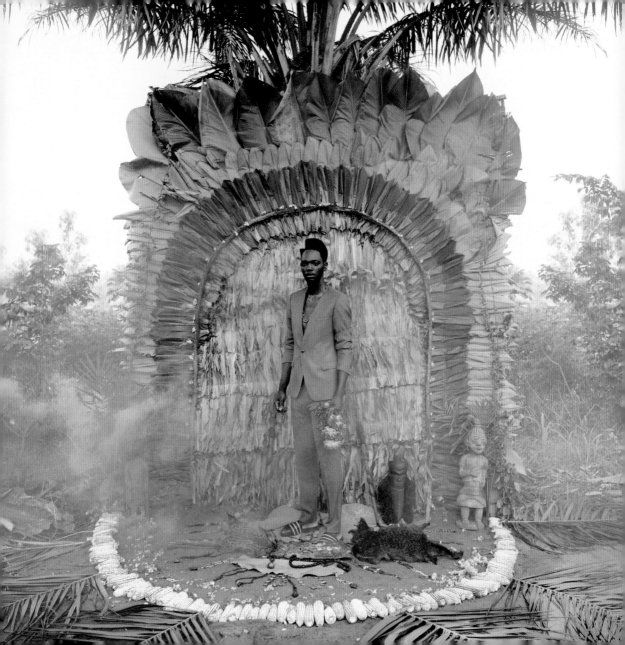

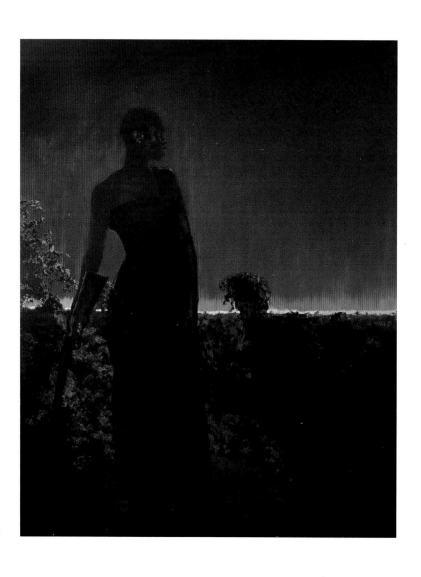

Kimathi Donkor, *Yaa Asantewaa Inspecting the Dispositions at Ejisu*, 2014

128

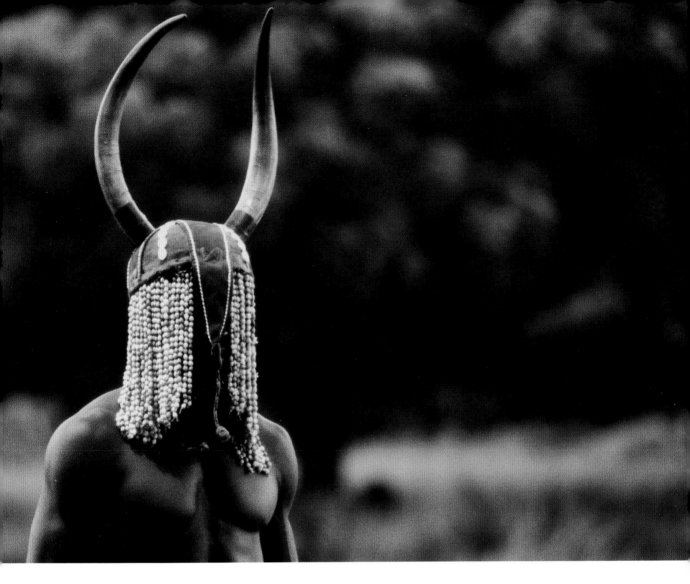

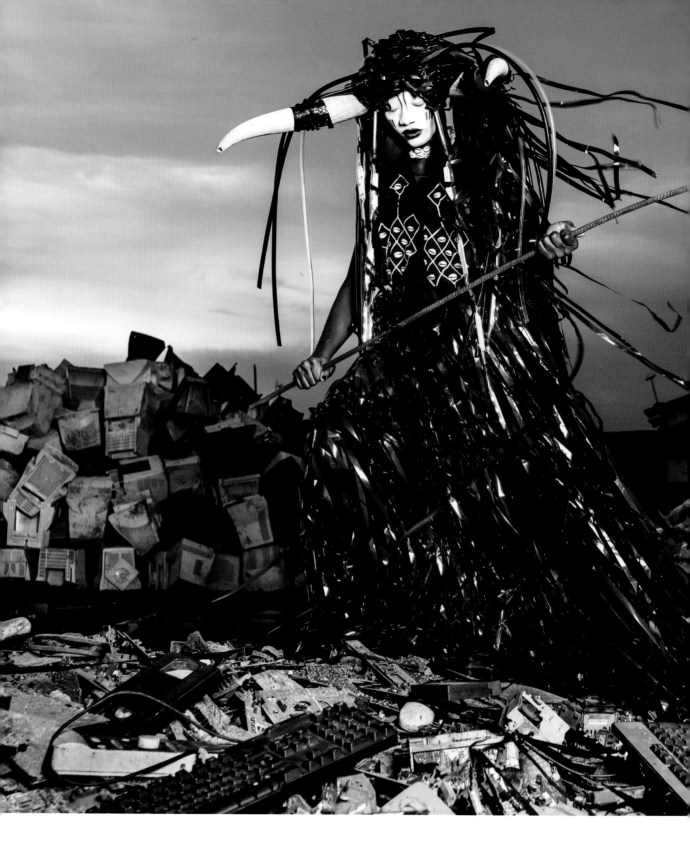

Fabrice Monteiro, *Untitled #11 / Ogun*
(from *The Prophecy* series), 2016

130

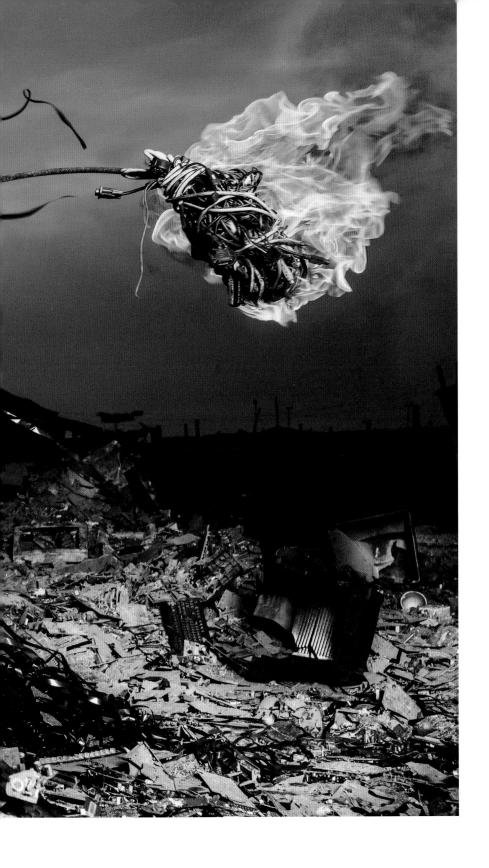

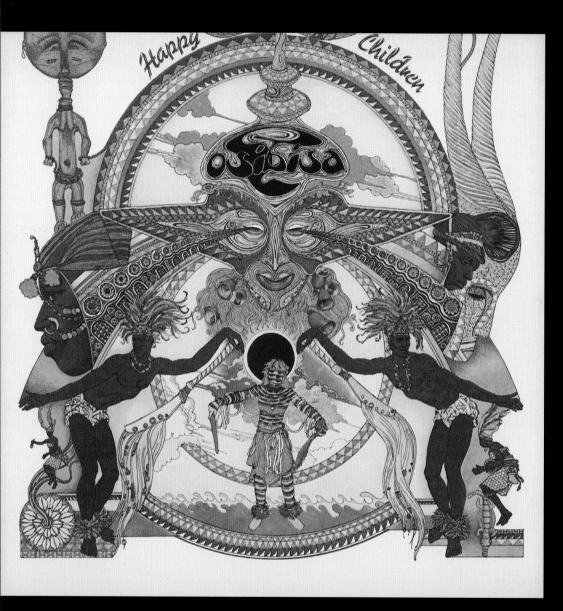

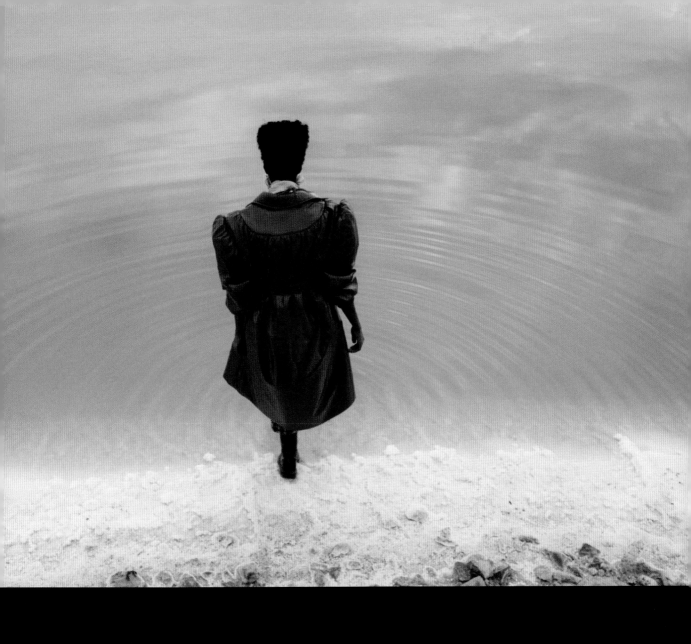

Markn, from 'From dawn to dusk' (stylist Louise Ford, model Bibi Abdulkadir), *Document Journal*, November 2018

INVOCATION: A SUMMONING OF SPIRITS

His House, dir. Remi Weekes (still), 2020

→
Ruby Okoro, *Untitled* (from *Days After Ascension* series), 2020

134

PART 1

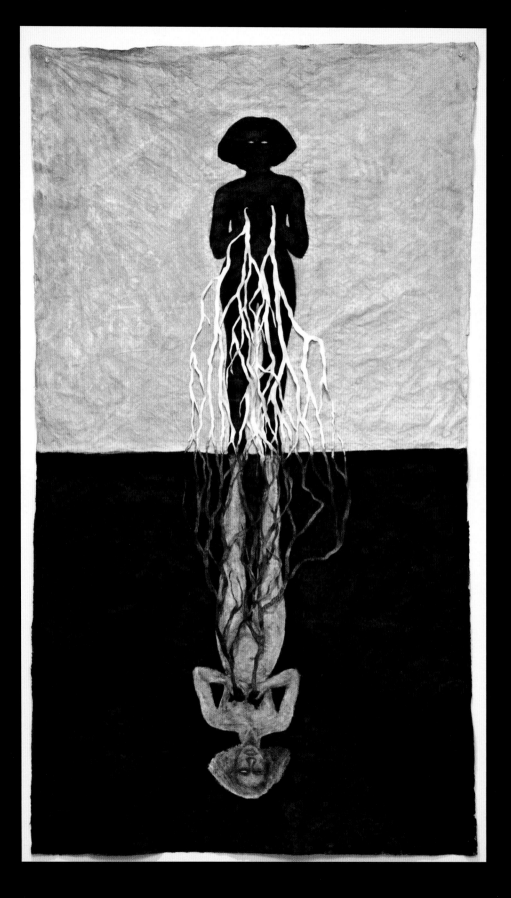

Alison Saar, *Equinox Study*, 2008

Black Feminist Voodoo Aesthetics, Conjure Feminism, and the Arts

Kameelah L. Martin

In our most ancient iterations, the African progenitors of the Black Atlantic communities existed in a world where the secular and spiritual intersect. Divinity and all the sacred magic within co-existed on a plane with the living, human world, the veil between the two being merely paper thin and quite accessible to those initiated into the upper echelons and crowned with spiritual knowledge. Other times, humanity is granted command over divine gifts by virtue of being made in the image of its Creator. This is readily evident in oral and folk traditions of West Africa. For the Asante kingdom of Ghana, their very founding is the result of the sacred and secular interacting. According to legend, the fetish priest known as Okomfo Anokye performed a divination ceremony to seek guidance on how to defeat the Denkyira people. The divination revealed that in order for the smaller Akan states to be successful against their common enemy, they would need to unite as one power. Okomfo Anokye gathered the paramount chiefs of these separate Akan states and commanded that a golden stool should fall from the heavens. Upon whomever among them the stool landed, that chief would be the divinely chosen leader.[1]

In present-day Mali, the Dogon proliferate a belief in the power of the spoken word to shift reality. That is, 'by human utterance or through the spoken Word, human beings can invoke a kind of spiritual power. But of course, the Word began with Amma or the Creator who created the world by uttering three successive words.'[2] Through the power of Nommo, or the spoken word, humanity is able to create and manifest life by similar means to Amma, the Dogon high god. The sacred and secular co-exist, and rely upon each other for the world to maintain itself: '"the Word," or the power of Nommo, does not rest solely with the Creator but also with human beings. It does not "stand above and beyond the early world"'; after all, notes writer Adisa A. Alkebulan, it is humans who have mastery over the Word.[3] Similarly, the Kongo concept of 'The Four Moments of the Sun' demonstrates the co-existence and necessity of the visible and invisible worlds to work in tandem.[4]

Among many African-descended populations and cultures, the tradition of the living, secular world bleeding into the sacred, supernatural one has always endured as part of a broader cultural epistemology. It should be of no surprise then that the idea of the Black fantastic is deeply embedded in the cultural beliefs and practices of Jamaica, Brazil, Haiti, New Orleans, Mexico, and elsewhere. The trauma of enslavement and the experience of the Middle Passage shifted the cosmologies of origin for Africans in bondage. Understanding and imagining the movement of earthly flesh across the *kalunga line*, or the liminal space of the *crossroads*, transitioned from a source of spiritual enlightenment and ontological awareness to a psycho-spiritual space of retreat.[5] Within such spaces, enslaved folk found the otherworldly space to breathe, to heal, to resist, to regenerate, to reincarnate, and to be empowered with the agency to commence spiritual battle with the trauma and violence of white supremacy.

The world bears witness to such adaptations in the Black cultural mythologies that evolved in the same spaces where Africans were held in bondage. The Myth of the Flying Africans which evolved from the mass suicide of enslaved Igbo on St Simon's Island, Georgia, is a prime example.[6] The belief in Ginen – the 'island under the sea' where the Haitian dead return after physical death – is another.[7] Narratives about the immortal exploits of Nana Yaa Asantewaa, Marie Laveau and Queen Nanny of the Windward Maroons offer more proof that other ways of knowing and speculative narration are at the core of Black Atlantic cultures.[8]

Arguably, there also exists a specific lineage of Black women's speculative interventions and knowledge that has evolved and continues to embed itself in their creative practices. Kinitra Brooks, LaKisha Simmons and I have come to refer to this ancient tradition of wisdom and spiritual praxis among

Africana women as *conjure feminism*.[9] It is an evolving theory of Black women's intellectual legacies of spirit work (divination, healing, dream interpretation, herbology) that informs their everyday existence – from childrearing, food ways and material culture to folklore, gardening and death practices.[10] Conjure feminism is a fluid concept, but at its source builds from specific African-derived tenets:

1. There are consequences for your actions, especially those meant to do harm.

2. Death is not an ending but a transition.

3. One is beholden to the Ancestors *and* the Unborn.

4. Spirit work is necessary for our physical, emotional and psychological health.

Conjure feminism is an epistemological framework for understanding Black women's work and experiences. It privileges women's sacred knowledge and folkloric practices of spirit work. It provides Black folk with the cultural fluidity necessary for survival in a world where race is a socially constructed fiction with real world consequences. The Divine Feminine is its source of knowledge, and conjure feminism is a type of activism. Spiritual systems such as rootwork, obeah, conjure, Vodou, Candomblé, Palo Mayombe and others are understood as freedom practices. Conjure feminism, above all else, ensures the survival of Black lives – gender notwithstanding. It is deeply *womanist* in this regard.[11] Most importantly, it is ancestral work that creates genealogies of knowledge and other ways of knowing that are inherited, transmitted and bequeathed orally among women of African descent. Conjure feminist foremothers include Tituba of the Salem Witch Trials, Queen Nanny, Marie Laveau, but also the madrinas, mambos, hoodoo ladies, obeah women, aunties, mamas, nannies and grannies who never appear in Western historical records.

Conjure and spirit traditions of the African diaspora are not solely the jurisdiction of Black women, to be sure. The theory that I push forward, however, does privilege Black women unabashedly. Valerie Lee outlines the specific ways Black women have functioned as 'culture bearers' in post-Middle Passage experiences – taking on the role of griot and djeli, bearing witness and imparting cultural memory to the next generations.[12] She argues that 'rather than the negative associations of witchcraft, conjuring has been an empowering concept for many black women. Conjuring pays homage to an African past, while providing a present-day idiom for magic, power, and ancient wisdom within a pan-African cultural context.'[13] Conjure feminism does absolutely and unapologetically privilege Black women as the source and site of this body of knowledge, but does not exclude other members of the community; Black men also have their own wisdom and mythic practices they inherit. Black women 'enlarge our conventional assumptions about the nature and function of their [ancient] tradition. Focusing on connection rather than separation, transforming silence into speech, and giving back power to the culturally disenfranchised, black women … affirm the wholeness and endurance of a vision, that, once articulated, can be shared – though its heritage, roots, survival and intimate possession *belong to black women alone*' (emphasis added).[14] But Black women ain't new to this. Even within the African-derived epistemologies from which conjure feminism is informed, being Black and female is a divine point of privilege. Zora Neale Hurston illustrates this point in *Tell My Horse* (1938):

'What is the truth?' Dr. Holly asked me, and knowing that I could not answer him he answered himself through a Voodoo ceremony in which the Mambo, that is the priestess, richly dressed is asked this question ritualistically. She replies by throwing back her veil and revealing her sex organs. The ceremony means that this is the infinite, the ultimate truth. There is no mystery beyond the mysterious source of life.[15]

What Hurston signifies here is that because of their physical ability to pass life (force) through the birth canal – a liminal space – women embody a spiritual portal through which Spirit can move between the invisible and visible worlds. Riva Nyri Précil adds that women are the literal *poto mitan*, or central pole within the peristyle (Vodou temple), through which the *lwa* (Vodou deities) descend during ritual. Women are much revered because of this in Haitian Vodou.[16] Black women are central to conjure feminism because they literally have Spirit on the main line, if you will.

CONJURE FEMINISM IN CREATIVE PRACTICE

Whether embedded in the oral tradition of 'telling lies' or in the cinematography of a television series like *Queen Sugar*, Hortense Spillers and Marjorie Pryse argue 'that however fleetingly history recorded their lives, there [exists] a women's tradition, handed down along female lines'.[17] I only dare to offer a name for it and advance the intellectual and *intertextual* discourse around it. There is little question about whether conjure feminism has infiltrated and informed Black women's creative endeavours. Allow me to explicate exactly how and where it is manifesting in contemporary art. Everything Black women create, from quilting, beading and body adornment to hair braiding, dance, song, narrative and visual art, bears evidence of conjure feminism. If conjure feminism is the philosophy through which to name Black women's ancient intellectual traditions, then *conjuring moments* and *black feminist voodoo aesthetics* are the creative application of such. A conjuring moment is an 'identifiable point in the text where conjuring or African-derived ceremonial practices occur and advance the narrative action'.[18] Black feminist voodoo aesthetics is a term I coined to convey what I see occurring in Black women's artistic production. I define it as 'the inscription of African ritual cosmologies on the black female body [which] become manifest in the performance of ceremony,

the inclusion of sacred objects or accoutrements on the body, the use of the body as a vessel for Spirit' and a variety of other expressions of Africanized religious and spiritual belief.[19]

Black women's literature is ripe with passages and characterizations of conjure feminist women and the spirit work used to help them self-actualize. Literary projects such as Pauline Hopkins's *Of One Blood* (1902–3), Toni Cade Bambara's *The Salt Eaters* (1980) and Toni Morrison's *Beloved* (1987) 'make it possible for their readers ... to recognize their common literary ancestors (gardeners, quilt makers, grandmothers, rootworkers) and to name each other as a community of [conjure feminist] inheritors'.[20] Black women writers cogently pull from the stories and memories of their ancestors, their experiences, their inherited wisdom – what Audre Lorde calls *biomythography* – to tell truer tales.[21] Characters such as Michelle Cliff's Mad Hannah and Mama Alli, Nalo Hopkinson's Mer, or, more recently, Tomi Adeyemi's Zélie and Mama Agba, Afia Atakora's May Belle and Rue, and other divine conjuring women are reflections of the cultural communities from which the authors spring.[22] Lee reminds us that '[t]he stories the historical [healers and midwives] recount and the stories the fictional narratives reconstruct create a larger meta-narrative wherein the oral histories of the [healers and midwives] read as cultural fictions, and the writers' fiction read as cultural performances'.[23] These characters evolve from cultural memory into cultural heroes through the use of conjuring moments and black feminist voodoo aesthetics. They use conjure to manipulate *asé* (life-force), to heal the souls of Black folk, and to time-travel and shape-shift – all to ensure the survival of Black people real and imagined. Ntozake Shange employs a conjuring moment in her description of Blue Sunday, whose body and spirit survive violent rape through escaping into the Black fantastic:

When he penetrated her, she turned into a crocodile. As a crocodile, *Blue Sunday* was benign. Her only struggle was to remain unconquered. Master Fitzhugh was left with one leg, but otherwise

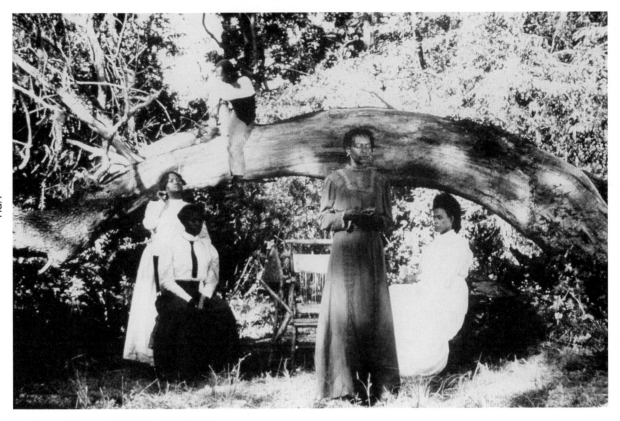

FIG. 1

Daughters of the Dust, dir. Julie Dash (still), 1991

quite himself. The Fitzhughs no longer cultivated indigo as a cash crop. *Blue Sunday* was never seen again by any white person, but women of color in labor called on her and heard her songs when they risked mothering free children.[24]

Literature of the African diaspora, especially that written by women, is ripe with such speculative and Afrofuturist stories of black magic women using the natural world and their innate divinity to advance liberation. This conjure feminist lore cycle has found its way into other forms of artistic expression as well. Katherine Dunham's performance and choreographic legacy is deeply based in Afro-Caribbean ritual movement and gendered folk dance.[25] Kara Walker's *Night Conjure* (2001) and *Keys to the Coop* (1997) signify on Black women's spiritual agency under the duress of slavery.[26] The lyrics and accompanying music video for 'Nan Dòmi' by Riva Nyri Précil is another example of black feminist voodoo aesthetics at

work; in fact, the songstress's body is literally inscribed with a tattoo of the sacred *vévé* of lwa Erzulie.[27] The impact and transfer of conjure feminism from the oral tradition to visual art is a natural progression for creative Black women. The output may be different, but the material culture is still produced by the community of inheritors. Julie Dash's iconic film, *Daughters of the Dust* (1991; fig. 1), is significant in this regard. The film takes a deep, conscious dive into visualizing Black women's folk and spiritual practices of the Gullah Geechee culture with the care and reverence it deserves.[28]

Dash's film creates for us a prototype for envisioning what culturally sensitive black feminist voodoo aesthetics can look like. Dash imposes the indigo-stained hands of the Black women elders on screen; the women wear ritual white as they gather. She normalizes spirit possession among the young women who dance and play on the beach, disassociating from the sensationalized foaming mouths

and epileptic seizures of white supremacist Hollywood depictions of black spirit work. Nana Peazant's 'Root Revival of Love', the bottle tree in the front yard, and the glass of water under Eula's bed meant to call her mother's spirit to her are all powerful visualizations of African spiritual philosophies that are practised by the Black women in the film.[29] The spiritual summons of the Unborn Child, a young girl, is the conjuring moment that advances the plot of Dash's filmic narrative. A summons initiated by Nana Peazant, the Black woman elder of the film. Food as ancestral memory is another relevant black feminist voodoo aesthetic in the film and an important conjure feminist practice. Jessica Harris and Psyche Williams-Forson have written about the cultural connections between West African and Black Atlantic cuisines; I expand this to include connection to the spiritual realm.[30] Conjure feminism places deep emphasis on how ancestral knowledge (how to prepare, on which occasion, and who gets served),

as well as the asé of the cook, becomes embedded in African-improvised dishes.

Kasi Lemmons's *Eve's Bayou* (1997; fig. 2) is another film written and directed by a Black woman wherein a multi-generation family engages in their inherited gift of divination, second-sight and healing work. Lemmons's depiction of Diahann Carroll as the voodooist Elzora challenges long-standing stereotypes of Black women and incorporates the face-painting traditions of the Yoruba.[31] She also fills the *mise-en-scène* with altars and Catholic iconography employed in Haitian Vodou and Louisiana Voodoo, respectively. Lemmons's depiction of the conjuring women in the film, inclusive of eleven-year-old Eve (played by Jurnee Smollett), is thoughtfully crafted and inspired by her familial history, as is Julie Dash's. The narrative action is moved forward by prophetic dreams, spiritual curses, and rituals that both heal and harm. The film leans heavily on the speculative practices of

FIG. 2

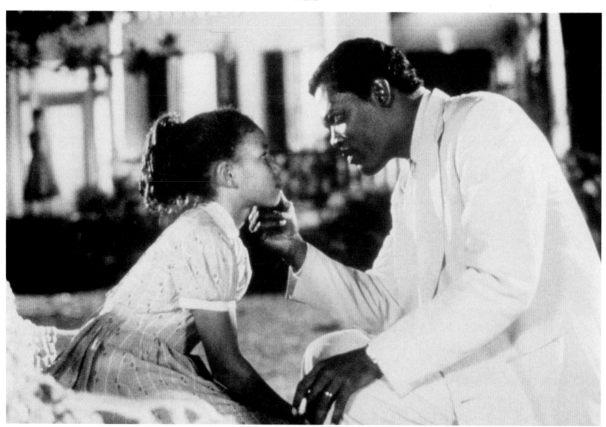

Eve's Bayou, dir. Kasi Lemmons (still), 1997

spirit work, leaving the audience to decide if Voodoo is, in fact, at the heart of the story.

Dash and Lemmons have set the bar for other Black women to experiment with envisioning Black women and spirit work in visual media. Beyoncé Knowles Carter more recently entered the arena of black feminist voodoo aesthetics with her visual albums, *Lemonade* (2016) and *Black Is King* (2020; fig. 3). Beyoncé's global popularity and reputation as a deeply involved, visionary entertainer made it possible for her to engage in this particular style of Black woman-centric narrative without apology. *Lemonade* pays homage to both Dash and Lemmons by reprising the images of Black women sitting in tree branches, dressed in vintage white attire, with the southern gothic landscape of the Louisiana bayou as the backdrop. She intentionally invokes Dash and Lemmons's visuals and the narrative forms that have become synonymous with Black women; she signals to her audience that she, too, is among the community of conjure feminist inheritors. *Lemonade*'s narrative arch moves from trauma to healing, relying heavily on an Africanist spiritual epistemology along the journey.[32] Water is an ever-present symbol used to signify on the various roads, or manifestations of the Orishas Oshún, who represents fresh water, and Yemanya, who is embodied by the river and/ or the ocean depending on which location of origin one investigates.[33] The film conveys the inestimable reverence and presence of the *egun*, or Ancestors; photographs of Beyoncé's literal ancestors fill the frame. They do so symbolically as well through the landscape and culture of Louisiana – the origin of the singer's maternal lineage.[34] The narrative woven in the film reminds Black women specifically that when in crisis they can go to the water, go home to their (mother's) people (living and dead), and go to heal among other women who believe in and practise African traditional religions. This is the essence of conjure feminism, and *Lemonade* is, in fact, where the seed of the idea emerged.[35] The film links the previous generation of black feminist voodoo aesthetics in films by and about Black women to the next.

A VISUAL NATION LANGUAGE

Why does it matter that we define and name the narrative and artistic style employed by Africana women artists? For one, the use of black feminist voodoo aesthetics and conjuring moments demonstrates engagement with and an activation of Ancestral memory. It, like passing along lineages in the poetic performance of the griot, ensures that Black women's knowledge and ancient wisdom continues to be disseminated and affirmed in the contemporary moment. This wisdom evolves and changes with migration, modernization and adaptation, for sure, but it also marks the user. The artist, novelist, filmmaker, horticulturalist, midwife and caretaker makes herself known as an inheritor among the beloved Black woman community by signalling conjure feminism artistically, giving those within no cause to inquire, as the old folks say, 'Who yo' people?' The use of African spiritual iconography and symbolism in creative and visual art advances Black women's representation in visual media, a Herculean task. It rejects Western cultural supremacy and privileges African-centred cosmologies in which dichotomies of good/evil, male/female, sacred/secular are not mutually exclusive, but rather two sides of one coin. Particularly for Black women, the use of conjure feminism as a theory of survival amplifies Black women's folk practices and other ways of knowing as valid, valuable and venerable. As the folk expression taunts, 'what is understood doesn't have to be explained'; the usage of a conjure feminist ethos and black feminist voodoo aesthetic in Black women's visual artistry expands the indecipherable 'double-speak' or signifyin' for which Black diaspora folk have become renowned.[36] Voodoo aesthetics are akin to a visual Nation Language, to use Edward Kamau Brathwaite's terminology.[37] He explains that, 'Nation Language is the language which is influenced very strongly by the African model, the African aspect of our New World/Caribbean heritage. English it may be in terms of some of its lexical features. But in its contours, its rhythm and timbre, its sound explosions, it is

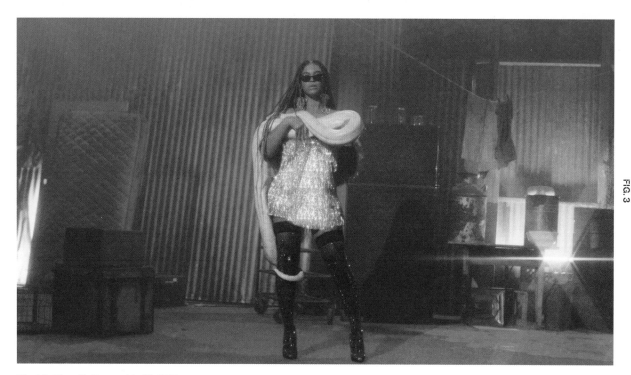

Black Is King, dir. Beyoncé (still), 2020

FIG. 3

not English … to a greater or lesser degree.'[38] Through visual signs such as indigo-stained hands, a yellow dress and deluge of water, a 'haint blue' being, Yoruba *ori* body paint, and raffia-covered Egungun masquerades, Black women artists named here are speaking across, through, and under the radar of Western, patriarchal, Christian and colonized understandings of the world. Black women, specifically, carried on about *Lemonade*'s subtexts for months after its premiere because Beyoncé was communicating directly to them in words, symbols, experiences, and knowing that was only accessible to them.[39] *Black Is King* is similarly unknowable to those who lack fluency in African philosophies of spirituality and religion. Less has been published on it, I suspect, because typical viewers lack the range of the conjure feminist/voodoo/African aesthetics with which Beyoncé speaks. This exemplifies my point about black feminist voodoo aesthetics functioning as a visual Nation Language. Conjure feminism derives from Black women's intellectual traditions that evolved from oral transmission. Brathwaite contends that this is where Nation Language finds its true meaning among the in-group: 'The oral tradition …

demands not only the griot but the audience to complete the community: the noise and sounds that the maker makes are responded to by the audience and are returned to him. Hence we have the creation of a continuum where meaning truly resides.'[40] The visualization of conjure feminism enacts a symbolic call and response of meaning between the artist and the fluent audience. It is transmitted in the common language of colour, lighting, symbols and other cinematic technique (English), but the space where meaning truly resides is the experiential knowledge and spiritual practices of Black women (anything but English). How fluent are you?

Migration

2

Journeys Across Sea & Space

In October 1964, at the height of the space race between the USA and the USSR, a grade-school science teacher in Zambia announced his own mission to the moon. 'Some people think I'm crazy,' admitted Edward Mukuka Nkoloso, founder of the self-styled National Academy of Science, Space Research and Philosophy. 'But I'll be laughing the day I plant Zambia's flag on the moon.'[1] The success of the project would prove the potential of a country that had recently won independence from colonial rule, said Nkoloso. 'Zambians are inferior to no men in science technology. My space plan will surely be carried out.'[2]

Nevertheless the teacher's plans were rudimentary. His rocket was to be made from copper and aluminium. At a training camp outside Lusaka, young would-be crew members were squeezed into oil drums and sent rolling down a steep hill to simulate weightlessness. 'I also make them swing from the end of a long rope,' volunteered Nkoloso. 'When they reach the highest point, I cut the rope. This produces the feeling of freefall.'[3] Funding was also a problem. A request for seven million pounds from UNESCO remained unanswered. Yet the mission was a vital one, insisted the teacher. It would prove that Africa, too, could claim a place in the stars. Space could not be the preserve of white nations alone. 'Our posterity, the Black scientists, will continue to explore the celestial infinity until we control the whole of outer space.'[4]

Perhaps unsurprisingly, the Zambia space mission never got off the ground. Government indifference, lack of international finance and the waning enthusiasm of Nkoloso's own cadets led the project to falter and eventually die. But in recent years, his quixotic vision of African space flight has found new life through the work of a number of artists and filmmakers.

Photographer Cristina de Middel's *The Afronauts* (2011) re-enacts the project in a series of images that have the hallucinatory quality of a waking dream. And Nuotama Bodomo's short film *Afronauts* (2014) imagines

Nkoloso's mission as reality. On the same night as the Apollo 11 moon launch in 1969, 'a group of exiles in the Zambian desert are rushing to launch their rocket first'.[5]

Independently of the Zambia story, the space-suit-clad African astronaut also features in imagery by contemporary artists from across the Black diaspora, including South Africa's Gerald Machona, Angola's Kiluanji Kia Henda, and Britain's John Akomfrah, Yinka Shonibare and Larry Achiampong.

The cosmic traveller has been a familiar element of the Black speculative imaginary since Sun Ra and George Clinton in the 1960s and 1970s. In the writing of Afrofuturist theorists such as Kodwo Eshun, Black space travel is a metaphor by which to revisit the 'founding trauma' of the Middle Passage, the forced migration of Africans across the Atlantic during the slave trade.[6] Ra's biographical narrative of being transported to Saturn as a child functions as a 'hyperbolic trope to explore the historical terms, the everyday implications of forcibly imposed dislocation'.[7]

If we dwell for a while further in the Middle Passage, we also see that the roots of fabulist Black travel narratives can be found in the lived experiences of Africans from the era of slavery itself. Consider, for example, the life of the writer and abolitionist Olaudah Equiano. Seized by slave traders as an eleven-year-old in Benin and taken to the Caribbean, Equiano managed to buy his freedom from bondage in his twenties, and became a prominent abolitionist in Britain. His memoir, *The Interesting Narrative of the Life of Olaudah Equiano, or Gustavus Vassa, the African* (1789), is a richly textured account of the horrors of slavery. But Equiano's life as a man of liberty is also notable. After his manumission he travelled to London. Being of a 'roving disposition' he found it hard to settle. For much of his subsequent life he was on the move. He was a crew-hand on voyages to Turkey, southern Europe and the West Indies. He played a role in the ill-fated British

recolonization effort to Sierra Leone. During a fraught British navy mission to pioneer a north-east passage to India, he even became the first Black person to journey to the Arctic. And all this while grappling with the constant bigotry and threats of violence he faced as an African in the West. With its connotations of autonomy and leisure, the designation of 'the traveller' is an awkward term to describe even free Black people at the height of slavery.

But Equiano's continued efforts to remain in motion across oceans and continents suggest him as a prototypical Black diasporic figure. A man, that is, whose personal history is shaped 'by the movements of black people – not only as commodities but engaged in various struggles towards emancipation, autonomy, and citizenship'.[8] And one who finds in an act of artistic expression, like penning an autobiography, 'the means towards both individual self-fashioning and communal liberation'.[9]

The kind of purposive self-fashioning that Equiano was engaged in throughout his life as a seafarer, an activist and a writer provides a signal example of how a Black person might journey through a world that treats them as alien and Other. For example, the Bahamian contemporary artist Tavares Strachan has developed an artistic practice based on feats of remarkable physical endurance. He has carried out four separate Arctic expeditions, becoming the first Bahamian to visit the North Pole, and trained as a cosmonaut at a Russian space centre in Moscow. Strachan's sculptures, installations and photographic collages can be read as 'allegories that tell of cultural displacement, human aspiration, and mortal limitation'.[10] But the driving force for his journeys is also personal. Growing up in Nassau, on a small island in the Atlantic, the artist became acutely aware of how patterns of travel and forced migration imposed during the slave trade had shaped his life and the fortunes of the Bahamas. As he told an interviewer, his projects are spurred by the desire to 'understand myself, my environment, my community and also the

future'. The answer to alienation lies in adopting the role of the traveller on his own terms. 'The only way to survive is to embrace exploration, right? To embrace being a foreigner.'[11]

Larry Achiampong's multidisciplinary *Relic Traveller* (2017–ongoing) offers similar reflection. The project imagines a future in which the global West is in perilous decline and the African Union has ascended into prosperity and harmony, taking responsibility for shaping the future of the planet. A series of films tracks the 'Relic Travellers' programme, an AU initiative that sends Afronauts to

FIG. 1

Larry Achiampong, *Pan African Flag for the Relic Travellers' Alliance*, 2017

explore territories outside Africa and retrieve data left by societies that were historically oppressed by systems such as colonization and globalization. A series of flags celebrates the programme. The fifty-four stars of their design represent Africa's fifty-four countries. A backdrop of yellow gold signifies a new age of prosperity for the continent. Achiampong has configured the symbolic elements of one flag, *Pan African Flag for the Relic Travellers' Alliance* (2017; fig. 1), into a form 'suggestive of a human figure in flight – a futuristic icon moving towards unity and equilibrium'.[12] Here, symbolically, a future in which African people lead the way to the stars, finds vivid realization.

Africa Pavilion, designed by Jacek Chyrosz and
Stanisław Rymaszewski, International Trade
Fair Centre, Accra, Ghana (chief architect Victor
Adegbite), 1962–67 (photograph by Alexia Webster)

→ THEESatisfaction, *EarthEE* (album cover artwork
by Rajni Perera and Dusty Summers), 2015

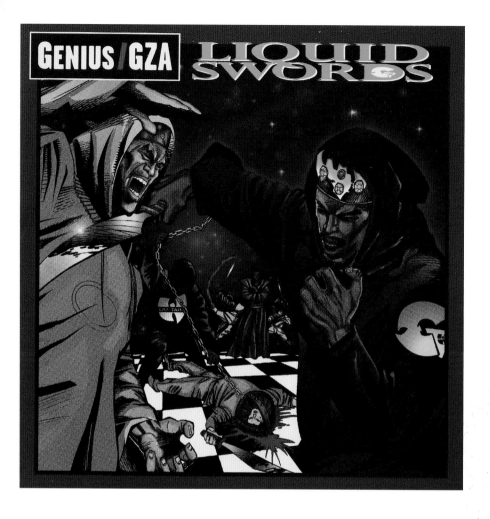

The cover of GZA's *Liquid Swords* depicts two groups of warriors doing battle on a life-sized chessboard. The setting is interstellar, the battle taking place on some astral realm beyond the known world. As a founding member of the legendary rap group Wu-Tang Clan, GZA helped craft the group's elaborate mythology, which drew from Eastern philosophy, Afrocentric beliefs and 1970s martial arts movies. The album art for *Liquid Swords*, designed by comic-book artist Denys Cowan, extends Wu-Tang mythos yet further, pitching GZA into the midst of an otherworldly spiritual struggle for the soul of hip-hop.

GZA, *Liquid Swords* (album cover artwork by Denys Cowan), 1995

Idris Ackamoor & The Pyramids, *An Angel Fell* (album cover artwork by Lewis Heriz), 2018

Ill Scholars, *Ill Scholars* (album cover
artwork by Ill Scholars), 2020

The Undisputed Truth, *Cosmic Truth* (album cover artwork by
Robert Gleason, art direction by Katarina Pettersson), 1975

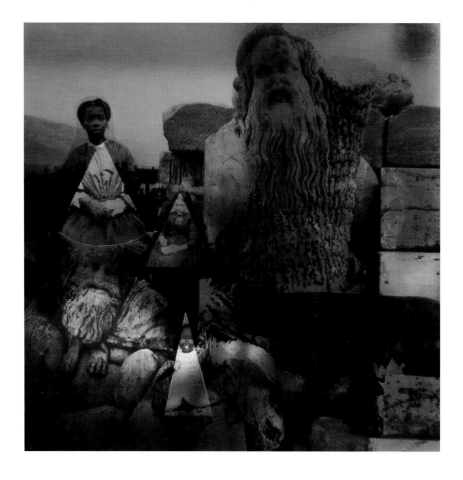

Cristina de Middel, *Yinqaba* (from *The Afronauts* series), 2011
Cristina de Middel, *Bambuit* (from *The Afronauts* series), 2011

Kandis Williams, *Cave before Cocytus*, 2018

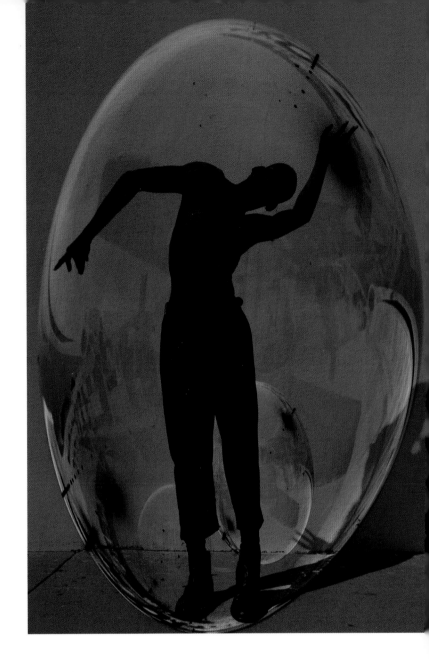

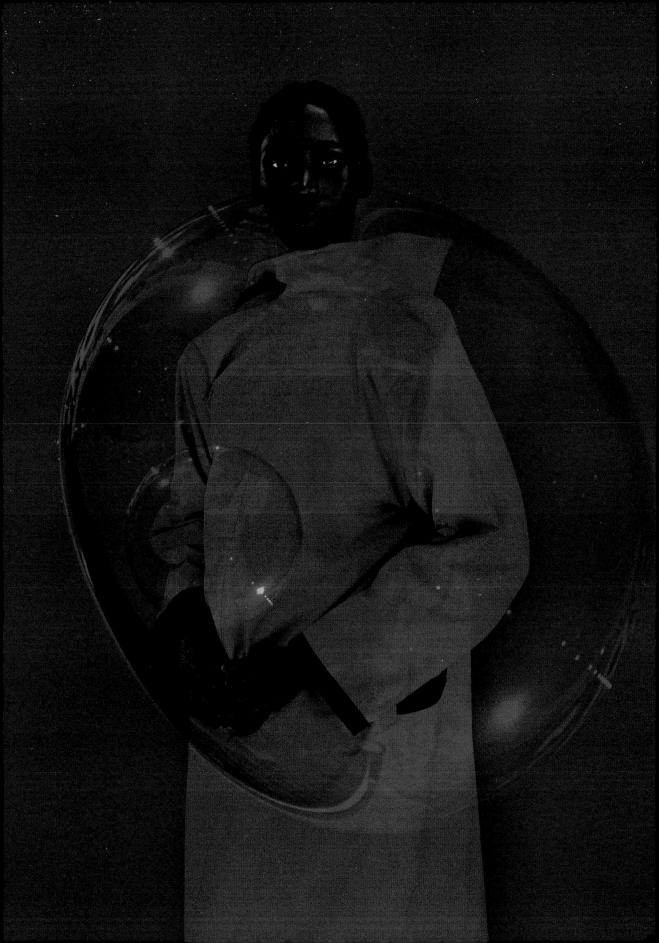

ABOVE: The vast, curving atrium of Zeitz MOCAA (Museum of
Contemporary Art Africa) in Cape Town is based on the scaled-up
shape of a single grain of corn. The design, created by Thomas
Heatherwick, references the building's former life on the city
waterfront as a grain silo. In gesturing to its previous function,
Heatherwick alludes to the complex legacies of migration, resistance
and survival tied to sea-borne colonial-era trade between Africa,
Europe and the Americas. RIGHT: This publicity image was taken for
the experimental hip-hop group Shabazz Palaces, led by Ishmael Butler
(left), who has styled himself as an interstellar traveller, a 'sent sentient
from some elsewhere', come to explore contemporary 'Amurderca'.

Zeitz MOCAA, Cape Town, South Africa, designed by
Thomas Heatherwick, 2011–17 (photograph by Iwan Baan)

PART 2

Victoria Kovios, *Shabazz Palaces*, 2017

MIGRATION: JOURNEYS ACROSS SEA & SPACE

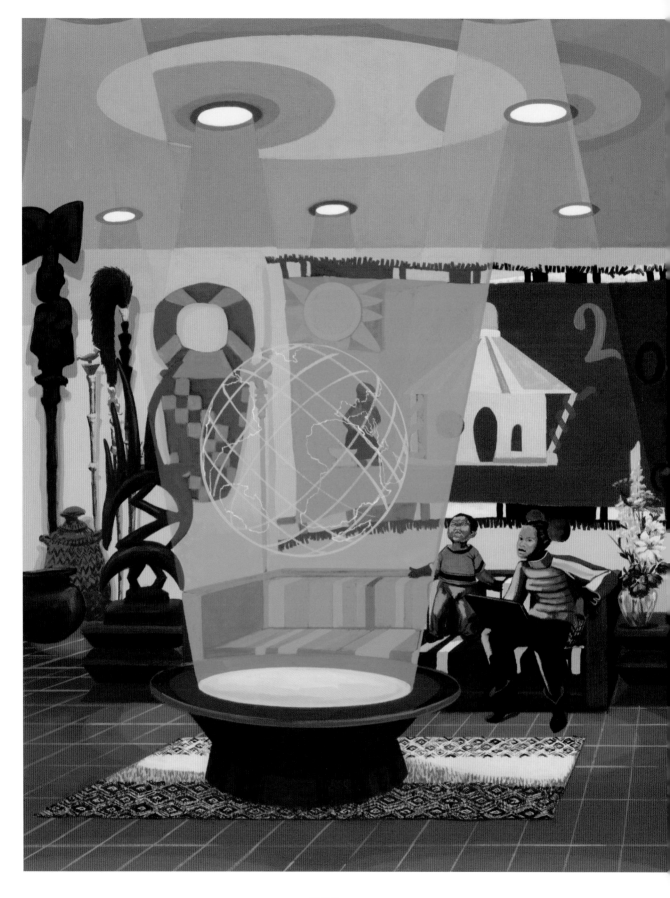

Kerry James Marshall, *Keeping the Culture*, 2010

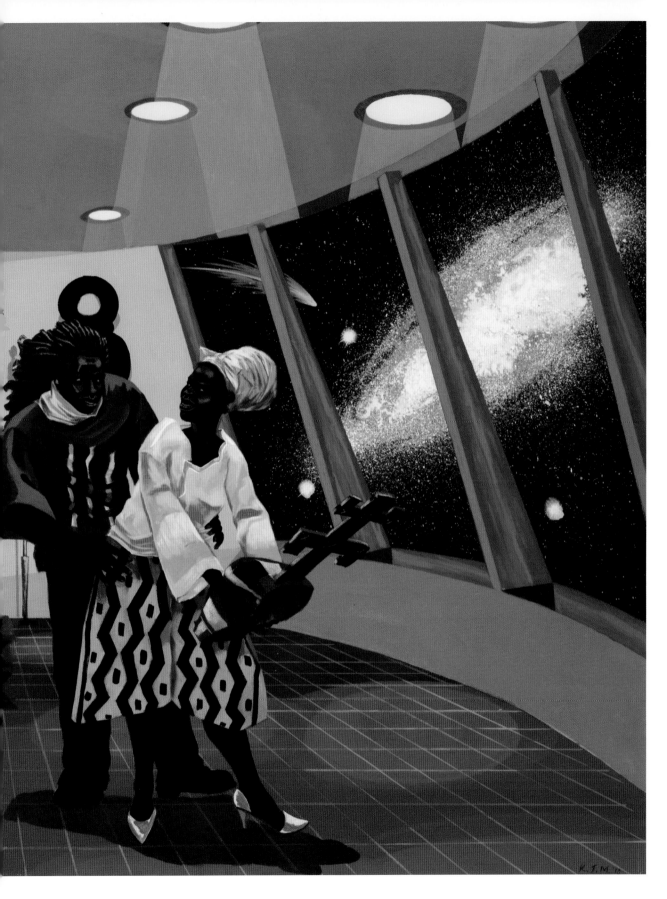

MIGRATION: JOURNEYS ACROSS SEA & SPACE

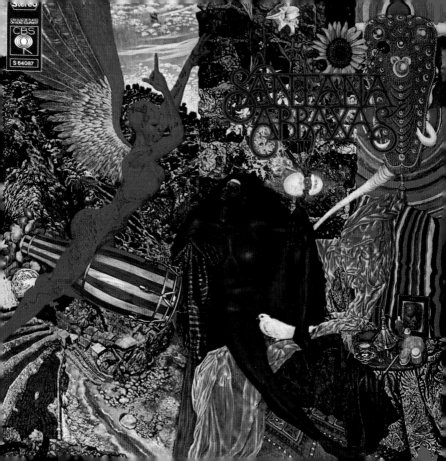

SANTANA

ABRAXAS

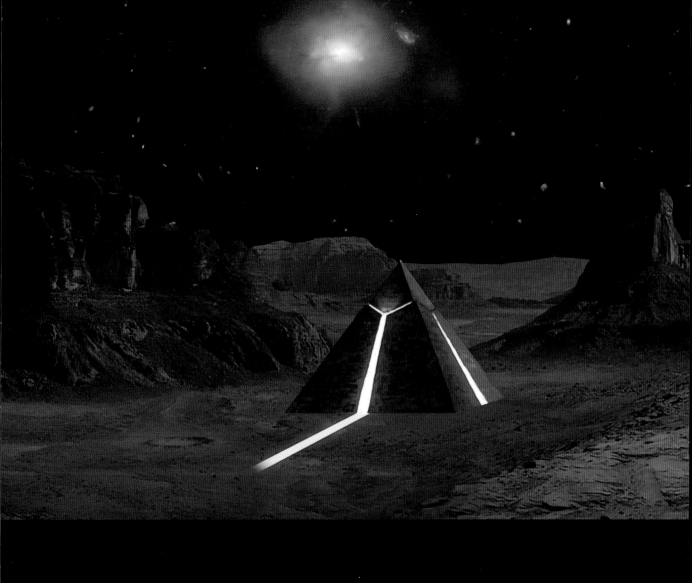

Zas Ieluhee, *Forbidden Knowledge*, 2018

MIGRATION: JOURNEYS ACROSS SEA & SPACE

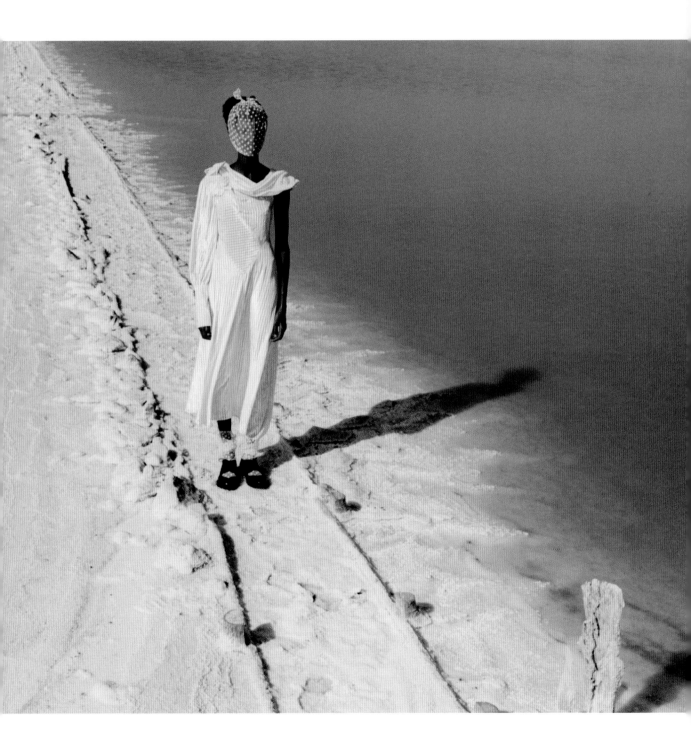

Markn, from 'From dawn to dusk' (stylist Louise Ford,
model Bibi Abdulkadir), *Document Journal*, November 2018

MIGRATION: JOURNEYS ACROSS SEA & SPACE

LION OF JUDAH

Temi Oh, *Do You Dream of Terra-Two?* (book cover), 2019
Larry Achiampong, *Relic 1* (still), 2017

PART 2

ASTRO BLACK

SUN RA

AS-9255

impulse! abc

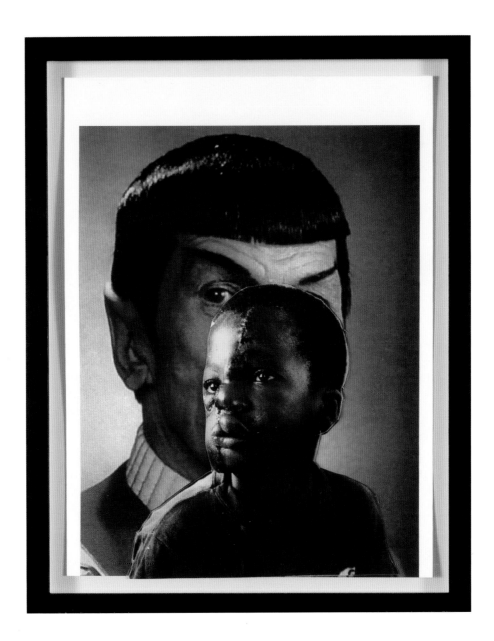

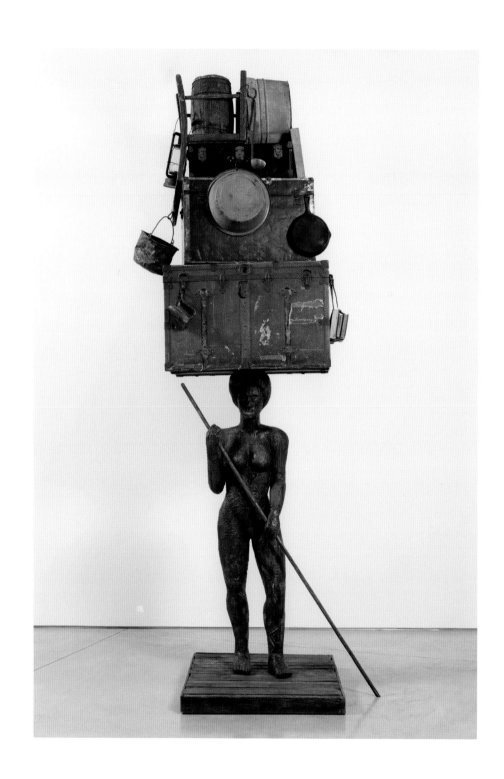

Alison Saar, *Breach*, 2016

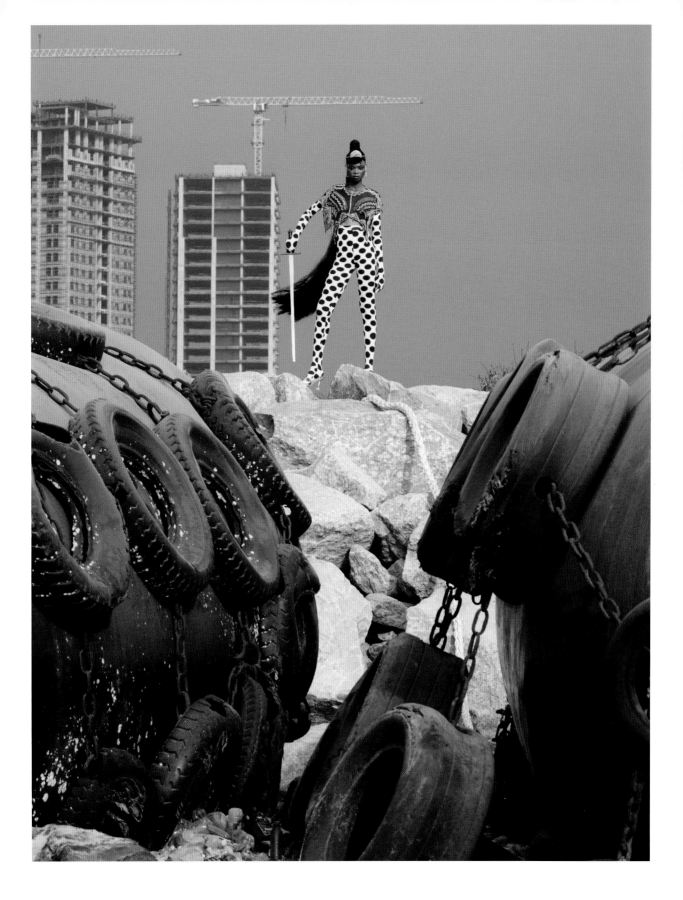

Marc Asekhame and Daniel Obasi, from 'Chaos and creation in Lagos pre-lockdown', *The Face*, May 2020

MIGRATION: JOURNEYS ACROSS SEA & SPACE

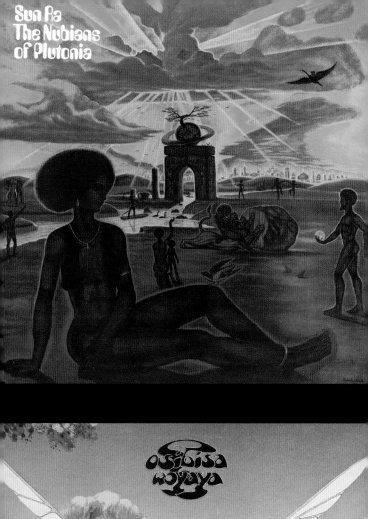

Sun Ra
The Nubians
of Plutonia

osibisa
woyaya

Saya Woolfalk, *Chimera* (still), 2013
Herbie Hancock, *Thrust* (album cover
artwork by Rob Springett), 1974

→
Stacey Robinson, *Afrotopia 1*, 2016

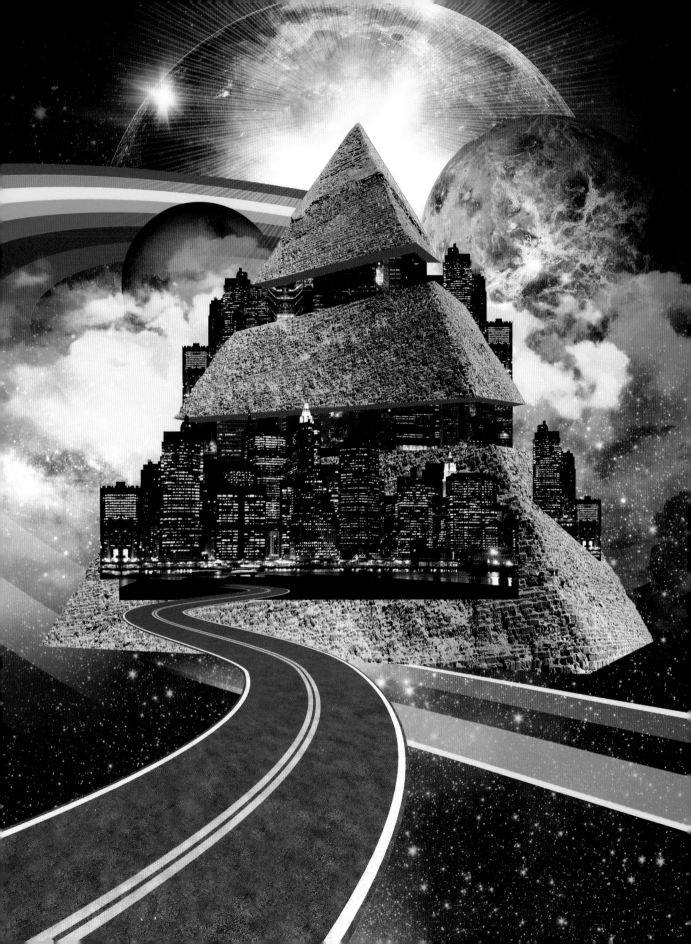

Kiluanji Kia Henda, from *Icarus 13, the First Journey to the Sun*, 2008

MIGRATION: JOURNEYS ACROSS SEA & SPACE

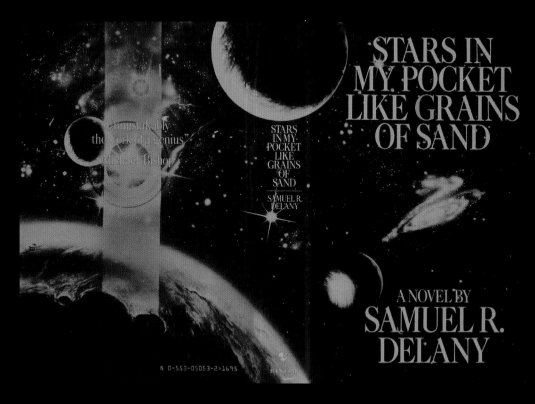

John Coltrane and Alice Coltrane, *Cosmic Music* (album cover
photograph by Jim Marshall, artwork by Byron Goto), 1972
Samuel R. Delany, *Stars in My Pocket like Grains of Sand*
(book cover artwork by Luis Royo), 1984

→

Yinka Shonibare, *Refugee Astronaut II*, 2016

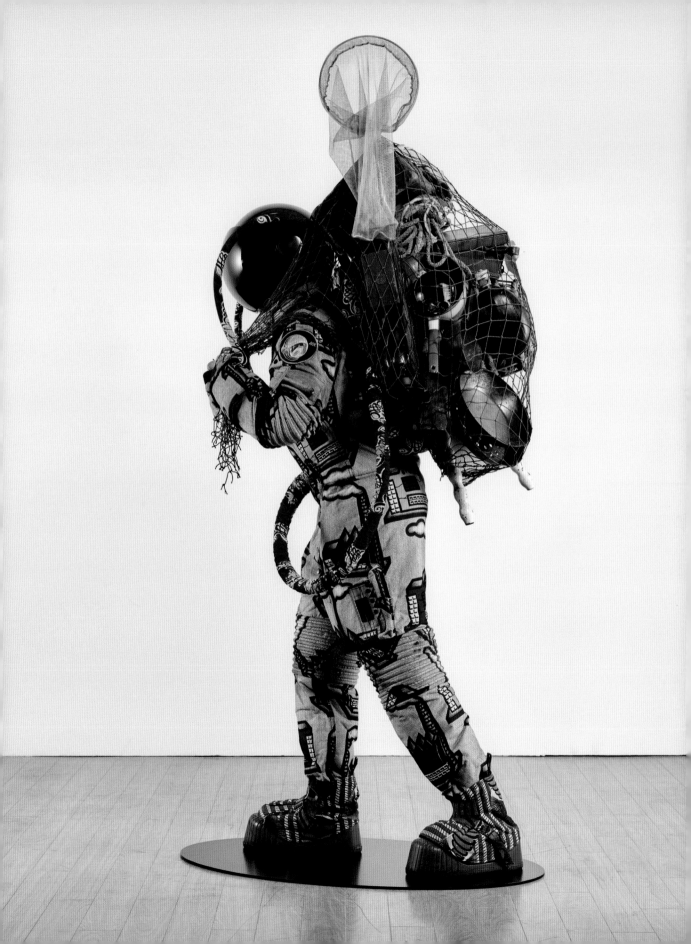

Public Enemy, *Fear of a Black Planet* (album
cover artwork by B. E. Johnson), 1990

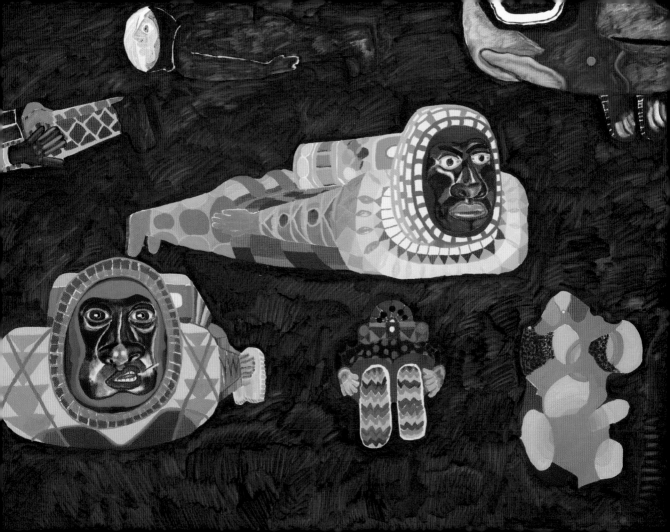

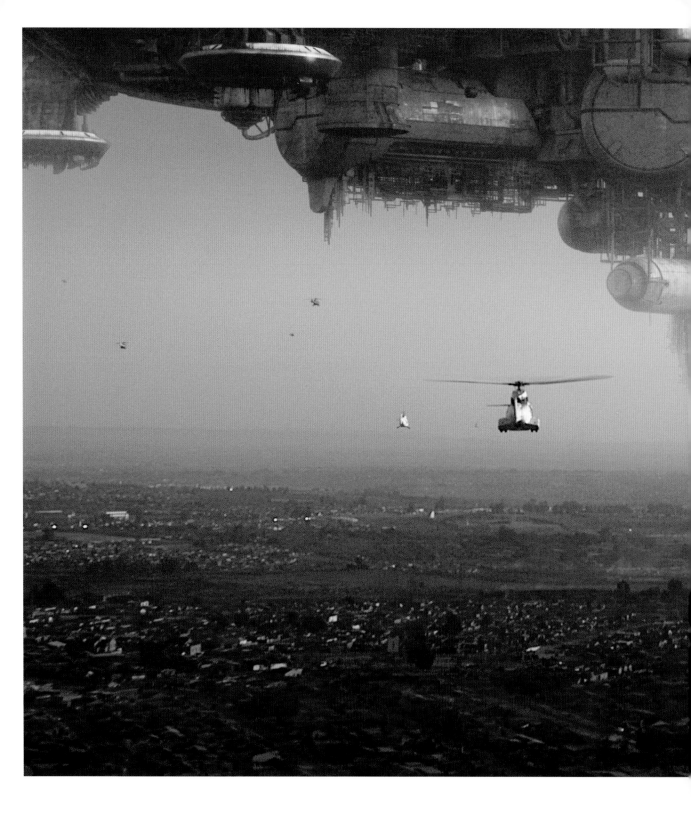

District 9, dir. Neill Blomkamp (still), 2009

PART 2

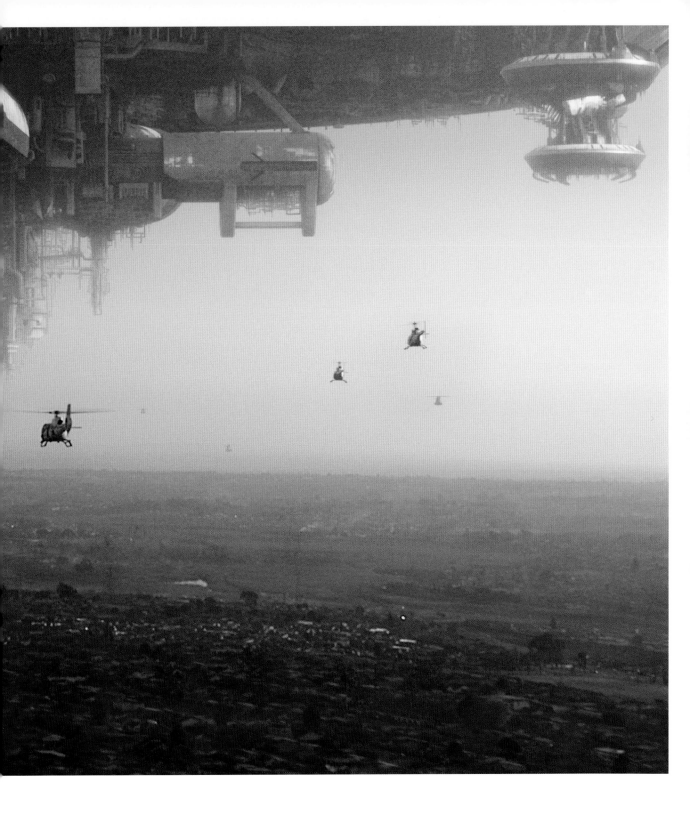

John Akomfrah's hugely influential film essay *The Last Angel of History* (1995) proposes science-fiction themes such as alien abduction, time travel and genetic engineering as a metaphor for the African diasporic experience of forced migration and cultural alienation in the West. Akomfrah's analysis is rooted in an exploration of the work of artists such as George Clinton and his *Mothership Connection*, Sun Ra's use of extraterrestrial iconography, and the very explicit connection drawn between Blackness and alienation in the writings of science-fiction authors Samuel R. Delany and Octavia E. Butler.

John Akomfrah, *The Last Angel of History* (still), 1995

ABOVE: *Rythm Mastr*, by the artist Kerry James Marshall, is a comic-strip story featuring African American superheroes based on traditional African sculpture and stories. Originally publishing the work as a newspaper strip to coincide with the 1999–2000 Carnegie International art exhibition, Marshall has continued to develop the project into a wide-ranging narrative that draws from diasporic African belief systems and the utopian fictions of Afrofuturism. RIGHT: In 1952, the photographer Gordon Parks collaborated with novelist Ralph Ellison to illustrate evocations of scenes from the latter's landmark novel, *Invisible Man*. In this image, Parks combines a night vista of the city with a reconstruction of the illuminated underground room in which the book's hero lives.

Kerry James Marshall, *Dailies, 1999–2000* (installation view)

→
Gordon Parks, *Invisible Man Retreat, Harlem, New York*, 1952

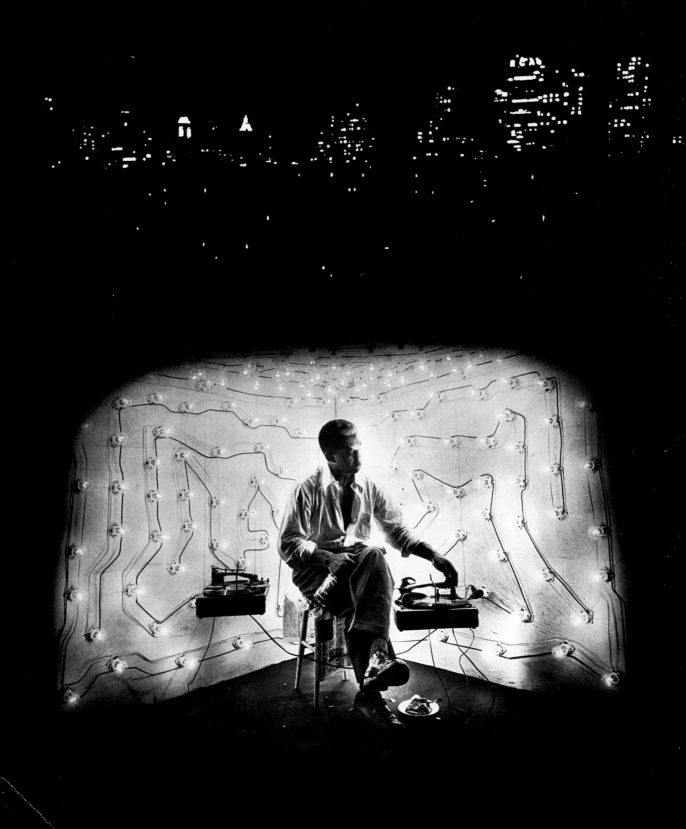

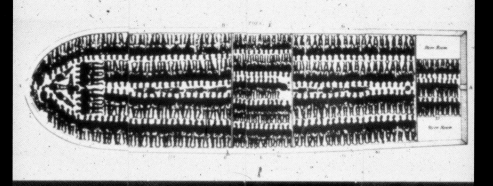

Go West

YOUNG.

MAN

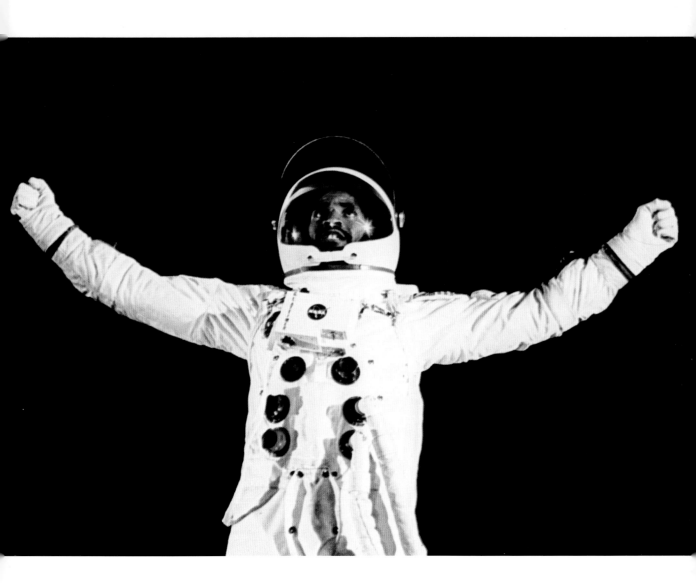

Imani Dennison, from *Afrofuturism, a love story*, 2017

Ruby Okoro, *An Eye For An Eye*, 2020

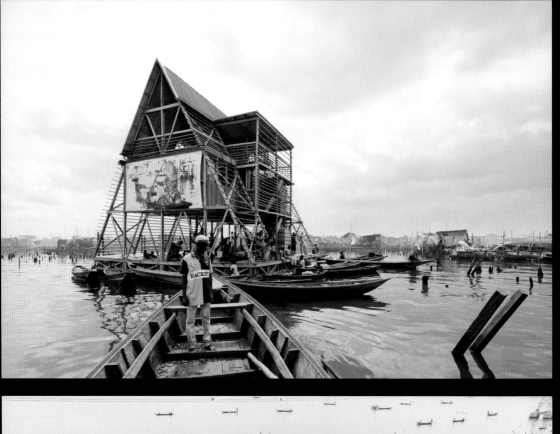
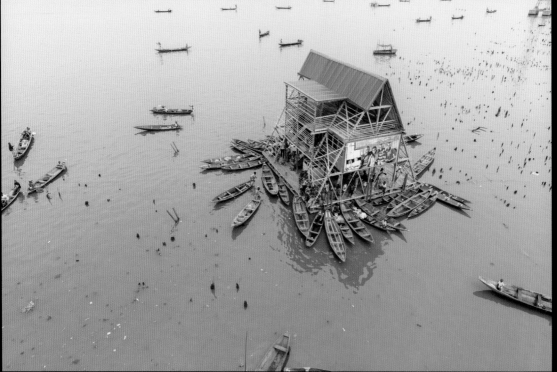

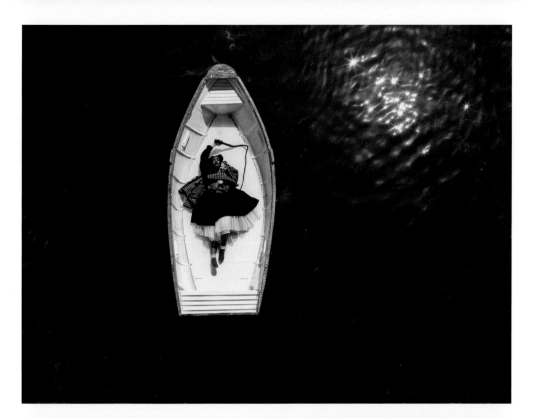

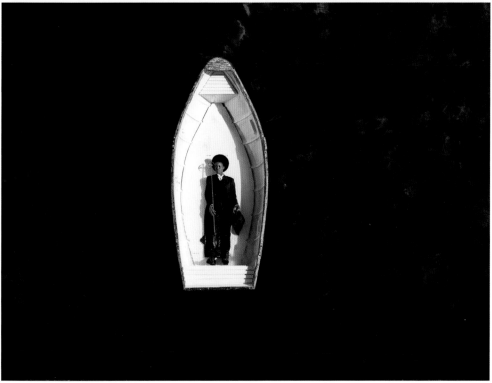

Mohau Modisakeng, *Passage 8*, 2017
Mohau Modisakeng, *Passage 1*, 2017

MIGRATION: JOURNEYS ACROSS SEA & SPACE

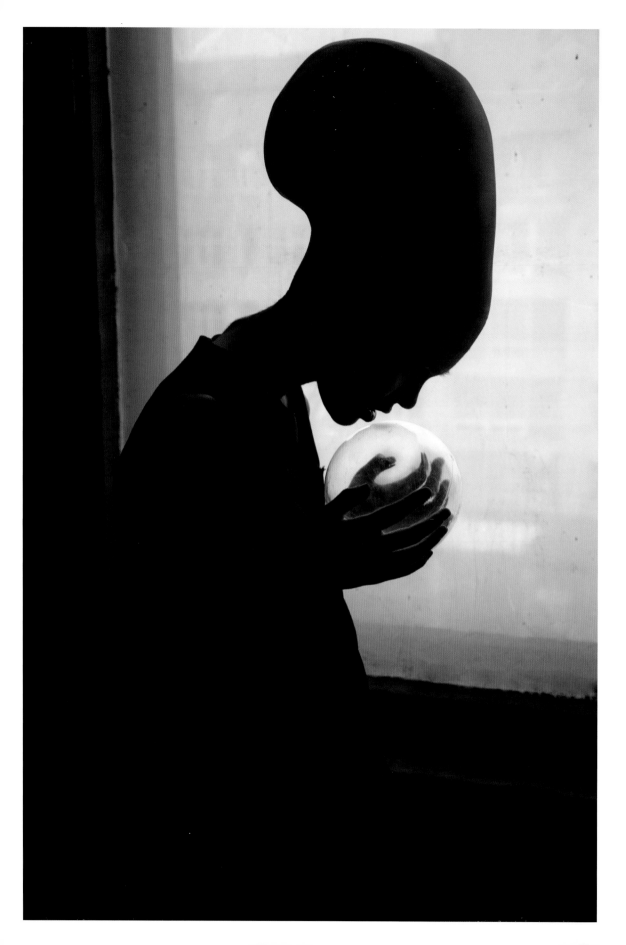

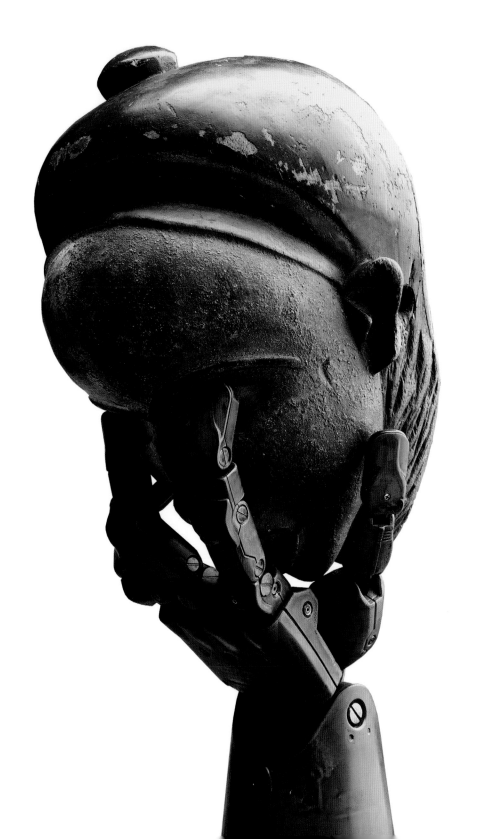

PAGE 202:
Tasha Orlova, from 'Portal' (art direction and fashion design
by Jenya Kartashova), *HUF Magazine*, March 2017

PAGE 203:
Michael MacGarry, *Eulogia*, 2018

Pumzi, dir. Wanuri Kahiu (still), 2009

→
Gerald Machona, *People from Far Away*
(stills), 2012

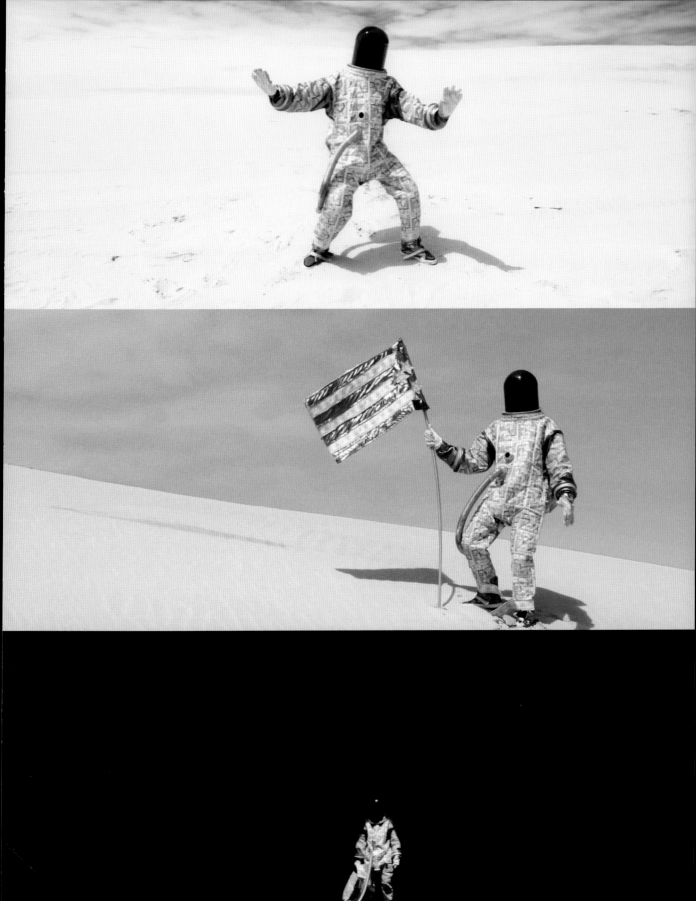

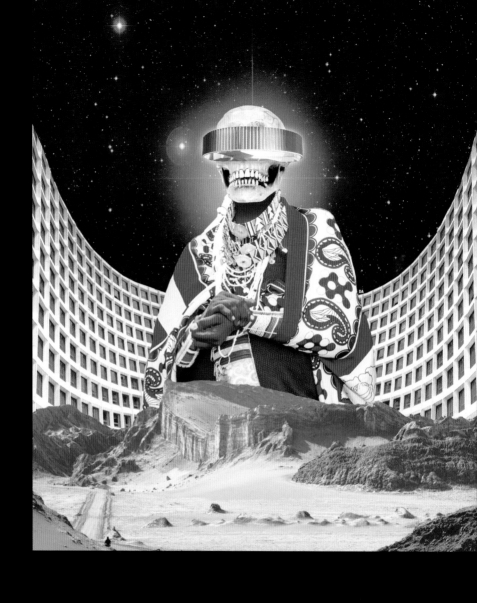

David Alabo, *Intergalactic Apostle of Funk*, 2018

Within the artwork: WE MUST BE THE BEST OF OURSELVES NOT TRY TO BE THE BEST OR WORST OF OTHERS

Gerald Williams, *Message from a Giant – Garvey*, 1976–2017

MIGRATION: JOURNEYS ACROSS SEA & SPACE

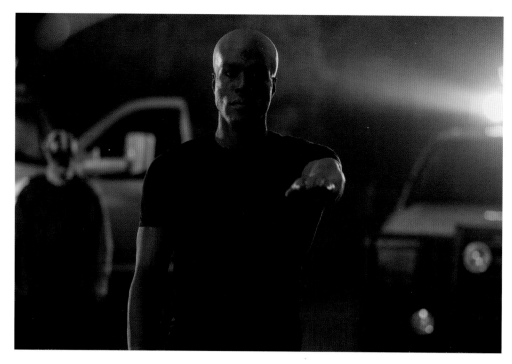

GRAND
PUBA
BLACK FROM THE FUTURE

PARENTAL
ADVISORY
EXPLICIT CONTENT

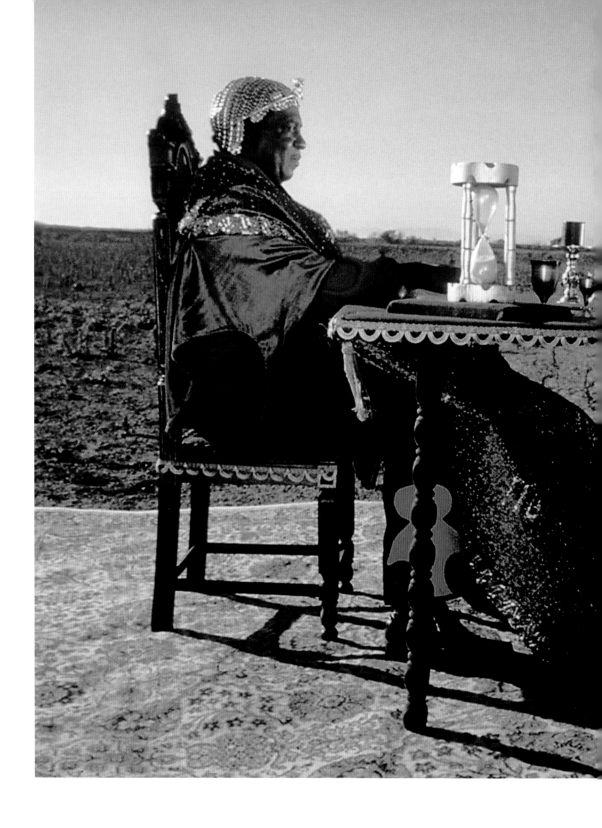

Space is the Place, dir. John Coney (still), 1974

PART 2

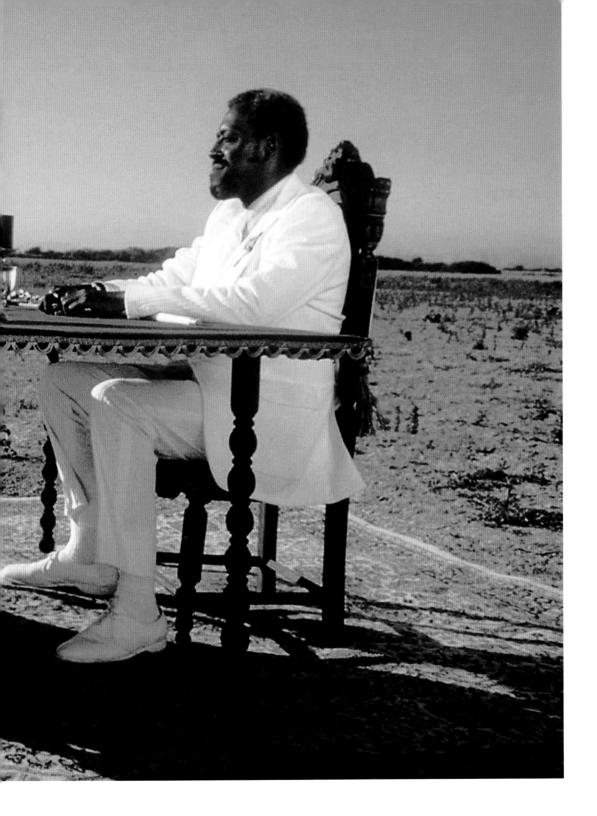

The film *Space is the Place* portrays the jazz musician Sun Ra as
a pharaonic visionary come to lead his people to freedom from
subjugation on Earth. Returning to America after a prolonged journey
beyond the solar system, Ra lands his spaceship in 1970s Oakland and
proclaims himself 'the living myth'. Finding social conditions fraught
for African Americans, he urges Oakland's youth to follow him to
salvation in space. In a pivotal scene in the film, Ra takes on his
malevolent white-suited counterpart, The Overseer, in a card duel
to decide the fate of Black America.

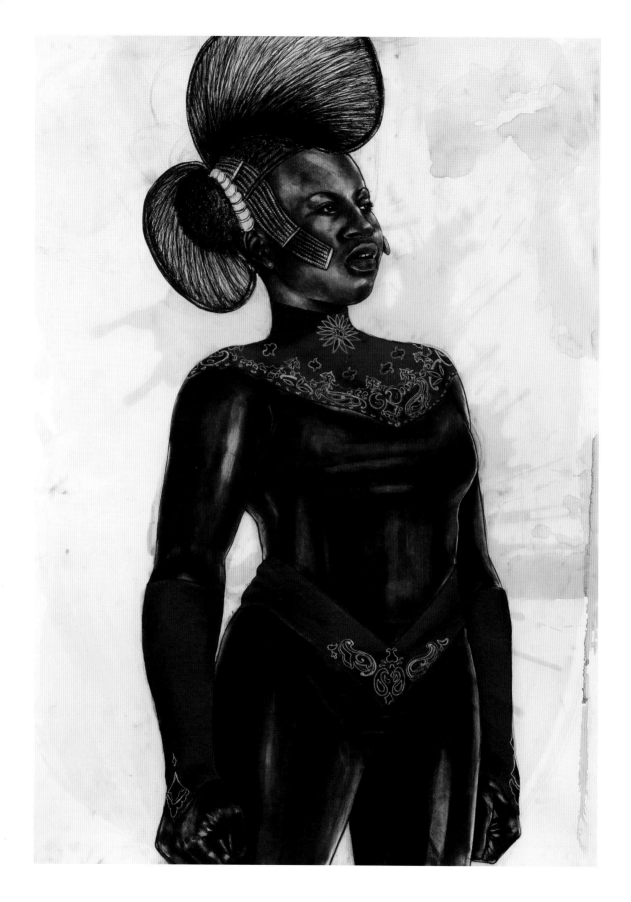

Robert Pruitt, *Captain America*, 2015

PART 2

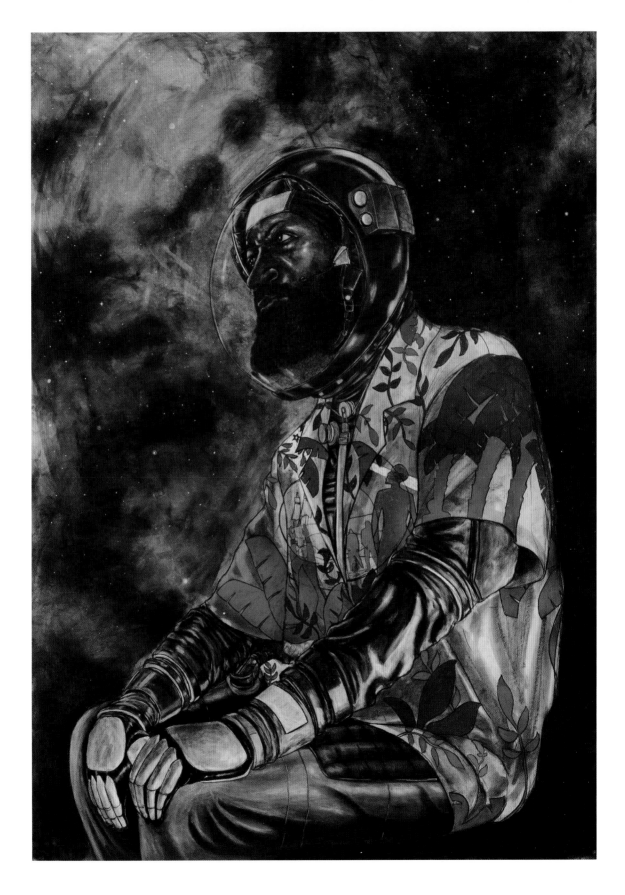

Computer render of Grand Théâtre de
Rabat, Morocco, designed by Zaha Hadid
Architects, 2010–21

→
Grace Jones, *Inside Story* (album cover
artwork by Richard Bernstein), 1986

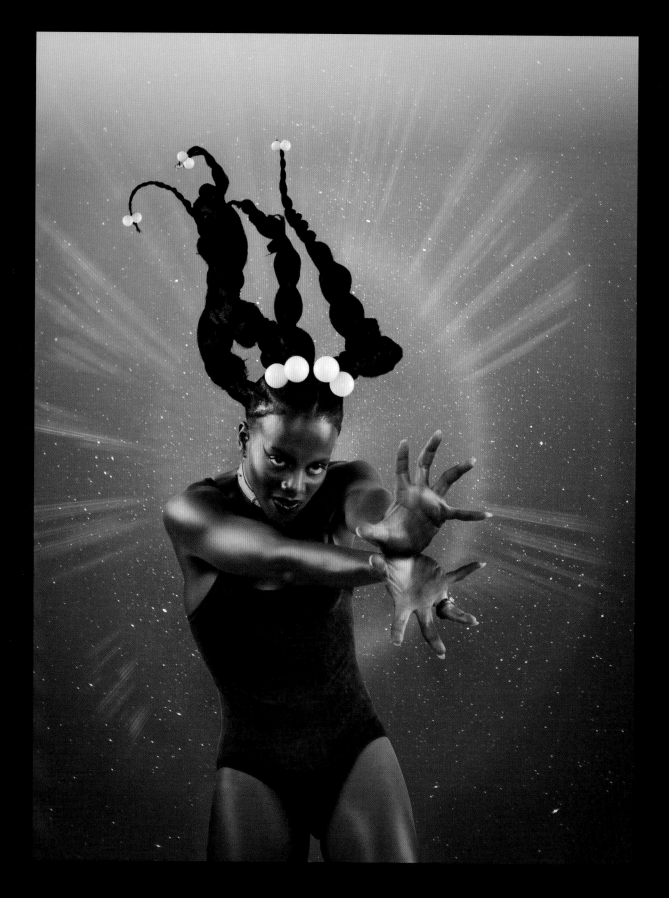

Juliana Huxtable, *Lil' Marvel*, 2015

In Populated Air: Flying Africans, Technology, and the Future

Michelle D. Commander

in populated air
our ancestors continue.
i have seen them.
i have heard
their shimmering voices
singing.

– Lucille Clifton, 'in populated air'[1]

that the whole ship's cargo were confined together, it became absolutely pestilential. The closeness of the place, and the heat of the climate, added to the number in the ship, which was so crowded that each had scarcely room to turn himself, almost suffocated us.'[2]

FLYING AFRICANS

Tightly tucked away in the bowels of ships, captive Africans laboured to breathe; they endeavoured to live. Annotated slave ship maps detailed how to pack human cargo most efficiently into the cramped holds. The Regulation of the Slave Trade Act of 1788, for example, permitted the British slave ship *Brookes* to transport 454 captives. The allocated space for each person was apportioned as 6 feet (1.8 m) by 1 foot 4 inches (0.41 m) to each man; 5 feet 10 inches (1.78 m) by 1 foot 4 inches (0.41 m) to each woman, and 5 feet (1.5 m) by 1 foot 2 inches (0.36 m) to each child. During illegal voyages, the *Brookes* secreted upwards of 600 captive Africans at once. Anguished screams and sighs no doubt filled the air of the crowded ship holds. Hunger, seasickness and infirmity seized the captives' bodies. The Middle Passage from African coastlines to the New World was a harrowing journey, during which losses of the kidnapped Africans were anticipated and accepted risks.

In one of the few, known, first-person accounts of the Middle Passage, *The Interesting Narrative of the Life of Olaudah Equiano, or Gustavus Vassa, the African*, Equiano, a captive from Benin, details the sensory excesses aboard slave ships on which crews notoriously dumped the dead, the dying, and sometimes perfectly healthy Africans overboard, ridding themselves of the perceived burden of care. On the upper decks and in the hold below, shipmen brutalized women, children, and men. 'The stench of the hold while we were on the coast was so intolerably loathsome,' Equiano writes, 'that it was dangerous to remain there for any time, and some of us had been permitted to stay on the deck for the fresh air; but now

In response to these conditions, first there was a song: 'Kum buba yali kum buba tambe / Kum kunka yalki kum kunka tambe'. And then, there was flight. An early iteration of the Flying African story from 1803 holds that, in rejection of the future that slavery had proffered for them, captive Igbo Africans sang together and then took up flight from the single-masted ship on which they had theretofore languished, jumping into the Dunbar Creek off St Simons Island, Georgia. Though this act appeared to be a mass suicide, the radicality of the unified movement was in the Igbos' determination to escape the bonds of slavery. They opted to return to their homelands in Africa in a kind of reverse Middle Passage, flying or, as some versions describe, walking across the Atlantic Ocean. It was not the first recorded instance of such an act of resistance. In his 1788 testimony before the British Parliament, Dr Ecroide Claxton testified about slave ship crew members' responses to flight as a form of enslaved people's resistance that quite literally sent enslavers' speculative investments up into thin air:

The captain in order to obviate this idea, thought of an expedient viz. to cut off the heads of those who died intimating to them that if determined to go, they must return without heads. The slaves were accordingly brought up to witness the operation. One of them by violent exertion got loose and flying to the place where the nettings had been unloosed in order to empty the tubs, he darted overboard. The ship brought to, a man was placed in the main chains to catch him which he perceiving, made signs

(which words cannot express) expressive of his happiness in escaping. He then went down and was seen no more.[3]

Fugitive flights as executed by these unnamed, jubilant Africans were perplexing to Claxton at sea and carried over into white plantation owners' disbelief that their property would flee on foot as well. The slipping away into the unknown, seemingly unchartered and permanent future, drowning in the Atlantic's oceanic necropolis, or into the darkness of the night, or into dangerous forests and across bodies of water, led to a medical diagnosis: drapetomania. Drapetomania, the idea that enslaved people who ran away or who could not be convinced to discontinue their attempts at flight had a mental illness that kept them on the move. Doctors and enslavers used this condition to rationalize enslaved people's unhappiness with their lot – as if the horrific violence and dehumanization that enslaved people experienced had gone unnoticed, unfelt.

Folklore across the African diaspora maintains that captive Africans were born with the ability to fly, with some versions suggesting that they only lost their capacity to do so if they consumed salt in the West. In the 1939–40 Georgia Writers' Project (GWP), a division of the Work Projects Administration's Federal Writers' Project, the US government paid out-of-work writers to travel to locations across the US South to collect narratives from formerly enslaved people, most of whom had been children at the end of the Civil War. On the Sea Islands, informants shared dozens of narratives with GWP workers that recalled the Flying African myth as it had been passed down in the informants' respective Gullah-Geechee families. Mose Brown from the Tin City village near Savannah, Georgia, recalled: 'My gran use tuh tell me bout folks flyin back tuh Africa. A man an his wife wuz brung frum Africa. Wen dey fine out dey wuz slabes an got treat so hahd, dey jis fret an fret. One day dey wuz standin wid some udduh slabes an all ub a sudden dey say, "We gwine back tuh Africa. So goodie bye, goodie bye." Den dey flied right out uh sight.'[4] On the island of Carriacou in Grenada, locals have for generations celebrated the Big Drum, a musical ritual in which the ancestors are venerated during a nation dance. In the Bongo dance and song, there is a recognition of the descendants' inability to travel back to their ancestors' villages to reunite, though they indeed yearned to return home:

> Oyo, Mama, Bel Louise oh
> Nu kai alé nâ ginî pu
> kotwé pawâ mwê
> lame bawé mwê
>
> We shall go to Africa to meet
> my parents
> The sea bars me.[5]

What became clear to African people across the diaspora is that the literal skill of riding the air was not the only way in which enslaved or otherwise persecuted people could take control of their bodies or their imaginations. Actively remembering and recreating cultural elements of the past to commemorate forebears – maintaining some control over the range of their psychic mobility – became a significant way to elide Western mores. The abolitionist Frederick Douglass's fugitivity was compelled by his understanding that his 'only chance for life was in flight', not via bodily ascension into the air but by running away on foot or various other modes of transport.[6] For Douglass, flight also became a way of living; it was about the creative uses of the imagination to free himself and eventually agitate on behalf of other enslaved people to ensure their ultimate freedom and full citizenship rights. In his autobiography *Narrative of the Life of Frederick Douglass, An American Slave*, Douglass not only describes flight as an epistemology through which to live, but also offers stunning insight into the stakes of movement away from and within the institution of slavery:

> I would keep the merciless slaveholder profoundly ignorant of the means of flight adopted by the slave. I would

leave him to imagine himself surrounded by myriads of invisible tormentors, ever ready to snatch from his infernal grasp his trembling prey. Let him be left to feel his way in the dark; let darkness commensurate with his crime hover over him; and let him feel that at every step he takes, in pursuit of the flying bondman, he is running the frightful risk of having his hot brains dashed out by an invisible agency.[7]

For an enslaved woman turned abolitionist such as Harriet Jacobs, flight meant establishing a *loophole of retreat*, a space of respite in which to secrete oneself away – in Jacobs's case, in her grandmother's attic, to which she escaped for several years to protect herself from her master's sexual harassment and to make plans for her and her children's futures. And for the untold numbers of enslaved people who successfully fled from plantations and created maroon communities or entered free states in the United States, Canada or Mexico, and for the millions of Black Americans who fled the South for better job opportunities and less hostile places in the US North and Midwest in the early and mid-twentieth century during the first and second waves of the Great Migration, flight was about the creation of alternative existences across relatively unknown geographies.

In more recent years, conversations in Black visual art and culture, literary studies, and a range of Afrofuturist projects have quite steadily centred on the history of the Middle Passage and notions of flight to offer access points toward liberation. These speculative works engage with elements of fantasy, abstraction, science fiction, technology, cultural myths and historical re-narrativization to create new worlds for Black lives, inverting the power of financial speculations in slavery, colonialism, empire, and their continuations.

'No one flies the Middle Passage no more,' laments the Ghanaian poet Kofi Anyidoho. In the introduction to his 1993 collection of poetry, *Ancestrallogic & Caribbeanblues*, Anyidoho charts his travels from his native Ghana en route to the United States, focusing on his deliberate stops throughout the Caribbean to acknowledge the connectedness of people of African descent via the Middle Passage. In several pieces within the text, Anyidoho lyrically recreates and acknowledges the dispossession and painful histories wrought by slavery and colonialism, and gestures toward the possibilities of cultural restoration through the logic of speculation. About the stakes of his travels through the Middle Passage, he writes:

> It is the quest for a future alive with the energy of recovered vision, a future released from the trauma of a cyclonic past and from the myopia of a stampeded present... The wounds must be sought out and washed clean with the iodine of pain. The trauma of death must be transformed into the drama of life, the destabilized soul purged of the heavy burden of permanent sorrow and of recurring seizures of rage.[8]

As an apparatus through which to connect African peoples worldwide, AfricanaAirways becomes Anyidoho's imaginary vessel to provide direct transfers and Pan-African connectedness between the diaspora and Africa. In his poem, 'HavanaSoul', Anyidoho expresses his frustration with the proliferation of airlines that require layovers in Europe before one is able to commune with one's ancestral pasts, and he comes to the realization that in order for African-descended peoples to understand each other, they must utilize the 'common alien tongue'.[9] In Anyidoho's poetry, elements of the blues music tradition with its mourning – the sitting with and articulation of the losses experienced – and the temporal flights afforded

by AfricanaAirways, serve as the fantastic means by which all African-descended peoples can attend to the trauma, dispossession and disconnections caused by slavery. He writes about the potential for reverse Middle Passages:

> ... from Ghana to Havana to
> Guyana
> And and [sic] on and on to Savannah
> in Georgia of the deep deep South.
> With AfricanaAirways we can
> renavigate the Middle Passage,
> clear
> the old debris and freshen the waters
> with iodine and soul-chlorine.
> And our journey into SoulTime
> will be
> The distance between the Eye
> and the Ear[10]

As the Trinidadian-Canadian poet Dionne Brand explains about such imaginative flights back to Africa, 'One may not call these ways practical but they certainly suggest a mastery of way-finding. So much so that no known map is necessary, nor any known methods of conveyance. Except escaping the body.'[11] The idea of return – mythic, psychic, or physical – is a liberating philosophy that has been taken up by people of African descent, whether their ancestors were in diaspora or remained on the African continent proper, in reaction to the cultural breaches caused during transatlantic slavery and the arduous passages on which millions suffered cruel fates over the several centuries. From nineteenth-century repatriation efforts to the cultural nationalist and Pan-Africanist sentiment that arose in the twentieth century to present-day decolonization movements, efforts to reclaim the African homeland and its attendant cultures have been a feature of the diasporic experience.

RETURNS TO THE MOTHERLAND

A few summers ago, a group of Black tourists eagerly awaited their journey to explore remnants of the transatlantic slave trade, including the Doors of No Return in Cape Coast and Elmina, Ghana. As diasporans, they viewed returning to the imagined motherland as the ultimate occasion for confronting the loss, trauma and memory of the initial injury that had haunted their kindred for generations. As they exited their plane in Accra and passed through the immigration desk and customs, they were greeted by a group of Black American expatriates who had committed themselves to initiating what they referred to as a 'clapping ceremony' to applaud and welcome newcomers to their imagined ancestral home. Ghana has been a significant symbolic Africa for homeland returns to the Black American cultural and political imaginaries since the 1950s, when President Kwame Nkrumah sought out Black political figures, artists and professionals to assist him in building the fledgling nation. Nkrumah's brand of Pan-Africanism, a philosophy concerned with the worldwide uplift and well-being of African-descended peoples, attracted this group of Black Americans who were fascinated by Nkrumah's ability to defeat colonialism, as they, too, were in the midst of a centuries-long freedom struggle back in the States and felt that there were many lessons to be learned from Ghana's inspiring example.

Motivated by news about this cohort of migrants to Ghana, the Black American writer Leslie Lacy explained his decision to go into self-imposed exile there in the early 1960s: 'I had applauded a speech in which President Nkrumah said he was black first, African second, and socialist third... I needed a community of people that could afford to be patient, and I did not believe that I could escape the taunts and attacks of America's racial madness in another American city. And Dr. W. E. B. Du Bois ... was black and radical, and in his life was the back-and-forth political pattern which was beginning to characterize mine... He was going to Ghana. "A socialist Africa is the future," he said.'[12] Lacy travelled to Ghana in 1962 on a specific mission to better understand his identity as an African in America.

Over the years, Ghana has maintained a similar courtship with the diaspora through what developed decades after the Nkrumah era into a tourism market that attracts tens of thousands of heritage roots tourists each year, who hold on to similar hopes as Lacy that they will somehow become endowed with a philosophy for negotiating their Blackness under global racism, and particularly as they settle back in their homes in the West after their travels in Ghana. The Ghanaian government's 2019 Year of Return and 2021 Beyond the Return initiatives attracted thousands of musicians, artists, entertainers and everyday people travelling to Ghana to engage with the vestiges of slavery that remain there – a sobering way to reckon with slavery and the re-emergence of aggressive forms of racial animus, and to imagine their futures outside of the West some four hundred years after the first British slave ship arrived in what is now the United States.

BLACK ARTISTIC FLIGHTS AND/AS TECHNOLOGIES

The filmmaker Haile Gerima has referred to the institution of slavery as 'a scientific adventure, an attempt by an industrialized society to create a robotic or mindless human being, pure labor... [T]he plantation school of thought believed [resistance and rebellion were] always provoked by outsiders, that Africans were not capable of having that human need.'[13] Through their leaps from slave ships, determination to escape slavery through fugitive flights, embrace of collective rebellion on plantations across the Atlantic world, and artful uses of the imagination to create Black futures, enslaved people and their descendants have established a sustainable, collective politics of refusal by assuming defiant postures in the imminence and immanence of death. They have inaugurated standpoints for actively rejecting the ways that they are historically relegated to spaces and places in which they could not and cannot truly survive. As the history of slavery and speculative, surrealist

methods continue to influence writers, filmmakers, visual artists and other creatives, a question arises: Is Black art technology? Technology is typically thought of as that which makes science practical – that which recognizes a deeper purpose and whose creator should have in mind the ways that their apparatus will render life easier for the user. The writer Amiri Baraka affirms that art is an apparatus that might serve sensory, aesthetic and narrative purposes, but also operates as a tool by which to represent and ultimately free Black lives. Certainly, this is not a wholly novel proposition. One only needs to recall the (US) American fugitive slave narrative tradition and its significance as the genre that gave rise to a long history of Black authors using their works to protest and properly represent the interiority of Black people's lives. In contemporary speculative cultural productions, Afrofuturism emerges as a liberating philosophy through which to construct more imaginative interpretations of, and oftentimes radical responses to, the environmental issues that plague societies.

In his essay 'Technology & Ethos', a cultural nationalist polemic based on the teachings of Maulana Karenga, Amiri Baraka argues that, in order to realize freedom, Black people should reconfigure how they understand the function of technology and science:

Machines, the entire technology of the West, is just that, the technology of the West. Nothing *has* to look or function the way it does. The West man's freedom, unscientifically got at the expense of the rest of the world's people, has allowed him to xpand [sic] his mind-spread his sensibility wherever it *cd* go, & so *shaped* the world, & its powerful artifact-engines. Political power is *also* the power to create–not only what you will–but to be freed to go where ever you can go–(mentally physically as well). Black creation–creation powered by the Black ethos brings very special results[.] Think of yourself, Black creator, freed

of european restraint which first means the restraint of self-determined mind development. Think what would be the results of the unfettered blood inventor-creator *with the resources of a nation behind him*. To imagine–to think–to energize!!! How do you communicate with the great masses of Black people? ... What are the Black purposes of space travel?[14]

In this final question, which is truly one about the stakes of flight, Baraka makes a fascinating, revolutionary call for Black creators to question the function of European-derived artistic thought. He articulates a desire for Black technologies that might offer everyday people psychological ascension over societal circumstances: his is a speculative proposition rooted in centuries of Black strivings. Baraka explains that, unlike the reality of the technology of the West, Black technology 'must be spiritually oriented because it must aspire to raise man's spirituality and expand man's consciousness. It must begin by being "humanistic" though the white boy has yet to achieve this. Witness a technology that kills both plants & animals, poisons the air & degenerates or enslaves man.'[15] For Baraka, Black art should not seek to imitate that of the West; indeed, as a speculative technology, Black art must liberate – freeing lives, articulating the truth, and making space for difference.

CODA

Images from the 2005 Hurricane Katrina disaster continue to haunt. In his 2006 mixed-media painting *Katrina, Katrina, Girl You're On My Mind* from his *Traumanauts* series (fig. 1), David Huffman tends to the agony that the hurricane wrought in the US Deep South a year prior, using astronaut and space iconography to recall and engage with that fateful moment. In the news media coverage in the days leading up to and after the storm, beautiful Black faces flashed across television screens, their expressions pained by the

knowledge that their city, state and country had left them to fend for themselves, as many of those left behind were poor or working class and therefore deemed unimportant. In some cases, bus transport that should have been used to shuttle these poor and working-class community members never arrived. And so families stayed together at home or alone to wait out the storm, the water rising so powerfully that the levees gave way. When television crews arrived during this environmental disaster, cameras scanned across a sea of Black faces, not unlike my own. In interviews, survivors bore witness to their struggles to navigate the deep waters that had invaded their homes, breaking down at the terror they were experiencing. The fortunate ones made it to the rooftops and spray-painted signs to those flying above that they needed food and help. Many had nothing to eat for days before finding shelter. Many of us who watched this heartrending spectacle over several days wished that some force could somehow swoop in and save the day, save lives.

At the Superdome in New Orleans, where New Orleanians could receive a measure of safety if they were fortunate, citizens whom the media quickly began to refer to as *refugees*, as if they had no country, clamoured for airtime, announcing the names of missing family members or drawing the world's attention to those who had passed away in the sweltering conditions, their bodies abandoned at the site of demise, in the middle of a sidewalk or on a highway overpass. The unforgiving heat, lack of water, food and care, the ways in which the dispossessed were packed into buses days later and sent to places unknown – the sheer irreverence with which they were treated – recalled some of the most appalling elements of slavery.

Huffman explains that his traumanauts are 'the psychological personalities coming from the rupture of slavery for Africans. I would label them a TRAUMAnaut, rather than an astronaut, because of this traumatic rupture of existence. From being captured, brought to America and parts of Europe, as workers, as

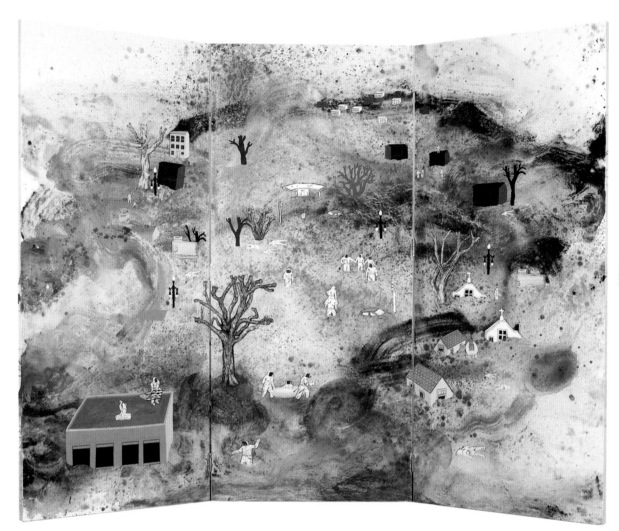

FIG. 1

David Huffman, *Katrina, Katrina, Girl You're on My Mind* (from *Traumanauts* series), 2006

slaves, there's a cultural identity that's been decimated. The traumanauts are constantly looking for a location, for home.'[16] As captured in *Katrina, Katrina*, the traumanauts appear in this reimagined scene as mystic presences in a setting that recalls outer space, but whose geographic and temporal bounds are unknown. The traumanauts are scattered throughout the landscape, their puffy white spacesuits nearly glowing against the bleak, abstract background. In the midst of rescuing others, seeking help from rooftops, or, more soberly, floating in the water (lifeless from drowning), the traumanauts' placement in similar postures to those that were seen in New Orleans forces the viewer to see the connection. The traumanauts are a kind of

performative empath, determined to make plain the suffering and loss that occurred. Huffman situates the Katrina catastrophe in a longer history of environmental injustice and, through his theorization of the futuristic traumanauts as always travelling, always in diaspora, he stresses the necessity of deliberate movements to the preservation of Black bodies, Black life. The water brought us. We must remember to ride the air. Perhaps Huffman's traumanauts sang just before taking flight: 'Kum buba yali kum buba tambe / Kum kunka yalki kum kunka tambe'.

Liberation

③

Dreams of Freedom

In March 2018, a billboard designed by Pittsburgh-based artist Alisha B. Wormsley was erected in the city's East Liberty neighbourhood. The sign was part of a public art project and it read: 'There Are Black People In The Future.' Wormsley's message sought to address the 'systemic oppression of black communities through space and time' by the claiming of a future that has historically been denied to them.[1] But her billboard only stood for a month before it was taken down by the building's landlord over complaints that it was 'offensive and divisive'. In response, Wormsley 'gave the phrase to the public', encouraging others to use it freely.[2] The billboard has since been replicated in Detroit, Charlotte, New York, Kansas City, Houston and London, and its wording used in essays, in songs, and on signs and banners during public protests.

Wormsley's reflection on Black futurity has precedent in popular culture. Take Richard Pryor's mordant riff on his *Bicentennial Nigger* album (1976), for instance. 'I went to see "Logan's Run," right. They had a movie of the future called "Logan's Run." Ain't no niggers in it. I said, well white folks ain't planning for us to be here.'[3] Or the words of Black science-fiction author Samuel R. Delany from a 1978 essay. 'We need images of tomorrow; and our people need them more than most. Without an image of tomorrow, one is trapped by blind history, economics and politics beyond our control.'[4]

The affirmatory nature of Wormsley's statement can also be placed within a span of Black utopian thinking that encompasses the early twentieth-century pan-Africanism of W. E. B. Du Bois and Marcus Garvey, the revolutionary politics of the Black Panther party and the AfriCOBRA artist collective, African independence movements of the 1960s, and the Afrofuturist world-building of Delany, Sun Ra and Octavia E. Butler. In the dreams and desires of these individuals and groups, a question reverberates: what does liberation look like? What physical form might Black utopia take?

We can find one answer in independence-era Africa. From the late 1950s onwards, nation after nation in Africa secured freedom from colonial rule. In Ghana, Kwame Nkrumah, the country's first leader under self-rule, vowed to see 'the humanism of traditional African life [reassert] itself in a modern technical community'.[5] For Nkrumah, and for countries across the continent, bold, visionary architecture became an emblematic way to express a new spirit of independence and national pride. Stadia, universities and parliament buildings, built to thrilling, unconventional designs, exemplified the optimism of the period. Ghana's flying saucer-like International Trade Fair Centre in Accra. The pink, cylindrical Kenyatta International Conference Centre in Nairobi, Kenya. Ivory Coast's extraordinary La Pyramide commercial centre in Abidjan, which resembled nothing less than the work of a latter-day pharaoh. These new structures illustrated a hunger to break free from conventional Western design in favour of an aesthetic of audacious inventiveness.

The influence of Africa's independence-era buildings can still be felt today in imaginary cities built to express Black yearning, such as the soaring towers and glass-domed buildings of Birnin Zana, capital city of the utopian nation of Wakanda, in Ryan Coogler's *Black Panther* (2018).

The quest to visualize Black utopia can also be witnessed in the sleeve art of a raft of musicians in the 1960s and 1970s. Free jazz pioneers such as John Coltrane, Archie Shepp and Ornette Coleman combined searching, improvisation-based music-making with an embrace of Black radical politics and pan-Africanism. Their influence spread to genres such as soul and funk. 'Freedom' as aesthetic, politics and 'oppositional discourse' is the governing theme of a range of wildly imaginative record sleeves from the period.[6] On albums such as Lonnie Liston Smith's *Visions of a New World* (1975), Undisputed Truth's *Cosmic Truth* (1975) and

Rahsaan Roland Kirk's *Prepare Thyself to Deal with a Miracle* (1973), musicians are spiritual travellers, journeying through outer and inner space in search of liberation.

Utopia can also mean a state of personal liberty. In the photography of South African artist Athi-Patra Ruga, we encounter a lavish fantasia based on the idea of Azania, an imaginary Southern African arcadia free from colonial rule that was conceived by anti-apartheid activists in the 1960s.[7] Ruga's version of the country is populated by exotic creatures, such as sabre-toothed zebras, and state territories where sexual freedom reigns – regions bear ribald names like Sodom and Kuntistan. Perched on a ceremonially decorated zebra, Ruga's character in the photograph *Night of the Long Knives I* (2013; fig. 1) is known as the 'Future White Woman of Azania'. Notwithstanding their name, the figure is in the midst of racial and sexual metamorphosis. Cocooned in multicoloured balloons, their identity is suspended between black and white, male and female, straight and queer. Ruga's image, and his constructed world, is both a riposte to the disappointments of the post-apartheid 'Rainbow Nation' and an affirmation of the validity of non-binary identity. In his photograph, the desire for political freedom becomes a spur for personal transformation.

A similar notion of change as the path to liberation informs Mickalene Thomas's *Orlando* (2019). The photography series takes as its starting point Virginia Woolf's eponymous 1928 novel, which tells the story of a young aristocrat born in the Elizabethan era who lives for 300 years without ageing, mysteriously switching gender during the course of their long life. In a series of portraits, Thomas casts her muse and partner Racquel Chevremont and performance artist Zachary Tye Richardson in the role of Orlando, consciously expanding the range of themes raised by the book to include race as well as gender.

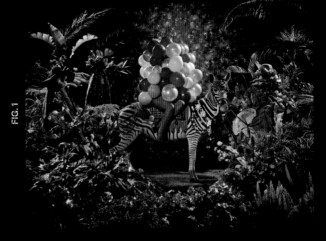

FIG. 1

Athi-Patra Ruga, *Night of the Long Knives I*, 2013

And in the stylized identities that popular music stars such as Grace Jones, Janelle Monáe and Erykah Badu have crafted, imagining themselves as alien, cyborg and Other, we witness striking examples of 'posthuman blackness', scholar Kristen Lillvis's term for the imaginative forms of resistance to boundaries of race, gender, time and place that 'enable black subjects to make connections to diasporic history in the present and also imagine the future as a site of power'.[8]

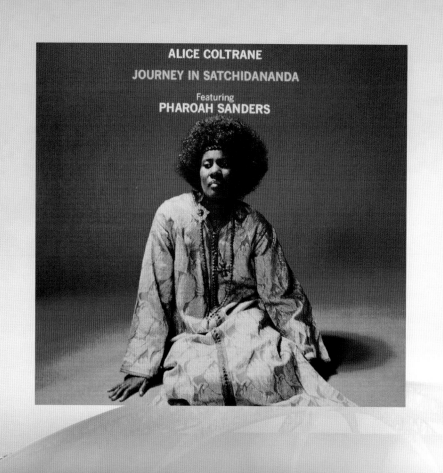

ALICE COLTRANE
JOURNEY IN SATCHIDANANDA
Featuring
PHAROAH SANDERS

In the post-war period, nation after nation in Africa secured independence from colonial rule. The optimism of liberation triggered a creative flourishing across the arts, from music to film and literature. The spirit of exuberance was also reflected in a raft of audaciously designed buildings erected in cities across the continent. The bold, modernist Hôtel Ivoire in Abidjan offers a striking example of the desire to break free from European aesthetic strictures in favour of an exhilarating architecture of freedom.

PAGE 228:
Alice Coltrane, *Journey in Satchidananda* (album cover photograph by Chuck Stewart), 1971
PAGES 228–9:
Computer render of International Conference Center, Ouagadougou, Burkina Faso, designed by Coldefy, 2009
PAGE 229:
Computer render of Burkina Faso National Assembly & Memorial Park, Ouagadougou, Burkina Faso, designed by Kéré Architecture, 2017

Yaoundé Olu, *Mother of Worlds*, 1975

Hôtel Ivoire, Abidjan, Côte d'Ivoire, designed by Moshe Mayer,
Heinz Fenchel and Thomas Leitersdorf, 1962–70, renovated by
Pierre Fakhoury (photograph by Iwan Baan)

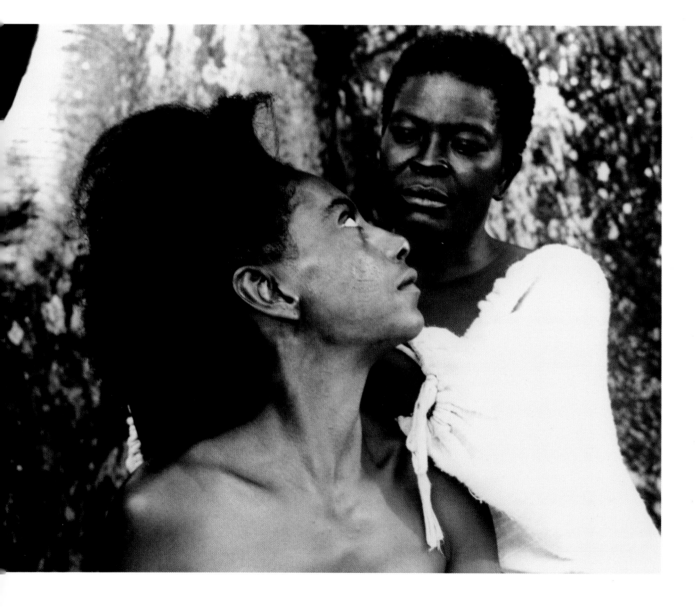

Sankofa, dir. Haile Gerima (still), 1993

PART 3

Cristina de Middel, *Idagiri* (from *This is What Hatred Did* series), 2014

LIBERATION: DREAMS OF FREEDOM

Robert Reed, *Galactic Journal: Antibes Vert*
(aka School Colors #2), 2004

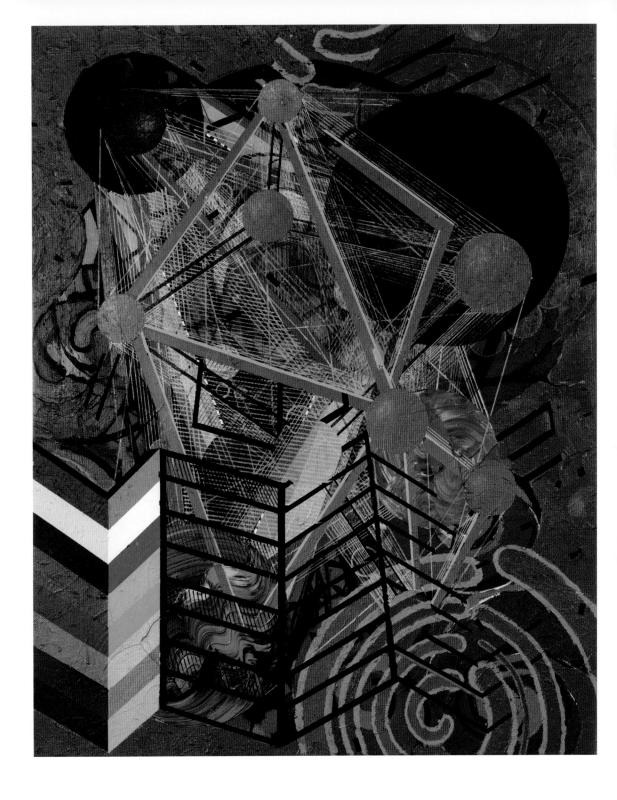

Kool & The Gang, *Spirit of the Boogie* (album cover
artwork by Diane Nelson and Frank Daniel), 1975

→
Place des Cinéastes, Ouagadougou, Burkina Faso,
designed by Ali Fao and Ignace Sawadogo, 1986–87

Hôtel du Lac, Tunis, Tunisia,
designed by Raffaele Contigiani, 1970–73

238

239 LIBERATION: DREAMS OF FREEDOM

Radcliffe Bailey, *Between Sea and Space*, 2019

Lonnie Liston Smith & The Cosmic Echoes, *Expansions*
(album cover artwork by Jack Martin), 1974

LIBERATION : DREAMS OF FREEDOM

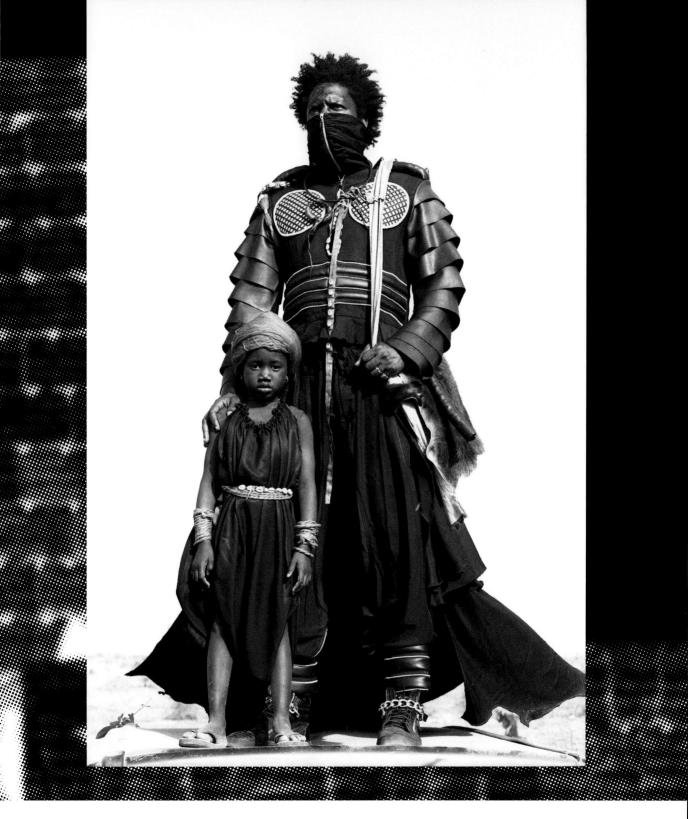

Fabrice Monteiro, *Untitled #6* (from *The Missing Link* series), 2014 **243** LIBERATION : DREAMS OF FREEDOM

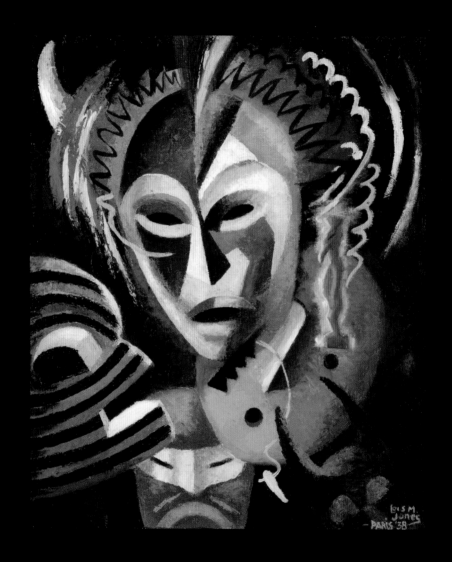

Loïs Mailou Jones, *Les Fétiches*, 1938

Erykah Badu, *New Amerykah Part Two (Return of the Ankh)*
(album cover artwork by Emek), 2010

245

Fabrice Monteiro, *Untitled #3* (from *The Missing Link* series), 2014 **246** PART 3

Afrofutures: Africa and the Aesthetics of Black Revolution

Tobias Wofford

Third Text, vol. 31, no. 5–6, 2017, pp. 633–49
[extract: pp. 634–41]

African American relations to Africa – as diasporic relations to a site of origin – are structured by a complex temporality. Invocations of Africa in contemporary African American art often suggest a concern with the past – part of a project of recovering black histories that has dominated black diasporic thinking during the twentieth century in what Kodwo Eshun described as 'an urgent need to demonstrate a substantive historical presence'.[1] Certainly, Africa has been a key point of inquiry in black artistic strategies that seek to mine the past and expose the workings of historical discourses that deny black roles in history.[2] However, in the diasporic logics of African American art, Africa can function not only as a means to stake black presence in the past, it can also function as a means to assert black presence in the future, offering aesthetic form through which to project the possibility of radical black futures.

Consider, for example, the underlying visual inspirations of the avant-garde musician Sun Ra and his Arkestra.[3] While Sun Ra's outlandish persona and spacey sounds were built on the artist's personal mythology of having originated in outer space, his visual persona – and indeed his name – borrows heavily from ancient Egyptian and contemporary Pan-African sources. Thus, Sun Ra's relationship to Africa is situated on a very different temporal continuum from that which mere history can reflect. Such is made strikingly clear in the 1972 [sic] film *Space is the Place*, starring Sun Ra and directed by John Coney. In the film, as in life, Sun Ra is figured as a visitor from outer space come to spread

peace and redemption for black people. Yet Africa is central to the visual and rhetorical strategies through which he and his Arkestra realise their other-worldly look, achieved through an invocation of Ancient Egypt, pairing his futuristic space machine with ancient Egyptian-inspired divinities and costumes.

In this way, Sun Ra achieves a blurring of time that is perhaps best analysed through the lens of the African diaspora. For, in the diaspora, time can be a tricky thing, often confounding the notion of the linear march into the future so key to Western conceptions of time. James Clifford suggested as much when he described one recurring aspect of diaspora's temporality:

> In diaspora experience, the copresence of 'here' and 'there' is articulated with an antiteleological (sometimes messianic) temporality. Linear history is broken, the present constantly shadowed by a past that is also a desired, but obstructed, future: a renewed, painful yearning.[4]

1 Kodwo Eshun, 'Further Considerations [on] Afrofuturism', *CR: The New Centennial Review*, vol. 3, no. 2, summer 2003, p. 287.

2 Think, for example, of the artistic interventions by Fred Wilson, such as his *Grey Area* (1993), which challenged the whitewashing of Egyptian history, staking a claim for black presence in its monumental past. This was a corrective to the notion of the continent put forward by Hegel of a pre-colonial Africa as ahistorical, with a summation of Africa as 'no historical part of the world; it has no movement or development in it – that is in its northern part – belong to the Asiatic or European World'. Georg W. F. Hegel, *The Philosophy of History*, J. Sibree, trans., Prometheus Books, Buffalo, New York, 1991, p. 99.

3 While I describe his music as 'avant-garde', Sun Ra didn't embrace the term. In an interview, he said, 'Well, it's more than avant-garde, because the "avant-garde" refers to, I suppose, advanced earth music, but this is *not* earth music.' Sun Ra, quoted in John Corbett, 'Sun Ra: Gravity and Levity', in *Extended Play: Sounding Off from John Cage to Dr. Funkenstein*, Duke University Press, Durham, North Carolina [1994], p. 311.

4 James Clifford, 'Diasporas', *Cultural Anthropology*, vol. 9, no. 3, August 1994, p. 318.

Sun Ra's film is nothing if not messianic in its structure, ending with the destruction of Earth after Sun Ra rescues the black people of Oakland in a scene that mirrors the film's opening sequence. The film's sci-fi blending of temporal registers embodies just the sort of time-play to which Clifford alludes.

Writers and critics have (aptly) framed Sun Ra's work as an early example of Afro-Futurism.[5] The term has been employed by a number of cultural theorists interested in the question of black futurity. Alondra Nelson defined the concept as 'African American voices' with 'other stories to tell about culture, technology and things to come'.[6] Emerging in the 1990s, the term Afrofuturism has been most intensely theorised through the discourses of black positions within science fiction and the technology boom of the last few decades.[7]

Yet, the invocation of Africa-as-future at the root of Afrofuturism reflects a broader phenomenon in African American culture, seen not only in the essential role of science fiction and technology for black artists like Sun Ra, but also in myriad other ways in which black subjects have imagined black presence in radically different futures. After all, Sun Ra was not alone in the 1960s and 1970s in engaging with radical imaginings of the future, nor was he alone in using Africa as a means through which to give such imaginings form. In politics and in culture, black revolutionaries in the United States were working to reframe and reimagine their

black communities and destinies (what Sun Ra often referred to as alter-destinies).

AfriCOBRA was one such group, its formation deeply rooted in the revolutionary rhetoric of Black Nationalism of the 1960s and 1970s. Short for 'the African Commune of Bad Relevant Artists', AfriCOBRA was founded in 1969 [*sic*] by artists who sought to develop a black aesthetic that was radically different from the American mainstream.[8] 'We need a new aesthetics,' founding member Jeff Donaldson wrote in his 1971 essay entitled 'The Role We Want for Black Art'.[9] Donaldson and AfriCOBRA's members worked as a black avant-garde, carefully and purposefully developing an art that was both socially efficacious and forward-looking. As he wrote in the AfriCOBRA manifesto, '10 in Search of a Nation':

5 John Corbett, Anthony Elms and Terri Kapsalis, *Pathways to Unknown Worlds: Sun-Ra, El Saturn and Chicago's Afro-futurist Underground*, White Walls, Chicago, Illinois, 2006.

6 Alondra Nelson, 'Introduction: Future Texts', in 'Afrofuturism', Alondra Nelson, ed., special issue, *Social Text*, vol. 71, summer 2002, p. 9.

7 Nelson noted that the term was coined by Mark Dery in 1993. Nelson, 'Introduction: Future

Texts', op. cit., p. 14. See also 'Black to the Future: Interviews with Samuel Delaney, Greg Tate, and Tricia Rose', in Mark Dery, ed., *Flame Wars: The Discourse of [Cyberculture]*, Duke University Press, Durham, North Carolina, 1994, pp. 179–222.

8 By the time of the 1970 group exhibition at the Studio Museum in Harlem, *AfriCOBRA I: Ten in Search of a Nation*, the group included the following ten members: Donaldson, Jae Jarrell, Wadsworth Jarrell, Barbara

J. Jones, Carolyn Lawrence, Nelson Stevens, Gerald Williams, Omar Lama, Sherman Beck and Napoleon Jones-Henderson. Jeff R. Donaldson, 'Ten in Search of a Nation', *Black World*, October 1970, pp. 80–89.

9 Jeff R. Donaldson, 'The Role We Want for Black Art', in Tom Lloyd, ed., *Black Art Notes*, 1971.

It is our hope that intelligent definition of the past, and perceptive identification in the present will project nation-full direction in the future – look for us there, because that's where we're at.[10]

Just as Sun Ra's Afrofuturism used Africa as a means to project a future, the Black Nationalist aesthetic favoured by AfriCOBRA in its early days used Africa as a touchstone for articulating a revolutionary and future-looking art movement, one that imagined a radically different future for people of African descent during the Black Arts Movement. While discussions of 'Afrofuturism' often focus on fantasy and science fiction, the political and rhetorical work of revolution requires a similar kind of conceptual reimagining of the world and its potential futures. Black Nationalism was certainly revolutionary in its rhetoric, and was particularly Afro-futuristic when it was given form through Africa. In the work of Jeff Donaldson and the other artists of AfriCOBRA, the invocation of Africa expresses not only a connection to the African past, but (most importantly) it mobilises Africa as a means to imagine a future and a mode of living in the diaspora.

The Revolutionary Aesthetics of AfriCOBRA

AfriCOBRA began in the crucible of cultural and political turmoil in the United States during the 1960s.[11] Like other artists of the Black Arts Movement, AfriCOBRA artists adopted the revolutionary rhetoric of Black Nationalism. Larry Neal referred to black art as the 'aesthetic and spiritual sister of the Black Power Concept'.[12] And, in this sense, AfriCOBRA was an aesthetic parallel to groups such as the Black Panther Party. AfriCOBRA artist statements and the catalogues that accompanied their exhibitions read like manifestoes aimed at the advancement of black art and culture. They explicitly rejected what they felt was a general push to change their art in order to be accepted into major mainstream art institutions.[13] 'It's NATION TIME and we are searching', proclaimed Donaldson in his article for *Black World*. He expressed what he meant by community – African people conceived of in the broadest sense.

10 Donaldson, 'Ten in Search of a Nation', op. cit., pp. 80–89 [pp. 82–83].

11 Lisa Gail Collins and Margo Natalie Crawford, 'Power to the People! The Art of Black Power', in Lisa Gail Collins and Margo Natalie Crawford, eds., *New Thoughts on the Black Arts Movement*, Rutgers University Press, New Brunswick, New Jersey [2006], pp. 1–19.

12 Larry Neal, 'The Black Arts Movement', *The Drama Review: TDR*, vol. 12, no. 4, summer 1968, p. 29.

13 Alice Thorson, 'AfriCobra – Then and Now: An Interview with Jeff Donaldson', *New Art Examiner*, March 1990, p. 28.

Our guidelines are our people – the whole family of
African People, the African family tree. And in this
spirit of familyhood, we have carefully examined
our roots and searched our branches for those
visual qualities that are most expressive of our
people/art.[14]

[...] As much as AfriCOBRA was dedicated to the
concept of nation-building, it maintained the artistic
mission of establishing and exercising an effective
group aesthetic as its foremost priority. Through
meetings and group critiques, its members sought to
elaborate a complex and extensive set of guidelines
through which they could express their version of a
black aesthetic.[15] [...] But the core aspect of AfriCOBRA's
revolutionary aesthetic was a turn to Africa. The group
deliberately chose particular aspects of their practice
that would reflect their African roots and express the
political circumstances in which they were working.
According to Donaldson's 1973 artist statement in
their group show at the University of Massachusetts,
Amherst, entitled 'AFRI-COBRA III', this included
'the *expressive awesomeness* that one experiences in
African Art and life in the USA ... the *symmetry* that
is *free*, repetition with change, based on African music
and African movement'.[16]

14 Donaldson, 'Ten in Search of a
Nation', op. cit., p. 82, emphasis
in the original.

[15] Indeed, the core of AfriCOBRA
meetings involved critiquing
members' work. See 'Meeting
Minutes', Box 4, 'Africobra Meetings'

folder, Jeff Donaldson Papers, circa
1960–2005, Archives of American
Art, Smithsonian Institution.

[16] This statement shares much
of the language of Donaldson's
1970 '[Ten] in Search of a Nation'.
See University Art Gallery,

AFRI-COBRA III, University
of Massachusetts at Amherst,
Amherst, MA, 1973, no pagination,
emphasis in the original.

PAGES 248–57:
Computer render of Memorial Thomas Sankara, Ouagadougou,
Burkina Faso, designed by Kéré Architecture, 2017–ongoing

258

Gustavo Nazareno, *The Birth of Exu*, 2020

Black Panther, dir. Ryan Coogler (still), 2018

LIBERATION : DREAMS OF FREEDOM

FIDAK (Foire Internationale de Dakar),
Dakar, Senegal, designed by Jean François
Lamoureux and Jean-Louis Marin, 1971–74
(photograph by Iwan Baan)

Afrika Bambaataa & Soul Sonic Force, *Renegades of Funk!*
(single cover artwork by Bob Camp), 1983

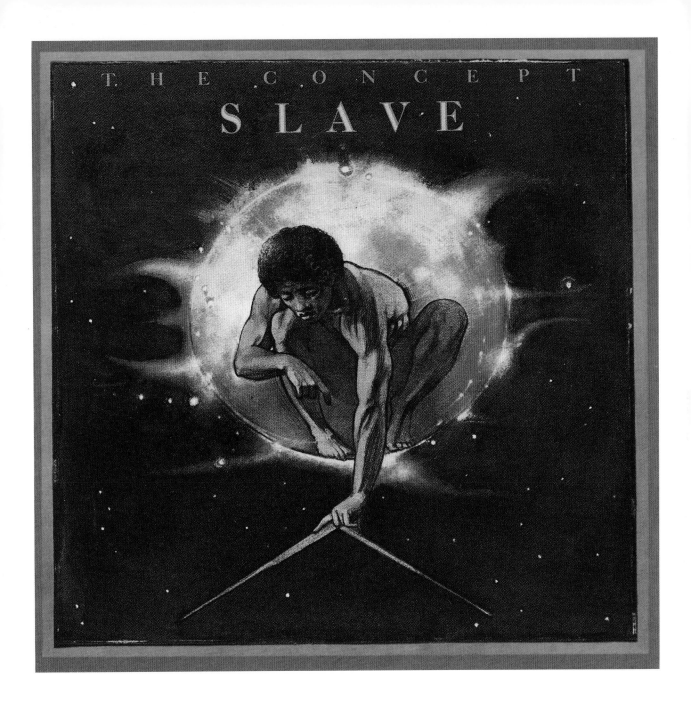

Slave, *The Concept* (album cover illustration
by Daniel Maffia, concept by Jeff Dixon and
Stephen Washington, design by Lynn Dreese
Breslin), 1978

LIBERATION : DREAMS OF FREEDOM

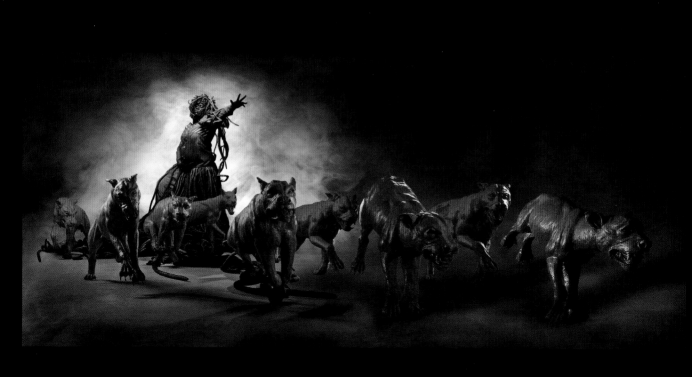

Mary Sibande, *Right Now!*, 2015
Ishmael Reed, *Mumbo Jumbo* (book cover artwork
by Ishmael Reed, 1972), this edition 2017

→
Juliana Huxtable, *Untitled in the Rage
(Nibiru Cataclysm)*, 2015

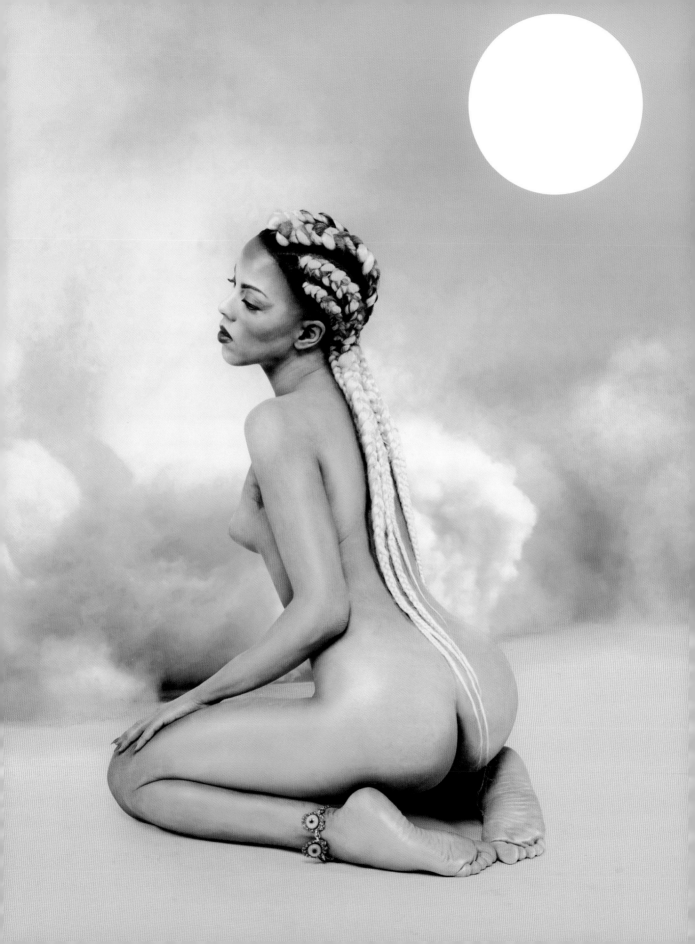

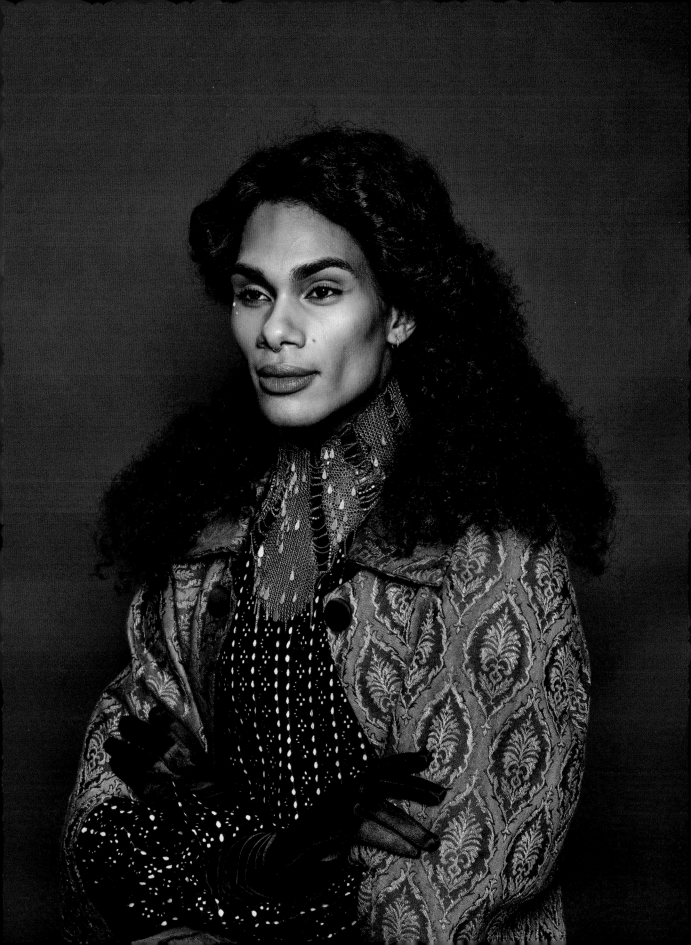

2019

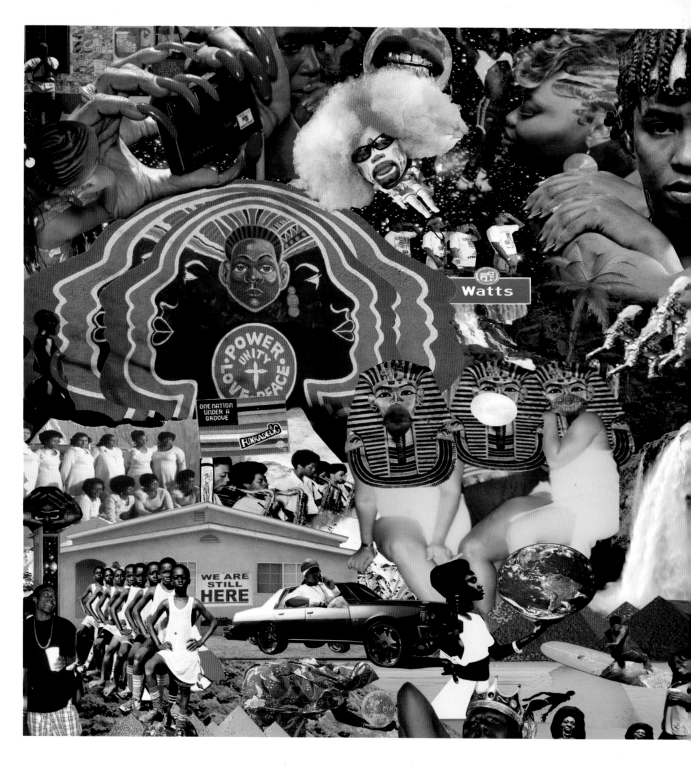

Lauren Halsey, *thang*, 2020

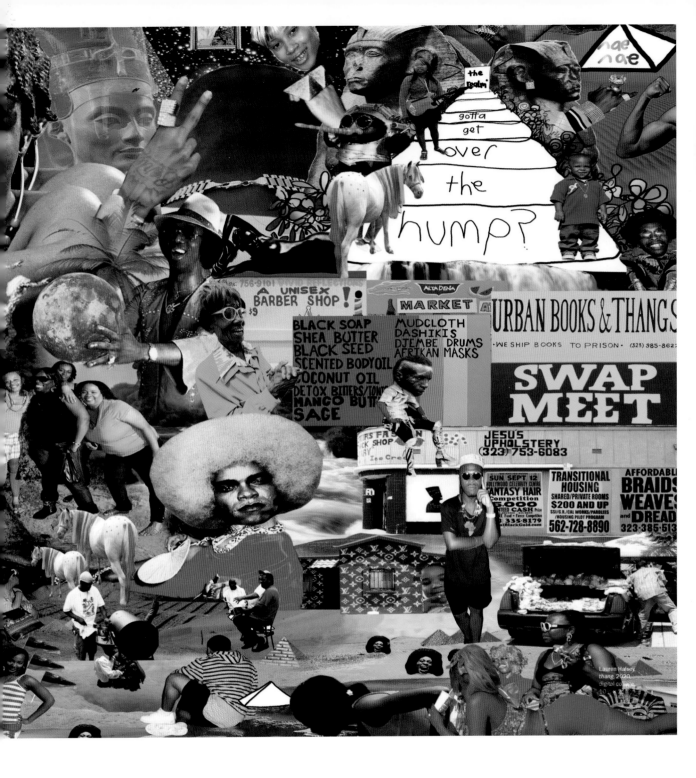

Lauren Halsey,
thang, 2020,
digital collage,
10...

Weldon Irvine, *Cosmic Vortex (Justice Divine)*
(album cover artwork by Dennis Pohl), 1974

→
Black Is King, dir. Beyoncé (stills), 2020

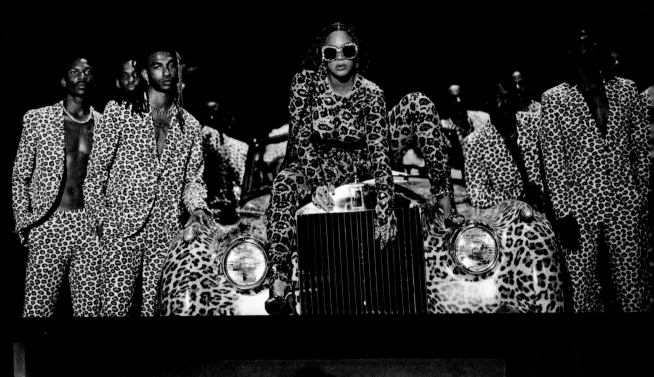

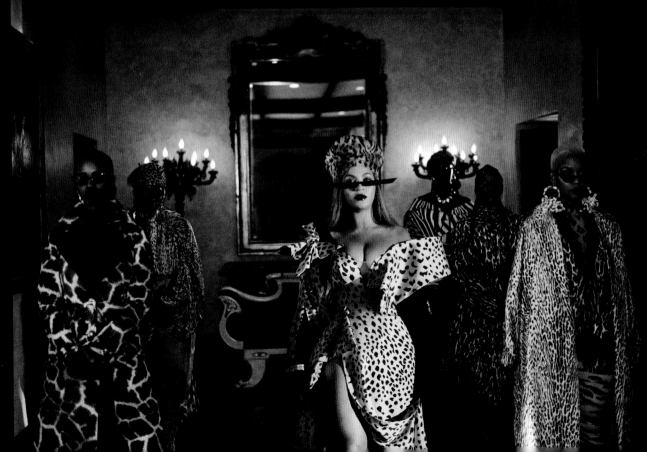

Kristin-Lee Moolman (stylist Ibrahim Kamara), in
'The Earthwise Issue', *i-D* magazine, no. 353, Fall 2018

↑ →

Madvillain, *Madvillainy* (album cover
photograph by Eric Coleman), 2004

LIBERATION: DREAMS OF FREEDOM

Umar Rashid (Frohawk Two Feathers), *New Axumite Stele, or, The Death of Ricky I of the Axumite Kingdom of Crenshaw. Codex of correlation between heat and sudden hood death syndrome. Try not to die if you can.*, 2018

Flying Lotus, *Flamagra* (album cover
artwork by Winston Hacking), 2019

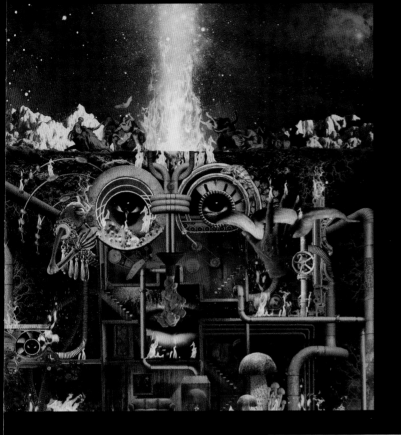

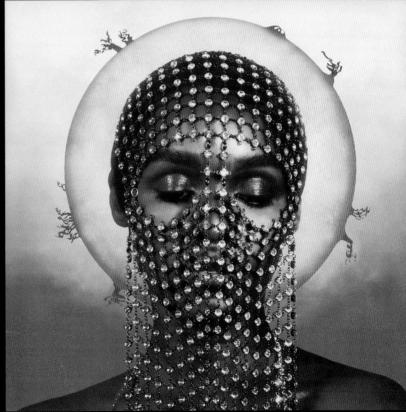

Janelle Monáe, *Dirty Computer* (album cover design concept by Joe Perez), 2018

LIBERATION: DREAMS OF FREEDOM

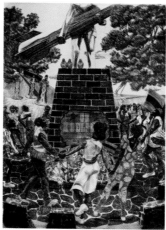
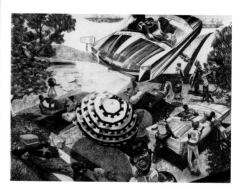

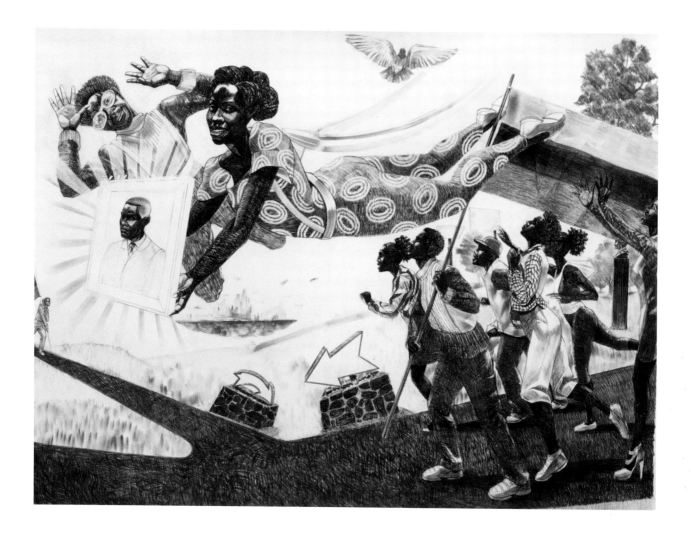

Kerry James Marshall, *Studies for Untitled Black Empire Suite*
(triptych and detail), 2015

PART 3

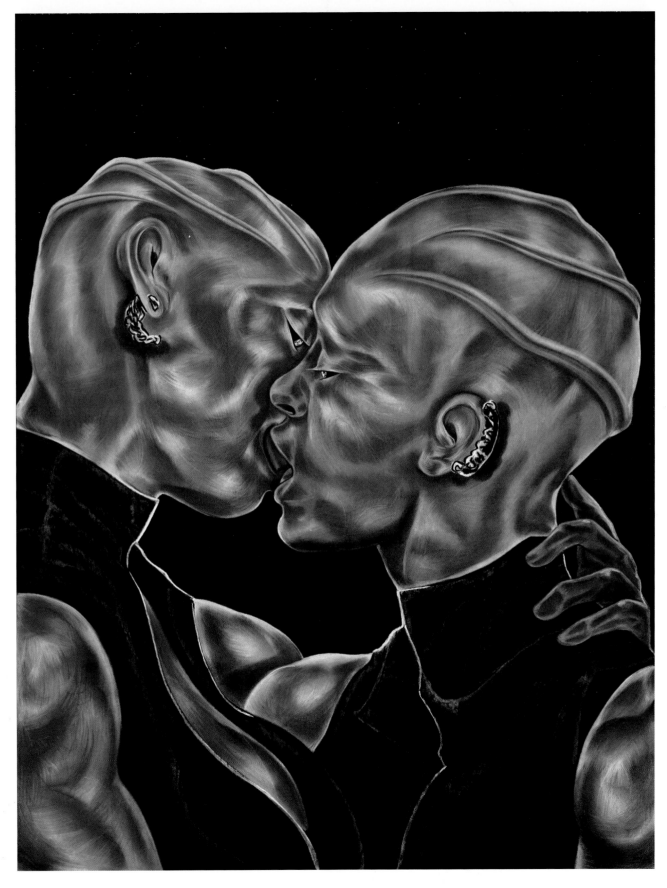

Toyin Ojih Odutola, *A Parting Gift; Hers and Hers, Only*, 2019 **283** LIBERATION: DREAMS OF FREEDOM

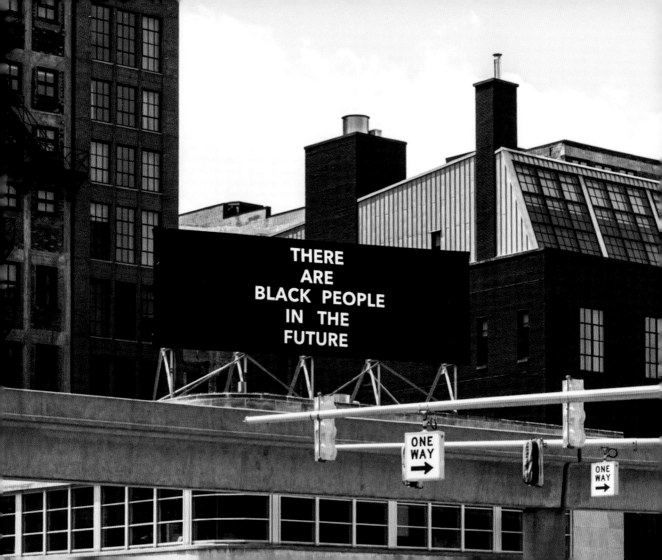

NOTES

INTRODUCTION

1. Simon Schama, 'Simon Schama's Power of Art', BBC television series (Simon Schama, *The Power of Art*, BBC Books), 2006.
2. Derek Walcott, 'The Sea is History', in *Collected Poems 1948–1984* (Faber & Faber, 1992), pp. 364–67.
3. '"I wanted to carve out a world both culture specific and race-free": an essay by Toni Morrison', *The Guardian*, 8 August 2019: https://www.theguardian.com/books/2019/aug/08/toni-morrison-rememory-essay (accessed 5 May 2021).
4. Ibid.
5. Toni Morrison, *Beloved* (Vintage International, 2004), foreword, p. 17.
6. The term 'Black fantastic' has been previously used, with a different meaning, by Richard Iton in *In Search of the Black Fantastic: Politics and Popular Culture in the Post-Civil Rights Era* (Oxford University Press, 2010).
7. Marek Oziewicz, 'Speculative Fiction', Oxford Research Encyclopedias, 29 March 2017: https://doi.org/10.1093/acrefore/9780190201098.013.78 (accessed 17 April 2020).
8. Rosemary Jackson, *Fantasy: The Literature of Subversion* (Routledge, 1981), p. 17.
9. In Ronald Kuykendall, 'Hegel and Africa: An Evaluation of the Treatment of Africa in The Philosophy of History', *Journal of Black Studies* 23 (4), 1993: 571–81.
10. Charles W. Mills, 'Black Radical Kantianism', *Res Philosophica* 95 (1), 2018: 1–33 (13). See also Pauline Kleingeld, 'Kant's Second Thoughts on Race', *The Philosophical Quarterly* 57 (229), 2007: 573–92.
11. In Louis Menand, 'Morton, Agassiz, and the Origins of Scientific Racism in the United States', *The Journal of Blacks in Higher Education* 34, 2001: 110–13 (112).
12. W. E. B. Du Bois, 'Strivings of the Negro People', *The Atlantic*, August 1897: https://www.theatlantic.com/magazine/archive/1897/08/strivings-of-the-negro-people/305446/ (accessed 7 June 2021).
13. Jayna Brown, *Black Utopias: Speculative Life and the Music of Other Worlds* (Duke University Press, 2021), p. 7.
14. Marek Oziewicz (2017).
15. Tabita Rezaire Portfolio, Goodman Gallery, 2020.
16. Brenda Cooper, *Magical Realism in West African Fiction* (Routledge, 2004), p. 1.
17. See Maria Takolander, 'Magical realism and irony's "edge": Rereading magical realism and Kim Scott's *Benang*', *Journal of the Association for the Study of Australian Literature* 14 (5), 2014: 1–11.
18. Mark Dery, 'Black to the Future: Interviews with Samuel R. Delany, Greg Tate, and Tricia Rose', in Dery (ed.), *Flame Wars: The Discourse of Cyberculture* (Duke University Press, 1994), p. 180.
19. Kodwo Eshun, *More Brilliant Than the Sun: Adventures in Sonic Fiction* (Quartet Books, 1998).
20. Martine Syms, 'The Mundane Afrofuturist Manifesto', Rhizome, 17 December 2013: https://rhizome.org/editorial/2013/dec/17/mundane-afrofuturist-manifesto/ (accessed 2 February 2020).
21. Hope Wabuke, 'Afrofuturism, Africanfuturism, and the Language of Black Speculative Literature', *Los Angeles Review of Books*, 27 August 2020: https://lareviewofbooks.org/article/afrofuturism-africanfuturism-and-the-language-of-black-speculative-literature/ (accessed 25 May 2021).
22. Homer, *The Odyssey*, translation by Emily Wilson (W. W. Norton & Company, 2018).
23. Derek Walcott, *Omeros* (Faber & Faber, 1990), p. 149.
24. See Mary Louise Pratt, 'Arts of the Contact Zone', *Profession*, 1991: 33–40.
25. Michelle D. Commander, *Afro-Atlantic Flight: Speculative Returns and the Black Fantastic* (Duke University Press, 2017), p. 24.
26. Elizabeth Alexander, *The Black Interior: Essays* (Graywolf Press, 2004), p. x.
27. Exhibition text, *Afro-Atlantic Histories*, Museu de Arte de São Paulo Assis Chateaubriand, 2018: https://masp.org.br/en/exhibitions/afro-atlantic-histories (accessed 4 April 2021).
28. In Farah Jasmine Griffin, 'On Time, In Time, Through Time: Aaron Douglas, Fire!! and the Writers of the Harlem Renaissance', *American Studies* 49 (1/2), 2008: 45–53 (46–47).
29. See Cynthia Moody, 'Midonz', *Transition* 77 (1998): 10–18.
30. Robin D. G. Kelley, *Freedom Dreams: The Black Radical Imagination* (Beacon Press, 2003), p. 172.
31. Kobena Mercer, 'Cosmopolitan Contact Zones', in Tanya Barson (ed.), *Afro Modern: Journeys through the Black Atlantic* (Tate Publishing, 2010), p. 45.
32. Patricia Leighten, 'The White Peril and L'Art Nègre: Picasso, Primitivism, and Anticolonialism', *The Art Bulletin* 72 (4), 1990: 609–30 (610).
33. See Betty LaDuke, 'Lois Mailou Jones: The Grande Dame of African-American Art', *Woman's Art Journal* 8 (2), 1987: 28–32.
34. Ibid.
35. In Wendy Dutton, 'The Problem of Invisibility: Voodoo and Zora Neale Hurston', *Frontiers: A Journal of Women Studies* 13 (2), 1993: 131–52 (141–42).
36. Robin D. G. Kelley, 'A Poetics of Anticolonialism', *Monthly Review*, 1 November 1999: https://monthlyreview.org/1999/11/01/a-poetics-of-anticolonialism/ (accessed 17 May 2021).
37. Ibid.
38. The group was originally named COBRA (Coalition of Black Revolutionary Artists); it changed its name and definition in 1970.
39. Henry Louis Gates, 'Introduction: "Tell Me, Sir, ... What *Is* 'Black' Literature?"', *PMLA* 105 (1), 1990: 11–22 (20).
40. Barbara Jones-Hogu, 'The History, Philosophy and Aesthetics of AFRICOBRA', AREA Chicago, December 2008: https://areachicagoarchive.wordpress.com/2009/02/23/the-history-philosophy-and-aesthetics-of-africobra/ (accessed 2 May 2021).
41. Ibid.
42. George E. Lewis, 'Purposive Patterning: Jeff Donaldson, Muhal Richard Abrams, and the Multidominance of Consciousness', *Lenox Avenue: A Journal of Interarts Inquiry* 5, 1999: 63–69 (64).
43. Jeff R. Donaldson, 'AfriCOBRA Manifesto? "Ten in Search of a Nation"', *Nka: Journal of Contemporary African Art* 30, Spring 2012: 76–83 (80).
44. Ibid.: 81.
45. 'Lynching in America: Confronting the Legacy of Racial Terror', Equal Justice Initiative, 2017: https://eji.org/reports/lynching-in-america/ (accessed 10 May 2021).
46. Wallace Best, 'The Fear of Black Bodies in Motion', HuffPost, 3 February 2015: https://www.huffpost.com/entry/the-fear-of-black-bodies-in-motion_b_6268672 (accessed 15 May 2021).
47. Kimberly Lamm, '"The Will to Adorn": Nick Cave's Soundsuits and the Queer Reframing of Black Masculinity', *Critical Arts* 31 (30), 2017: 35–52 (41).
48. Lewis R. Gordon and Jane Anna Gordon, *Not Only the Master's Tools: African American Studies in Theory and Practice* (Routledge, 2016), p. 111.
49. Quoted in Lamm (2017): 40.
50. Raphael Chijioke Njoku, *West African Masking Traditions and Diaspora Masquerade Carnivals: History, Memory, and Transnationalism* (Boydell and Brewer, 2020), p. 7.
51. Indra Khanna, 'How Do You Want Me?', 2008, hewlocke.net (accessed 7 July 2021).
52. In Brian Wallis, 'The Sound of Defiance: How can listening to images reveal the visual histories of the African diaspora?', *Aperture*, 25 October 2017: https://aperture.org/editorial/tina-campt-conversation-brian-wallis/ (accessed 29 May 2021).
53. See Henry Louis Gates, 'The "Blackness of Blackness": A Critique of the Sign and the Signifying Monkey', *Critical Inquiry* 9 (4), 1983: 685–723.
54. Beckett Mufson, 'The Creator's Project: Stop Playing in Rashaad Newsome's Face: Studio Visits', De Buck Gallery: https://www.debuckgallery.com/stop-playing-rashaad-newsomes-face-studio-visits-creators-project/ (accessed 2 June 2021).
55. Exhibition statement, *To Be Real*, Fort Mason Center for Arts & Culture, 2020: https://fortmason.org/event/newsome/ (accessed 3 June 2021).
56. Samuel R. Delany, *Aye, and Gomorrah: And Other Stories* (Vintage Books, 2003).
57. José Esteban Muñoz, *Cruising Utopia: The Then and There of Queer Futurity* (New York University Press, 2009), p. 1.
58. *Matthew Paris's English History: From the Year 1235 to 1273*, Vol. 1, trans. J. A. Giles (George Bell & Sons, 1889), p. 358. See also Andrew Fleck, 'Here, There, and In between: Representing Difference in the *Travels* of Sir John Mandeville', *Studies in Philology* 97 (4), 2000: 379–400.
59. Geraldine Heng, quoting Debra Strickland, *The Invention of Race in the European Middle Ages* (Cambridge University Press, 2018), p. 35.
60. This definition is drawn from 'Whiteness', https://nmaahc.si.edu/learn/talking-about-race/topics/whiteness (accessed 28 January 2022).
61. Asa Simon Mittman, 'Are the "monstrous

races" races?', *postmedieval: a journal of medieval cultural studies* 6 (1), Spring 2015: 36–51 (47).

62. See Josh Niland, 'Only in Dreams: Sedrick Chisom's lurid dreamscapes and the primacy of artistic imagination': matthewbrowngallery.com (accessed 20 December 2021).

63. Hilton Als, 'Hilton Als on the Films of Kara Walker', frieze.com, 26 September 2019: https://www.frieze.com/article/hilton-als-films-kara-walker (accessed 20 July 2021).

64. Kittredge Cherry, 'The Two Rebeccas: Queer black pair founded Shaker religious community in 1800s', QSpirit, 24 May 2021: https://qspirit.net/two-rebeccas-queer-black-shaker/ (accessed 6 July 2021).

65. Rebecca Cox Jackson, *Gifts of Power: The Writings of Rebecca Jackson, Black Visionary, Shaker Eldress*, ed. Jean McMahon Humez (University of Massachusetts Press, 1987).

66. Jayna Brown (2021), p. 12.

67. Ibid.

68. Fanta Sylla, 'Cauleen Smith: The Art of Giving', *Flash Art*, 13 January 2019: https://flash---art.com/article/the-art-of-giving/ (accessed 5 June 2021).

69. Franya J. Berkman, *Monument Eternal: The Music of Alice Coltrane* (Wesleyan University Press, 2010), p. 13.

70. Ibid., p. 14.

71. Quoted in Berkman (2010), pp. 13–14.

72. Christina Spicer, 'The Perpetual Paradox: A Look into Liberian Colonization', *The Corvette* 3 (2), 2015–16: 37. See also Naomi Anderson Whittaker, 'On Racialized Citizenship: The History of Black Colonialism in Liberia', CERS Working Paper, Centre for Ethnicity and Racism Studies, University of Leeds, April 2015.

73. See Donna Haraway, 'Anthropocene, Capitalocene, Plantationocene, Chthulucene: Making Kin', *Environmental Humanities* 6, 2015: 159–65.

INVOCATION

1. Gullah is also known as Geechee, or Sea Island Creole English.

2. Anne-Marie Paquet-Deyris, 'The Gullah Kaleidoscope, *Daughters of the Dust* (1991), by African American film director and writer Julie Dash', *Cercles* 15, 2006: 1–14 (3).

BLACK FEMINIST VOODOO AESTHETICS, CONJURE FEMINISM, AND THE ARTS

1. 'Asante Kingdom: Osei Tutu and Founding Of', in *Encyclopedia of African History* (Routledge, 2004).

2. Adisa A. Alkebulan, 'The Spiritual and Philosophical Foundation for African Languages', *Journal of Black Studies* 44 (1), 2013: 50–62 (55).

3. Ibid.: 56.

4. Robert Farris Thompson, *Flash of the Spirit: African & Afro-American Art & Philosophy* (Vintage, 1983), pp. 109–12.

5. Ibid., p. 109.

6. Sophia Nahli Allison, 'Revisiting the Legend of Flying Africans', *The New Yorker*, 7 March 2019: https://www.newyorker.com/culture/culture-desk/revisiting-the-legend-of-flying-africans (accessed 3 May 2021), and Timothy B. Powell, 'Ebos Landing', *New Georgia Encyclopedia*, 16 July 2020: https://www.georgiaencyclopedia.org/articles/

history-archaeology/ebos-landing (accessed 3 May 2021).

7. Joan Dayan, *Haiti, History, and the Gods* (University of California Press, 1995), p. 29, and David Patrick Geggus, *Haitian Revolutionary Studies* (Indiana University Press, 2002), p. 40.

8. Martha Ward, *Voodoo Queen: The Spirited Lives of Marie Laveau* (University Press of Mississippi, 2004), and Karla Gottlieb, *The Mother of Us All: A History of Queen Nanny, Leader of the Windward Jamaican Maroons* (Africa World Press, 2000).

9. Kinitra Brooks, Kameelah L. Martin and LaKisha Simmons, eds., 'Conjure Feminism: Tracing the Genealogy of Black Women's Intellectual Traditions', Special Issue of *Hypatia: Journal of Feminist Philosophy* 36 (3) (Summer 2021).

10. Kameelah L. Martin, *Conjuring Moments in African American Literature: Women, Spirit Work, and Other Such Hoodoo* (Palgrave McMillan, 2012), pp. 1–3.

11. Alice Walker, *In Search of Our Mothers' Gardens* (Harcourt, 1983), p. xi.

12. Valerie Lee, *Granny Midwives and Black Women Writers* (Routledge, 1996), p. 2.

13. Ibid., p. 13.

14. Marjorie Pryse and Hortense J. Spillers, *Conjuring: Black Women, Fiction, and Literary Tradition* (Indiana University Press, 1985), p. 5.

15. Zora Neale Hurston, *Tell My Horse: Voodoo and Life in Haiti and Jamaica* (first pub. 1938; HarperCollins, 1990), p. 113.

16. Riva Nyri Précil, 'Haitian Vodou', Virtual Guest Lecture, African American Studies Program/Globally Connected Courses, College of Charleston, 7 and 9 October 2020.

17. Pryse and Spillers (1985), p. 4.

18. Martin (2012), pp. 5–6.

19. Kameelah L. Martin, *Envisioning Black Feminist Voodoo Aesthetics: African Spirituality in American Cinema* (Routledge, 2016), p. xvi.

20. Pryse and Spillers (1985), p. 5.

21. Claudia Tate, *Black Women Writers at Work* (Continuum, 1983), p. 115.

22. Michelle Cliff, *Abeng: A Novel* (Crossing Press, 1984); Nalo Hopkinson, *The Salt Roads* (Grand Central Publishing, 2004); Tomi Adeyemi, *Children of Blood and Bone* (Henry Holt and Company, 2018); Afia Atakora, *Conjure Women: A Novel* (4th Estate, 2020).

23. Lee (1996), p. 4.

24. Ntozake Shange, *Sassafrass, Cypress and Indigo* (St Martin's Press, 1982), p. 223.

25. Joanna Dee Das, *Katherine Dunham: Dance and the African Diaspora* (Oxford University Press, 2017), and Katherine Dunham, *Island Possessed* (University of Chicago Press, 1994).

26. Kara Walker, *Keys to the Coop* (Art Institute of Chicago, 1997), and *Kara Walker: My Complement, My Enemy, My Oppressor, My Love* (Walker Art Center, 2007).

27. Riva Nyri Précil, 'Nan Dòmi', CD Baby Pro, 17 July 2015: https://youtu.be/F1mtEwxe2Hk (accessed 3 May 2021).

28. Julie Dash, Toni Cade Bambara, and bell hooks, *Daughters of the Dust: The Making of an African American Woman's Film* (New Press, 1992).

29. Ibid., and Martin (2016), pp. 75–112.

30. Jessica B. Harris, *High on the Hog: A Culinary Journey from Africa to America* (Bloomsbury, 2012), and Psyche A. Williams-Forson, *Building Houses Out of Chicken Legs: Black Women, Food, and Power* (University of North Carolina Press, 2006).

31. Martin (2016), pp. 75–113.

32. Kinitra D. Brooks and Kameelah L. Martin, '"I Used to be Your Sweet Mama": Beyoncé at the Crossroads of Blues and Conjure in *Lemonade*', in Brooks and Martin (eds.), *The Lemonade Reader* (Routledge, 2019), pp. 202–14.

33. Gary Edwards and John Mason, *Black Gods: Òrìṣà Studies in the New World* (Yoruba Theological Archministry, 1998).

34. Patricia Coloma Peñate, 'Beyoncé's Diaspora Heritage and Ancestry in *Lemonade*', in Brooks and Martin (eds.), *The Lemonade Reader* (2019), pp. 111–22.

35. Chris Robichaud, 'Beyoncé's *Lemonade*', Episode 34, *This Week in Dystopia* podcast, 21 May 2019: https://this-week-in-dystopia.simplecast.com/episodes/6d1958ef (accessed 25 May 2021).

36. Henry Louis Gates, Jr., *The Signifying Monkey: A Theory of Afro-American Literary Criticism* (Oxford University Press, 1988).

37. Edward Kamau Brathwaite, *History of the Voice: The Development of Nation Language in Anglophone Caribbean Poetry* (New Beacon Books, 1984).

38. Ibid., p. 311.

39. Blue Telusma, 'Beyoncé's "Lemonade" is the love letter to black women we've been thirsting for', TheGrio, 24 April 2016: https://thegrio.com/2016/04/24/beyonces-lemonade-is-the-love-letter-to-black-women-weve-been-thirsting-for/ (accessed 25 May 2021).

40. Brathwaite (1984), p. 312.

MIGRATION

1. Namwali Serpell, 'The Zambian "Afronaut" Who Wanted to Join the Space Race', *The New Yorker*, 11 March 2017: https://www.newyorker.com/culture/culture-desk/the-zambian-afronaut-who-wanted-to-join-the-space-race (accessed 7 May 2021).

2. Edward Mukuka [Makuka] Nkoloso, 'We're going to Mars! With a Spacegirl, Two Cats and a Missionary', in 'Zambia's forgotten Space Program', *Lusaka Times*, 28 January 2011: https://www.lusakatimes.com/2011/01/28/space-program/ (accessed 7 July 2021).

3. Serpell (2017).

4. Ibid.

5. See Flavia Ferrucci, 'Afronauts – Zambia's Space Program', Good Short Films, 2014: http://www.goodshortfilms.it/en/articles/afronauts-il-programma-spaziale-dello-zambia (accessed 6 May 2021).

6. See Kodwo Eshun, 'Further Considerations on Afrofuturism', *CR: The New Centennial Review* 3 (2), Summer 2003: 287–302.

7. Ibid.

8. Paul Gilroy, *The Black Atlantic: Modernity and Double Consciousness* (Verso Books, 1993), p. 16.

9. Ibid., p. 40.

10. 'Tavares Strachan', Marian Goodman Gallery: https://www.mariangoodman.com/artists/tavares-strachan/ (accessed 1 May 2021).

11. Zoë Lescaze, 'The Artist Whose Medium is Science', *The New York Times Style Magazine*, 20 September 2020: https://www.nytimes.com/2020/09/16/t-magazine/tavares-strachan.html (accessed 5 June 2021).

12. Artist statement, 'Relic Traveller: Phase 1', 2017: https://www.larryachiampong.co.uk/projects/relic-traveller-phase-1 (accessed 1 April 2021).

IN POPULATED AIR: FLYING AFRICANS, TECHNOLOGY, AND THE FUTURE

1. Lucille Clifton, extract from 'in populated air', in *Two-Headed Woman* (University of Massachusetts Press, 1980).
2. Olaudah Equiano, *The Interesting Narrative of the Life of Olaudah Equiano, or Gustavus Vassa, the African* (first pub. 1789; Modern Library, 2004), pp. 78–79.
3. Quoted in Daniel P. Mannix and Malcolm Cowley, *Black Cargoes: A History of the Atlantic Slave Trade, 1518–1865* (Viking, 1962), p. 118.
4. United States, Work Projects Administration: *Drums and Shadows: Survival Studies Among the Georgia Coastal Negroes* (University of Georgia Press, 1940), p. 18. In recent years, scholars have questioned the accuracy of the Black dialect that the WPA researchers captured in their transcripts. Debates abound regarding whether the interviewers had intentionally framed the interviewees as ignorant and socially backward, thus falling into unfortunate racial stereotypes.
5. Andrew Pearse, *The Big Drum Dance of Carriacou* (recording insert), Ethnic Folkways Library, Album No. FE 4011.B5, 1956.
6. Frederick Douglass, *Narrative of the Life of Frederick Douglass, An American Slave* (first pub. 1845; Modern Library, 2000), p. 91.
7. Ibid., p. 95.
8. Kofi Anyidoho, *Ancestrallogic & Caribbeanblues* (Africa World Press, 1992), p. xii.
9. Ibid., p. xi.
10. Ibid., pp. 16–17.
11. Dionne Brand, *A Map to the Door of No Return: Notes to Belonging* (Doubleday Canada, 2001), p. 195.
12. Leslie Alexander Lacy, *The Rise and Fall of a Proper Negro* (Macmillan, 1970), p. 110.
13. Haile Gerima and Pamela Woolford, 'Filming Slavery', *Transition* 64 (1994): 90–104 (92).
14. Amiri Baraka, 'Technology & Ethos', in *Kawaida Studies: The New Nationalism* (Third World Press, 1972), pp. 30–32.
15. Ibid., p. 32.
16. Jennine Scarboro, 'Interview with David Huffman', *Noah Becker's Whitehot Magazine of Contemporary Art*, August 2009: https://whitehotmagazine.com/articles/2009-interview-with-david-huffman/1918 (accessed 2 May 2021).

LIBERATION

1. Artist statement: https://alishabwormsley.com/#/there-are-black-people-in-the-future/ (accessed 25 May 2021).
2. 'Alisha B. Wormsley', Times Square Arts: http://arts.timessquarenyc.org/times-square-arts/artists/alisha-b-wormsley/index.aspx (accessed 25 May 2021).
3. Gregory E. Rutledge, 'Futurist Fiction & Fantasy: The "Racial" Establishment', *Callaloo* 24 (1), 2001: 236–52 (236).
4. Samuel R. Delany, *Starboard Wine: More Notes on the Language of Science Fiction* (Wesleyan University Press, 2012), p. 14.
5. Samuel Goff, 'Building Blocs: How Ghana's architecture was reimagined with a little help from communist Europe', *The Calvert Journal*, 4 February 2016: https://www.calvertjournal.com/features/show/5407/red-africa-ghana-architecture-communist-europe (accessed 20 May 2021).
6. Marithé Van der Aa, 'Improvised Music – an Act of Racial Liberation?', *The Attic*, 4 September 2020: https://theatticmag.com/features/2364/improvised-music---an-act-of-racial-liberation%3F.html (accessed 17 May 2021).
7. The name Azania originally emerged in the Greco-Roman world in reference to the semi-mythical lands of East Africa.
8. Kristen Lillvis, *Posthuman Blackness and the Black Female Imagination* (University of Georgia Press, 2017), p. 8.

FILM, MUSIC AND READING LISTS

WATCH LIST

Africa Paradise, dir. Sylvestre Amoussou, 2006
Afro Punk Girl, dir. Annetta Laufer, 2016
Afro Samurai: Resurrection, dir. Fuminori Kizaki, 2009
Afronauts, dir. Nuotama Frances Bodomo, 2014
Alive in Joburg, dir. Neill Blomkamp, 2005
Allumuah, dir. Curtis Essel, 2020
An Ecstatic Experience, dir. Ja'Tovia Gary, 2015
An Oversimplification of her Beauty, dir. Terence Nance, 2012
As Told To G/D Thyself, dir. The Ummah Chroma, 2019
Atlanta (TV series), dir. Hiro Murai et al., 2016
Atlantics, dir. Mati Diop, 2019
Beloved, dir. Jonathan Demme, 1998
between a whisper and a cry, dir. Alberta Whittle, 2019
Black Box, dir. Emmanuel Osei-Kuffour Jr., 2020
Black Dynamite (TV series), dir. Carl Jones et al., 2011–15
Black Is King, dir. Beyoncé, 2020
Black Lightning (TV series), dir. Salim Akil, 2017–21
Black Orpheus, dir. Marcel Camus, 1959
Black Panther, dir. Ryan Coogler, 2018
Black Panther: Wakanda Forever, dir. Ryan Coogler, 2022
Blackenstein, dir. William A. Levey, 1974
Blacula, dir. William Crain, 1972
BLKNWS, dir. Kahlil Joseph, 2019
Bones, dir. Ernest R. Dickerson, 2001
Born in Flames, dir. Lizzie Borden, 1983
Brown Girl Begins, dir. Sharon Lewis, 2017
Busta Rhymes, 'Gimme Some More', dir. Hype Williams, 1998
Busta Rhymes, 'Put Your Hands Where My Eyes Could See', dir. Hype Williams, 1997
Busta Rhymes, feat. Janet Jackson, 'What's It Gonna Be?!', dir. Hype Williams, 1999
Cosmic Slop, dir. Reginald Hudlin et al., 1994
Crumbs, dir. Miguel Llansó, 2015
Dark Matters, dir. Monique Walton, 2010
Daughters of the Dust, dir. Julie Dash, 1991
Diasporadical Trilogía, dir. Blitz Bazawule, 2017
Dirty Computer, dir. Andrew Donoho and Chuck Lightning, 2018
District 9, dir. Neill Blomkamp, 2009
Don't Let Go, dir. Jacob Aaron Estes, 2019
Dr Black, Mr Hyde, dir. William Crain, 1976
Eve's Bayou, dir. Kasi Lemmons, 1997
Flying Lotus: Until the Quiet Comes, dir. Kahlil Joseph, 2013
Ganja & Hess, dir. Bill Gunn, 1973
Get Out, dir. Jordan Peele, 2017
Ghost Dog: The Way of the Samurai, dir. Jim Jarmusch, 1999
Hasaki Ya Suda, dir. Cédric Ido, 2011
Hello Rain, dir. C. J. Obasi, 2018
Here is the Imagination of the Black Radical, dir. Rhea Storr, 2020
His House, dir. Remi Weekes, 2020
Horror Noire: A History of Black Horror, dir. Xavier Burgin, 2019
Hydra Decapita, dir. The Otolith Group, 2010
I Snuck Off the Slave Ship, dir. Cyrus Moussavi and Lonnie Holley, 2019
In the Year of the Quiet Sun, dir. The Otolith Group, 2013
JAY-Z, '4:44', dir. Arthur Jafa, 2017
Jonah, dir. Kibwe Tavares, 2013
Kati Kati, dir. Mbithi Masya, 2016
Kindred, dir. Joe Marcantonio, 2020
Kuso, dir. Flying Lotus, 2017
Leave the Edges, dir. Baff Akoto, 2020
Lemonade, dir. Beyoncé Knowles-Carter et al., 2016
Les Saignantes (The Bloodettes), dir. Jean-Pierre Bekolo, 2005
Love is the Message, The Message is Death, dir. Arthur Jafa, 2016
Lovecraft Country (TV series), dir. various, 2020
Missy Elliott, 'She's a Bitch', dir. Hype Williams, 1999
Missy Elliott, feat. Da Brat, 'Sock It 2 Me', dir. Hype Williams, 1997
Moonlight, dir. Barry Jenkins, 2016
Naked Reality, dir. Jean-Pierre Bekolo, 2016
Native Sun, dir. Blitz Bazawule and Terence Nance, 2011
1968 < 2018 > 2068, dir. Keisha Rae Witherspoon, 2018
Once There Was Brasilia, dir. Adirley Queirós, 2017
Ornette: Made in America, dir. Shirley Clarke, 1985
Pumzi, dir. Wanuri Kahiu, 2009
Raising Dion (TV series), dir. various, 2019
Random Acts of Flyness (TV series), dir. Terence Nance, 2018
Rebirth is Necessary, dir. Jenn Nkiru, 2017
Robots of Brixton, dir. Kibwe Tavares, 2011
Sampha: Process, dir. Kahlil Joseph, 2017
Sankofa, dir. Haile Gerima, 1993
Scream, Blacula, Scream, dir. Bob Kelljan, 1973
See You Yesterday, dir. Stefon Bristol, 2019
Sleight, dir. J. D. Dillard, 2016
Son of Ingagi, dir. Richard C. Kahn, 1940
Sorry to Bother You, dir. Boots Riley, 2018
Space is the Place, dir. John Coney, 1974
Sugar Hill, dir. Paul Maslansky, 1974
Sweetheart, dir. J. D. Dillard, 2019

FILM, MUSIC AND READING LISTS

Swimming in Your Skin Again, dir. Terence Nance, 2015
The Becoming Box, dir. Monique Walton, 2011
The Brother from Another Planet, dir. John Sayles, 1984
The Burial of Kojo, dir. Blitz Bazawule, 2018
The Changing Same, dir. Cauleen Smith, 2001
The Dream That Refused Me, dir. Jabu Nadia Newman, 2021
The Golden Chain, dir. Adebukola Bodunrin and Ezra Claytan Daniels, 2016
The Last Angel of History, dir. John Akomfrah, 1996
The Polymath, or the Life and Opinions of Samuel R. Delany, Gentleman, dir. Fred Barney Taylor, 2007
The Spook Who Sat by the Door, dir. Ivan Dixon, 1973
The Underground Railroad (TV series), dir. Barry Jenkins, 2021
The Wiz, dir. Sidney Lumet, 1978
They Charge for the Sun, dir. Terence Nance, 2016
To Catch a Dream, dir. Jim Chuchu, 2015
Touch, dir. Shola Amoo, 2013
Twaaga, dir. Cédric Ido, 2013
Us, dir. Jordan Peele, 2019
Vertigo Sea, dir. John Akomfrah, 2015
Watchmen (TV series), dir. various, 2019
Water Ritual #1: An Urban Rite Of Purification, dir. Barbara McCullough, 1979
Welcome II the Terrordome, dir. Ngozi Onwurah, 1995
When I Get Home, dir. Solange Knowles, 2019
Yasuke (TV series), dir. various, 2021
Yeelen (Brightness), dir. Souleymane Cissé, 1987
Zombies, dir. Baloji, 2019

PLAY LIST

A Tribe Called Quest, *The Low End Theory* (1991)
——, *Beats, Rhymes and Life* (1996)
Actress, *Karma & Desire* (2020)
Adrian Younge, *The American Negro* (2021)
Africa HiTech, *93 Million Miles* (2011)
Afrikan Sciences, 'The New Dun Language' (2021)
Alice Coltrane, 'The Sun' (1968)
——, *Journey in Satchidananda* (1971)
——, *Lord of Lords* (1972)
——, 'Krishna Krishna' (1981)
Angel Bat Dawid, *Hush Harbour Mixtape Vol. 1 Doxology* (2021)
Art Ensemble of Chicago, *A Jackson in Your House* (1969)
——, 'Theme de Yoyo' (1970)
Billy Preston, 'Outa-Space' (1971)
Black Jazz Consortium, *Evolution of Light* (2019)
Blixaboy, 'Azanian Funk' (2020)
Blood Orange, 'Orlando' (2018)
Bobbi Humphrey, *Blacks and Blues* (1973)
Busta Rhymes, *Extinction Level Event – The Final World Front* (1998)
Carlos Garnett, 'Mother of the Future' (1974)
Chic, 'At Last I am Free' (1978)
Chino Amobi, 'Blackout' (2017)
DA-IO, 'The Future is … Futureless' (2011)
Damon Locks & Black Monument Ensemble, *Where Future Unfolds* (2019)
Dean Blunt, *Black Metal* (2014)
Dexter Wansel, *Life on Mars* (1976)
——, *The Story of the Flight Crew to Mars* (2021)
Divine Styler, 'Grey Matter' (1992)
Don Blackman, 'Holding You, Loving You' (1982)
Don Byron, 'Basquiat' (1999)
Don Cherry, *Organic Music Society* (1972)
Donald Byrd, 'The Emperor' (1971)
Donny Hathaway, 'Someday We'll All Be Free' (1973)
Drexciya, *Neptune's Lair* (1999)
Earth, Wind & Fire, 'Drum Song' (1974)

Erykah Badu, *Mama's Gun* (2000)
——, *New Amerykah Part One (4th World War)* (2007)
——, *New Amerykah Part Two (Return of the Ankh)* (2010)
Ezra Collective, *Juan Pablo: The Philosopher* (2017)
FKA Twigs, 'Two Weeks' (2014)
——, 'Cellophane' (2019)
Flying Lotus, 'Zodiac Shit' (2010)
——, *Flamagra* (2019)
——, feat. Kendrick Lamar, 'Never Catch Me' (2014)
Gary Bartz, 'Celestial Blues' (1971)
——, 'Uhuru Sasa' (1971)
Gil Scott-Heron, 'Whitey on the Moon' (1970)
Grace Jones, *Slave to the Rhythm* (1985)
Gregory Isaacs, 'Black Liberation Struggle' (1979)
GZA, *Liquid Swords* (1995)
Hieroglyphic Being, Sarathy Korwar & Shabaka Hutchings, 'Calling the Loas' (2017)
Hype Williams, *L's* (2020)
Ibaaku, 'Djula Dance' (2016)
James Brown, 'Never Can Say Goodbye' (1972)
——, 'Mind Power' (1973)
Janelle Monáe, *Dirty Computer* (2018)
Jason Moran, *Ten* (2010)
Joe Smooth, 'Promised Land' (1987)
Jonzun Crew, 'Pack Jam (Look Out for the OVC)' (1982)
Jungle Brothers, *Done by the Forces of Nature* (1989)
Kamasi Washington, *The Epic* (2015)
——, *Heaven and Earth* (2018)
Kanye West, 'Ultralight Beam' (2016)
Kendrick Lamar, *To Pimp a Butterfly* (2015)
——, *DAMN* (2017)
——, *Black Panther: The Album, Music From and Inspired By* (2018)
Laraaji, *Vision Songs Vol. 1* (1984)
——, *Moon Piano* (2020)
Larry Heard, *Genesis* (1999)
Lonnie Liston Smith, *Cosmic Funk* (1974)
Lonnie Liston Smith & The Cosmic Echoes, 'Expansions' (1974)
——, *Visions of a New World* (1975)
Madvillain, *Madvillainy* (2004)
Makaya McCraven, *Universal Beings* (2018)
Mandingo Griot Society, 'Sounds from the Bush' (1978)
MF Doom, *Operation: Doomsday* (1999)
Model 500, 'No UFO's' (1985)
——, 'The Chase' (1989)
Moodymann, *Black Mahogani* (2004)
Moor Mother, *Fetish Bones* (2016)
Muhal Richard Abrams, *Afrisong* (1975)
Nina Simone, 'Strange Fruit' (1965)
——, 'Blackbird' (1966)
——, 'Four Women' (1966)
——, 'Why? (The King of Love is Dead)' (1968)
Ornette Coleman, *Science Fiction* (1972)
OSHUN, 'Sango' (2015)
OutKast, 'ATLiens' (1996)
——, 'Prototype' (2003)
Oy, 'Space Diaspora' (2016)
Parliament, *Mothership Connection* (1975)
——, 'Flash Light' (1977)
Pastor T. L. Barrett and the Youth for Christ Choir, 'Father I Stretch My Hands' (1976)
Pharoah Sanders, *Jewels of Thought* (1969)
——, 'The Creator has a Master Plan' (1969)
——, 'Astral Travelling' (1971)
——, *Elevation* (1973)
——, 'You've Got to Have Freedom' (1980)
Public Enemy, *Fear of a Black Planet* (1990)
Rahsaan Roland Kirk, *Prepare Thyself to Deal With a Miracle* (1973)
Ras G & The Afrikan Space Program, 'Lisa Bonet' (2009)
Robert Glasper, *Fuck Yo Feelings* (2019)

Robert Glasper Experiment, feat. Erykah Badu, 'Afro Blue' (2012)
Ron Trent, *Cinematic Travels (Ancient/Future)* (2007)
Roy Ayers Ubiquity, *A Tear to a Smile* (1975)
——, *Mystic Voyage* (1975)
Roy Davis Jr. and Peven Everett, *Gabriel* (1997)
Sault, *Untitled (Black Is)* (2020)
——, *Untitled (Rise)* (2020)
Scientist, 'Miss Know It All' (1996)
Shabaka & The Ancestors, 'Go My Heart, Go to Heaven' (2020)
——, *We Are Sent Here by History* (2020)
Shabazz Palaces, feat. Thaddillac, 'Shine a Light' (2017)
Solange, *A Seat at the Table* (2016)
——, *When I Get Home* (2019)
Sons of Kemet, 'In the Castle of my Skin' (2015)
——, *Black to the Future* (2021)
Soul II Soul, 'Keep On Movin'' (1989)
Speaker Music, *Black Nationalist Sonic Weaponry* (2020)
Steve Reid, 'Free Spirits – Unknown' (1976)
Stevie Wonder, *Songs in the Key of Life* (1976)
Sudan Archives, 'Come Meh Way' (2017)
Sun Ra, 'Tapestry from an Asteroid' (1967)
——, *Space is the Place* (1972)
——, *Lanquidity* (1978)
——, 'Space Fling' (1979)
Sun Ra & his Solar Arkestra, *I Roam the Cosmos* (1972)
The Comet is Coming, *Trust in the Lifeforce of the Deep Mystery* (2019)
The O'Jays, *Ship Ahoy* (1973)
The Revolutionaries, 'Kunta Kinte Dub' (2007)
The Whatnauts, 'Message from a Black Man' (1970)
THEESatisfaction, 'QueenS' (2012)
Theo Parrish, *Wuddaji* (2020)
Vijay Iyer Trio, 'Mystic Brew' (2009)
Viktor Vaughn, *Vaudeville Villain* (2003)
Warp 9, 'Nunk – New Wave Funk' (1982)
Weldon Irvine, *Cosmic Vortex (Justice Divine)* (1974)
Wu-Tang Clan, *Enter the Wu-Tang (36 Chambers)* (1993)
Yussef Kamaal, *Black Focus* (2016)

READING LIST

A. Timothy Spaulding, *Re-Forming the Past: History, the Fantastic, and the Postmodern Slave Narrative* (Ohio State University Press, 2005)
A. Van Jordan, *Quantum Lyrics* (W. W. Norton & Company, 2007)
Afia Atakora, *Conjure Women: A Novel* (4th Estate, 2020)
Akwaeke Emezi, *Freshwater* (Faber & Faber, 2018)
Alex Zamalin, *Black Utopia: The History of an Idea from Black Nationalism to Afrofuturism* (Columbia University Press, 2019)
Alexander G. Weheliye, *Habeas Viscus: Racializing Assemblages, Biopolitics, and Black Feminist Theories of the Human* (Duke University Press, 2014)
Alexis Pauline Gumbs, *Spill: Scenes of Black Feminist Fugitivity* (Duke University Press, 2016)
——, *Dub: Finding Ceremony* (Duke University Press, 2020)
Amos Tutuola, *The Palm-Wine Drinkard* (Faber & Faber, 1952)
——, *My Life in the Bush of Ghosts* (Faber & Faber, 1954)
——, *The Witch-Herbalist of the Remote Town* (Faber & Faber, 1981)
——, *Pauper, Brawler, and Slanderer* (Faber & Faber, 1987)

André M. Carrington, *Speculative Blackness: The Future of Race in Science Fiction* (University of Minnesota Press, 2016)

Ben Okri, *The Famished Road* (Jonathan Cape, 1991)

Calvin L. Warren, *Ontological Terror: Blackness, Nihilism, and Emancipation* (Duke University Press, 2018)

Carl Hancock Rux, *Pagan Operetta* (Fly by Night Press, 1998)

Charles Chesnutt, *The Conjure Woman* (Houghton, Mifflin & Co., 1899)

Chelsea M. Frazier, 'Troubling Ecology: Wangechi Mutu, Octavia Butler, and Black Feminist Interventions in Environmentalism', in *Critical Ethnic Studies* 2 (1), Spring 2016

Chiji Akọma, *Folklore in New World Black Fiction: Writing and the Oral Traditional Aesthetics* (Ohio State University Press, 2007)

Christina Sharpe, *In the Wake: On Blackness And Being* (Duke University Press, 2016)

Christopher Freeburg, *Counterlife: Slavery after Resistance and Social Death* (Duke University Press, 2020)

Colson Whitehead, *The Intuitionist* (Anchor Books, 1999)

——, *Zone One* (Doubleday, 2011)

——, *The Underground Railroad* (Fleet, 2016)

Courttia Newland, *A River Called Time* (Canongate, 2021)

David Kazanjian, *The Brink of Freedom: Improvising Life in the Nineteenth-Century Atlantic World* (Duke University Press, 2016)

Dawn Keetley (ed.), *Jordan Peele's Get Out: Political Horror* (Ohio State University Press, 2020)

Deji Bryce Olukotun, *Nigerians in Space* (The Unnamed Press, 2014)

Derek Walcott, *Omeros* (Faber & Faber, 1990)

Dionne Brand, *A Map to the Door of No Return: Notes to Belonging* (Doubleday Canada, 2001)

Ebony Elizabeth Thomas, *The Dark Fantastic: Race and the Imagination from Harry Potter to the Hunger Games* (New York University Press, 2019)

Édouard Glissant, *Poetics of Relation* (University of Michigan Press, 1997)

Edward Austin Johnson, *Light Ahead for the Negro* (Grafton Press, 1904)

Elisabeth Abena Osei, 'Wakanda Africa do you see? Reading Black Panther as a decolonial film through the lens of the Sankofa theory', in *Critical Studies in Media Communication* 37 (4), September 2020

Elizabeth Alexander, *The Black Interior: Essays* (Graywolf Press, 2001)

Erik Steinskog, *Afrofuturism and Black Sound Studies: Culture, Technology, and Things to Come* (Palgrave Macmillan, 2017)

fahima ife, *Maroon Choreography* (Duke University Press, 2021)

Frantz Fanon, *Black Skin, White Masks* (Grove Press, 1967)

George Schuyler, *Black No More* (Macaulay Co., 1931)

GerShun Avilez, *Radical Aesthetics and Modern Black Nationalism* (University of Illinois Press, 2016)

Greg Tate, *Flyboy In The Buttermilk: Essays On Contemporary America* (Prentice Hall & IBD, 1992)

Helen Oyeyemi, *Peaces* (Faber & Faber, 2021)

Henriette Gunkel and kara lynch (eds.), *We Travel the Space Ways: Black Imagination, Fragments, and Diffractions* (transcript publishing, 2019)

Henry Dumas, *Ark of Bones and Other Stories* (Southern Illinois University Press, 1970)

Imani Perry, *Vexy Thing: On Gender and Liberation* (Duke University Press, 2018)

Ishmael Reed, *Mumbo Jumbo* (Doubleday, 1972)

——, *Reckless Eyeballing* (St Martin's Press, 1986)

Isiah Lavender III, *Race in American Science Fiction* (Indiana University Press, 2011)

——, *Afrofuturism Rising: The Literary Prehistory of a Movement* (Ohio State University Press, 2019)

Isiah Lavender III and Lisa Yaszek (eds.), *Literary Afrofuturism in the Twenty-First Century* (Ohio State University Press, 2020)

Jack J. Nielsen, *The Afrofuturism Cyclicality of Past, Present, and Future in Kendrick Lamar's To Pimp a Butterfly* (Independently Published, 2018)

Jayna Brown, *Black Utopias: Speculative Life and the Music of Other Worlds* (Duke University Press, 2021)

Jennifer Nansubuga Makumbi, *Kintu* (Oneworld, 2018)

Jerry Rafiki Jenkins, *The Paradox of Blackness in African American Vampire Fiction* (Ohio State University Press, 2019)

John Murillo III, *Impossible Stories: On the Space and Time of Black Destructive Creation* (Ohio State University Press, 2021)

John F. Szwed, *Space is the Place: The Lives and Times of Sun Ra* (Payback Press, 1997)

Joshua Bennett, *Being Property Once Myself: Blackness and the End of Man* (Harvard University Press, 2020)

Kara Keeling, *Queer Times, Black Futures* (New York University Press, 2019)

Karen Lord, *Redemption in Indigo* (Small Beer Press, 2010)

Katherine McKittrick, *Dear Science and Other Stories* (Duke University Press, 2021)

Kathryn Yusoff, *A Billion Black Anthropocenes or None* (University of Minnesota Press, 2018)

Katrina Hazzard-Donald, *Mojo Workin': The Old African American Hoodoo System* (University of Illinois Press, 2012)

Kevin Quashie, *Black Aliveness, or A Poetics of Being* (Duke University Press, 2021)

Kinitra D. Brooks, Alexis McGee and Stephanie Schoellman, 'Speculative Sankofarration: Haunting Black Women in Contemporary Horror Fiction', in *Obsidian* 42 (1–2), 2016

Kinitra D. Brooks and Kameelah L. Martin (eds.), *The Lemonade Reader* (Routledge, 2019)

Kodwo Eshun, *More Brilliant Than the Sun: Adventures in Sonic Fiction* (Quartet Books, 1998)

——, 'Further Considerations on Afrofuturism', in *CR: The New Centennial Review* 3 (2), 2003

L. H. Stallings, *Mutha is Half a Word: Intersections of Folklore, Vernacular, Myth, and Queerness in Black Female Culture* (Ohio State University Press, 2007)

La Marr Jurelle Bruce, *How to Go Mad without Losing Your Mind: Madness and Black Radical Creativity* (Duke University Press, 2021)

Lizelle Bisschoff, 'African Cyborgs: Females and Feminists in African Science Fiction Film', in *Interventions* 22 (5), 2020

Louis Chude-Sokei, *The Sound of Culture: Diaspora and Black Technopoetics* (Wesleyan University Press, 2015)

M. NourbeSe Philip, *Zong!* (Wesleyan University Press, 2008)

Maha Marouan, *Witches, Goddesses and Angry Spirits: The Politics of Spiritual Liberation in African Diaspora Women's Fiction* (Ohio State University Press, 2013)

Margo Natalie Crawford, *Black Post-Blackness: The Black Arts Movement and Twenty-First-Century Aesthetics* (University of Illinois Press, 2017)

Mark Jay and Philip Conklin, *A People's History of Detroit* (Duke University Press, 2020)

Mark Rifkin, *Fictions of Land and Flesh: Blackness, Indigeneity, Speculation* (Duke University Press, 2019)

Marleen S. Barr (ed.), *Afro-Future Females: Black Writers Chart Science Fiction's Newest New-Wave Trajectory* (Ohio State University Press, 2008)

Marlon James, *The Book of Night Women* (Riverhead Books, 2009)

——, *Black Leopard, Red Wolf* (Riverhead Books, 2019)

Martin Delany, *Blake; or, the Huts of America* (Harvard University Press, 2017; Part 1 first pub. *The Anglo-African*, 1859, and Part 2 *Weekly Anglo-African Magazine*, 1861–62)

Melvin G. Hill, *Black Bodies and Transhuman Realities: Scientifically Modifying the Black Body in Posthuman Literature and Culture* (Lexington Books, 2019)

Michelle D. Commander, 'The Space for Race: Black American Exile and the Rise of Afro-speculation', in *ASAP/Journal* 1 (3), September 2016

——, *Afro-Atlantic Flight: Speculative Returns and the Black Fantastic* (Duke University Press, 2017)

Michelle M. Wright, *Physics of Blackness: Beyond the Middle Passage Epistemology* (University of Minnesota Press, 2015)

N. K. Jemisin, *The Broken Kingdoms* (Orbit, 2010)

——, *The Hundred Thousand Kingdoms* (Orbit, 2010)

——, *The Kingdom of Gods* (Orbit, 2011)

——, *The Fifth Season* (Orbit, 2015)

——, *The Obelisk Gate* (Orbit, 2016)

——, *The Stone Sky* (Orbit, 2017)

Nalo Hopkinson, *Brown Girl in the Ring* (Warner Aspect, 1998)

——, *Midnight Robber* (Warner Aspect, 2000)

——, *Skin Folk* (Warner Aspect, 2001)

Namwali Serpell, *The Old Drift* (Hogarth, 2019)

Naomi Beckwith, *The Freedom Principle: Experiments in Art and Music, 1965 to Now* (Museum of Contemporary Art Chicago, 2015)

Nettrice R. Gaskins, 'The African Cosmogram Matrix in Contemporary Art and Culture', in *Black Theology* 14 (1), 2016

Ngũgĩ wa Thiong'o, *Wizard of the Crow* (Harvill Secker, 2006)

Nnedi Okorafor, *Who Fears Death* (DAW/Penguin, 2010)

——, *Binti* (Tor.com, 2015)

——, *Binti: Home* (Tor.com, 2017)

——, *Binti: The Night Masquerade* (Tor.com, 2018)

Octavia E. Butler, *Patternmaster* (Doubleday, 1976)

——, *Kindred* (Doubleday, 1979)

——, *Wild Seed* (Doubleday, 1980)

——, *Dawn* (Warner Books, 1987)

——, *Parable of the Sower* (Four Walls Eight Windows, 1993)

——, *Bloodchild and Other Stories* (Four Walls Eight Windows, 1995)

——, *Parable of the Talents* (Seven Stories Press, 1998)

——, *Fledgling* (Seven Stories Press, 2005)

Orlando Patterson, *Slavery and Social Death: A Comparative Study* (Harvard University Press, 1982)

Paul Gilroy, *The Black Atlantic: Modernity and Double-Consciousness* (Verso Books, 1993)

Paul Steinbeck, *Message to Our Folks: The Art Ensemble of Chicago* (The University of Chicago Press, 2017)

Paul Wilson, 'The Afronaut and Retrofuturism in Africa', in *ASAP/Journal* 4 (1), January 2019

Paul Youngquist, *A Pure Solar World: Sun Ra and the Birth of Afrofuturism* (University of Texas Press, 2016)

R. A. Judy, *Sentient Flesh: Thinking in Disorder, Poiesis in Black* (Duke University Press, 2020)

LIST OF EXHIBITED WORKS

Ralph Ellison, *Invisible Man* (Random House, 1952)

Ramzi Fawaz, 'Space, that Bottomless Pit: Planetary Exile and Metaphors of Belonging in American Afrofuturist Cinema', in *Callaloo* 35 (4), Fall 2012

Rasheedah Phillips, *Recurrence Plot: And Other Time Travel Tales* (Afrofuturist Affair/House of Future Sciences Books, 2014)

Rashid Darden, *Birth of a Dark Nation* (Old Gold Soul Press, 2013)

Reginald Hudlin, *Black Panther: The Deadliest of the Species* (Marvel Comics, 2009)

Reynaldo Anderson and Charles E. Jones (eds.), *Afrofuturism 2.0: The Rise of Astro-Blackness* (Lexington Books, 2015)

Reynaldo Anderson and Clinton R. Fluker (eds.), *The Black Speculative Arts Movement: Black Futurity, Art+Design* (Lexington Books, 2019)

Robert Farris Thompson, *Flash of the Spirit: African & Afro-American Art & Philosophy* (Vintage Books, 1983)

Robin D. G. Kelley, *Freedom Dreams: The Black Radical Imagination* (Beacon Press, 2002)

Roxane Gay et al., *Black Panther: World of Wakanda* (Marvel Comics, 2017)

Saidiya Hartman, *Scenes of Subjection: Terror, Slavery and Self-Making In Nineteenth-Century America* (Oxford University Press, 1997)

—, *Lose Your Mother: A Journey Along the Atlantic Slave Route* (Farrar, Straus & Giroux, 2006)

Samantha A. Noël, *Tropical Aesthetics of Black Modernism* (Duke University Press, 2021)

Sami Schalk, *Bodyminds Reimagined: (Dis)ability, Race, and Gender in Black Women's Speculative Fiction* (Duke University Press, 2018)

Samuel R. Delany, *Babel-17* (Ace Books, 1966)

—, *Nova* (Doubleday, 1968)

—, *Dhalgren* (Bantam Books, 1975)

—, *Trouble on Triton: An Ambiguous Heterotopia* (Bantam Books, 1976)

—, *Stars in My Pocket like Grains of Sand* (Bantam Books, 1984)

—, *Aye, and Gomorrah: And Other Stories* (Vintage Books, 2003)

Sandra Jackson and Julie E. Moody-Freeman (eds.), *The Black Imagination: Science Fiction, Futurism and the Speculative* (Peter Lang, 2011)

Sarah Jane Cervenak, 'Like Blood or Blossom: Wangechi Mutu's Resistant Harvests', in *Feminist Studies* 42 (2), 2016

—, *Black Gathering: Art, Ecology, Ungiven Life* (Duke University Press, 2021)

Sheree R. Thomas (ed.), *Dark Matter: A Century of Speculative Fiction from the African Diaspora* (Warner Aspect, 2000)

Siphiwe Gloria Ndlovu, *The Theory of Flight* (Catalyst Press, 2018)

Stefanie K. Dunning, *Black to Nature: Pastoral Return and African American Culture* (University Press of Mississippi, 2021)

Sun Ra, *This Planet is Doomed* (Kicks Books, 2011)

Suzanna Chan, '"Alive...again." Unmoored in the Aquafuture of Ellen Gallagher's "Watery Ecstatic"', in *Women's Studies Quarterly* 45 (1/2), Spring/Summer 2017

Ta-Nehisi Coates, *Black Panther: A Nation Under Our Feet, Book 1* (Marvel Comics, 2016)

—, *The Water Dancer* (One World/Random House, 2019)

Tade Thompson, *Rosewater* (Apex Publications, 2016)

Tananarive Due, *My Soul to Keep* (HarperCollins, 1997)

—, *The Black Rose* (One World/Ballantine, 2000)

—, *The Living Blood* (Pocket Books, 2001)

—, *Blood Colony* (Atria Books, 2008)

Tara T. Green, *Reimagining the Middle Passage: Black Resistance in Literature, Television, and Song* (Ohio State University Press, 2018)

Tavia Nyong'o, *Afro-Fabulations: The Queer Drama of Black Life* (New York University Press, 2018)

The Otolith Group, *World 3* (Bergen Kunsthall, 2014)

Theri Alyce Pickens, *Black Madness :: Mad Blackness* (Duke University Press, 2019)

Tiffany Lethabo King, *The Black Shoals: Offshore Formations of Black and Native Studies* (Duke University Press, 2019)

Tochi Onyebuchi, *Riot Baby* (Tor.com, 2020)

Tommie Shelby, *We Who Are Dark: The Philosophical Foundations of Black Solidarity* (Harvard University Press, 2005)

Toni Morrison, *Beloved* (Knopf, 1987)

—, *Playing in the Dark: Whiteness and the Literary Imagination* (Harvard University Press, 1992)

—, *A Mercy* (Knopf, 2008)

Victor LaValle, *The Ecstatic, or, Homunculus* (Crown, 2002)

Vincent Brown, *The Reaper's Garden: Death and Power in the World of Atlantic Slavery* (Harvard University Press, 2008)

W. E. B. Du Bois, *Darkwater: Voices from Within the Veil* (Harcourt, Brace & Howe, 1920)

Wadsworth A. Jarrell, *AFRICOBRA: Experimental Art toward a School of Thought* (Duke University Press, 2020)

Walter Mosley, *Blue Light* (Little, Brown & Co., 1998)

—, *Futureland: Nine Stories of an Imminent World* (Aspect, 2001)

—, *The Wave* (Aspect, 2005)

Waýetu Moore, *She Would Be King* (Graywolf Press, 2018)

William Sites, *Sun Ra's Chicago: Afrofuturism and the City* (The University of Chicago Press, 2020)

Zora Neale Hurston, *Tell My Horse: Voodoo and Life in Haiti and Jamaica* (Lippincott, 1938)

List of Exhibited Works

Dimensions are given in centimetres (followed by inches), and are height × width × depth. List of works correct at time of printing.

NICK CAVE
BORN 1959, FULTON, MO, USA. LIVES IN CHICAGO, IL., USA

Soundsuit, 2014
Mixed media including fabric, buttons, antique sifter and wire
211 × 60.5 × 67.5 (83⅛ × 23¾ × 26.5)

Chaplet, 2020
Cast bronze and vintage tole flowers
109 × 33 × 33 (43 × 13 × 13)

Chain Reaction, 2022
Resin and metal
Variable dimensions

Soundsuit 9:29, 2022
Mixed media including sequined appliqués, metal and mannequin
250 × 78 × 55 (98⅜ × 30⅝ × 21⅝)

Unarmed, 2022
Cast bronze, metal and vintage beaded flowers
60.3 × 47.3 × 22.6 (23¾ × 18⅝ × 8⅞)

Wallwork, 2022
Matte vinyl wallpaper
615 × 1001 (242⅛ × 394)
Designed in collaboration with Bob Faust

SEDRICK CHISOM
BORN 1989, PHILADELPHIA, PA, USA. LIVES IN NEW YORK, USA

An Early Episode of The Empire's Preemptive Counterattack on The Monstrous Races in The Savage South, 2019
Oil, acrylic, spray paint and watercolour pencil on tiled sheets of paper glued to canvas
151.8 × 112.4 (59¾ × 44¼)

The Drunk Cooldown Rhythms Capitulated By a Deserter of The Southern Cross on Intimate Terms with Catastrophe, 2020
Oil, acrylic, spray paint and watercolour pencil on tiled sheets of paper glued to canvas
182.9 × 127 (72 × 50)

Untitled, 2020
Oil on canvas
20.3 × 27.9 (8 × 11)

Untitled, 2020
Oil on canvas
20.3 × 27.9 (8 × 11)

Medusa Wandered the Wetlands of the Capital Citadel Undisturbed by Two Confederate Drifters Preoccupied by Poisonous Vapors that Stirred in the Night Air, 2021
Oil, acrylic, spray paint and watercolour pencil on tiled sheets of paper glued to canvas
151.6 × 208.3 × 0.3 (59⅝ × 82 × ⅛)

ALBERT ECKHOUT
C. 1610–1665, NETHERLANDS

Portrait of the African male, 1641
Oil on canvas
273 × 167 (107½ × 65¾)

ELLEN GALLAGHER
BORN 1965, PROVIDENCE, RI, USA. LIVES IN
ROTTERDAM, NETHERLANDS, AND
NEW YORK, USA

*Watery Ecstatic (RA 18h 35m 37.73s D37° 22'
31.12'),* 2017
Cut paper
140 × 148 (55⅛ × 58¼)

Ecstatic Draught of Fishes, 2020
Oil, palladium leaf and paper on canvas
249 × 202 × 4 (98 × 79½ × 1⅝)

Ecstatic Draught of Fishes, 2021
Oil, palladium leaf and paper on canvas
249 × 202 × 4 (98 × 79½ × 1⅝)

Watery Ecstatic, 2021
Watercolour, varnish, egg tempera and cut paper
on paper
197.3 × 139.2 (77⅝ × 54⅞)

Watery Ecstatic, 2021
Watercolour, varnish and cut paper on paper
198 × 140 (78 × 55⅛)

Watery Ecstatic, 2021
Watercolour, varnish, egg tempera and cut paper
on paper
208 × 139.2 (81⅞ × 54⅞)

HEW LOCKE
BORN 1959, EDINBURGH, UK. LIVES IN
LONDON, UK

Albion, 2007
C-type photograph
231 × 182 (90¹⁵/₁₆ × 71⅝)

Congo Man, 2007
C-type photograph
231 × 182 (90¹⁵/₁₆ × 71⅝)

Harbinger, 2007
C-type photograph
231 × 182 (90¹⁵/₁₆ × 71⅝)

Requiem, 2007
C-type photograph
231 × 182 (90¹⁵/₁₆ × 71⅝)

Saturn, 2007
C-type photograph
231 × 182 (90¹⁵/₁₆ × 71⅝)

Ambassador 1, 2021
Mixed media – wood, resin, fabric, metal, plastic
155 × 50 × 137 (61 × 19⅝ × 53¹⁵/₁₆)

Ambassador 2, 2021
Mixed media – wood, resin, fabric, metal, plastic
149 × 62 × 137 (58⅝ × 24⅜ × 53¹⁵/₁₆)

Ambassador 3, 2021
Mixed media – wood, resin, fabric, metal, plastic
157 × 52 × 137 (61⅞ × 20⁷/₁₆ × 53¹⁵/₁₆)

Ambassador 4, 2021
Mixed media – wood, resin, fabric, metal, plastic
approximately 152 × 76 × 152 (59⅞ × 29¹⁵/₁₆ × 59⅞)

WANGECHI MUTU
BORN 1972, NAIROBI, KENYA. WORKS IN NEW
YORK, USA, AND NAIROBI, KENYA

Blue Rose, 2007
Ink, paint, mixed media, plant material and
plastic pearls on Mylar
58.4 × 55.9 (23 × 22)

Madame Repeateat, 2010
Mixed media, ink, spray paint and collage on
Mylar
138.1 × 135.6 × 1.6 (54⅜ × 53⅜ × ⅝)

The End of eating Everything, 2013
Video animation
8:10 minutes

Long John flapper, 2014
Collage painting on vinyl
203.7 × 173.2 × 8.9 (80¼ × 68⅛ × 3½)

The screamer island dreamer, 2014
Collage painting on vinyl
173.8 × 203.7 × 8.9 (68½ × 80¼ × 3½)

Sentinel V, 2021
Red soil, paper pulp, wood glue, emulsion paint,
charcoal, ink, gourd, wood, horn, pumice stone
207.5 × 61 × 56 (81¾ × 24⅛ × 22⅛)

The Backoff Dance, 2021
Soil, charcoal, paper pulp, wood glue, wood,
shell, coral bean (*Erythrina herbacea*), dead
base rock, gourd, brass bead, horn (*Bos taurus*),
spray paint
179 × 87.5 × 103.5 (70⅜ × 34⅜ × 40¾)

RASHAAD NEWSOME
BORN 1979, NEW ORLEANS, LA, USA. LIVES IN
NEW YORK AND OAKLAND, CA, USA

Stop Playing in My Face!, 2016
Single channel video with sound
4:02 minutes

Ansista, 2019
African mahogany wood, silicone, leather, metal
armature, textile, resin, paint, Swarovski
crystal
177.8 × 177.8 (70 × 70)

Stabilizer, 2020
Collage on paper in custom mahogany and resin
artist frame with automotive paint and crystals
97.8 × 111.4 × 10.2 (38½ × 43⅞ × 4)

Formation of Attention, 2022
Collage on paper
134.6 × 127 × 2.5 (53 × 50 × 1)

JOY!, 2022
Collage on paper in custom mahogany and resin
artist frame with automotive paint and crystals
171.4 × 170.2 × 12.7 (67½ × 67 × 5)

O.G. (Oppositional Gaze), 2022
Photo collage on paper in custom mahogany and
resin artist frame with automotive paint
97.8 × 111.4 × 10.2 (38½ × 43⅞ × 4)

CHRIS OFILI
BORN 1968, MANCHESTER, UK. LIVES IN
PORT OF SPAIN, TRINIDAD

Annunciation, 2006
Bronze
200.7 × 213.4 × 119.4 (79 × 84 × 47)

Calypso (Green), 2019
Oil, gold leaf and charcoal on linen
200.3 × 310.5 cm (78⅞ × 122¼)

Kiss (Calypso & Odysseus), 2019
Oil, gold leaf and charcoal on linen
200 × 309.9 (78¾ × 122)

Odyssey 11, 2019
Oil, gold leaf and graphite on linen
309.9 × 200 (122 × 78¾)

TABITA REZAIRE
BORN 1989, PARIS, FRANCE. LIVES IN
CAYENNE, FRENCH GUIANA

Ultra Wet – Recapitulation, 2017
Pyramid projection mapping installation
Variable dimensions, 11:18 minutes

CAULEEN SMITH
BORN 1967, RIVERSIDE, CA, USA. LIVES IN
LOS ANGELES, CA, USA

Epistrophy, 2018
Multichannel video (colour, sound), four CCTV
cameras, four monitors, projection, custom
wood table, taxidermied raven, wood figures,
bronze figures, plastic figures, books, seashells,
minerals, jar of starfish, Magic 8-Ball, maneki-
neko, mirror, metal trays, plaster objects, wood
objects, wire object, fabric, glass vase, plants
Variable dimensions

A Public Apology to Siksika Nation, 2019
Gouache on paper
30.5 × 22.9 (12 × 9)

Bessie, 2019
Gouache on paper
30.5 × 22.9 (12 × 9)

Canto General, 2019
Gouache on paper
30.5 × 22.9 (12 × 9)

Flash of the Spirit, 2019
Gouache on paper
30.5 × 22.9 (12 × 9)

Mind of My Mind, 2019
Gouache on paper
30.5 × 22.9 (12 × 9)

Planetary Geology, 2019
Gouache on paper
30.5 × 22.9 (12 × 9)

Return From Exile, 2019
Gouache on paper
30.5 × 22.9 (12 × 9)

LINA IRIS VIKTOR
BORN IN LONDON, UK. LIVES IN
NAPLES, ITALY, AND LONDON, UK

Second, 2017–18
Pure 24 karat gold, acrylic, ink, gouache,
copolymer resin, print on cotton rag paper
132.1 × 101.6 (52 × 40)

Sixth, 2018
Pure 24 karat gold, acrylic, ink, gouache,
copolymer resin, print on cotton rag paper
132.1 × 101.6 (52 × 40)

Tenth, 2018
Pure 24 karat gold, acrylic, ink, gouache,
copolymer resin, print on cotton rag paper
132.1 × 101.6 (52 × 40)

Eleventh, 2018
Pure 24 karat gold, acrylic, ink, copolymer resin,
print on matte canvas
165.1 × 127 (65 × 50)

Diviner I / The Watcher, 2022
Volcanic rock, marble, bronze
Height approximately 182.9 (72)

Diviner II / The Listener, 2022
Volcanic rock, bronze
Height approximately 91.5 (36)

Red| Carzini, 2022
Medium unknown
approximately 191 × 127 (75 × 50)

Red| Sun, 2022
Medium unknown
approximately 191 × 127 (75 × 50)

Red| Meridian, 2022
Medium unknown
approximately 191 × 127 (75 × 50)

KARA WALKER
BORN 1969, STOCKTON, CA, USA. LIVES IN
NEW YORK, USA

Prince McVeigh and the Turner Blasphemies, 2021
Video, colour, sound: original score by Lady
Midnight
12:06 minutes

Picture Credits

Dimensions are given in centimetres (followed by feet/inches), and are height × width × depth.

9 Ellen Gallagher, *Ecstatic Draught of Fishes*, 2021. Oil, palladium leaf and paper on canvas, 249 × 202 × 4 (98 × 79½ × 1⅝). Photo Tony Nathan. Courtesy the artist and Hauser & Wirth. © Ellen Gallagher

11 Tabita Rezaire, *Ultra Wet – Recapitulation*, 2017. Pyramid projection mapping installation, 11:18 minutes. Photo Rob Battersby. Courtesy the artist and Goodman Gallery, South Africa

12 Chris Ofili, *Kiss (Odysseus & Calypso)*, 2019. Oil, gold leaf and graphite on linen, 200 × 309.9 (78¾ × 122). Courtesy the artist and David Zwirner. © Chris Ofili

14 (above) Aaron Douglas, *Aspiration*, 1936. Oil on canvas, 152.4 × 152.4 (60 × 60). Fine Arts Museums of San Francisco, Museum purchase, the estate of Thurlow E. Tibbs Jr., the Museum Society Auxiliary, American Art Trust Fund, Unrestricted Art Trust Fund, partial gift of Dr. Ernest A. Bates, Sharon Bell, Jo-Ann Beverly, Barbara Carleton, Dr. and Mrs. Arthur H. Coleman, Dr. and Mrs. Coyness Ennix, Jr., Nicole Y. Ennix, Mr. and Mrs. Gary Francois, Dennis L. Franklin, Mr. and Mrs. Maxwell C. Gillette, Mr. and Mrs. Richard Goodyear, Zuretti L. Goosby, Marion E. Greene, Mrs. Vivian S. W. Hambrick, Laurie Gibbs Harris, Arlene Hollis, Louis A. and Letha Jeanpierre, Daniel and Jackie Johnson, Jr., Stephen L. Johnson, Mr. and Mrs. Arthur Lathan, Lewis & Ribbs Mortuary Garden Chapel, Mr. and Mrs. Gary Love, Glenn R. Nance, Mr. and Mrs. Harry S. Parker III, Mr. and Mrs. Carr T. Preston, Fannie Preston, Pamela R. Ransom, Dr. and Mrs. Benjamin F. Reed, San Francisco Black Chamber of Commerce, San Francisco Chapter of Links, Inc., San Francisco Chapter of the N.A.A.C.P., Sigma Pi Phi Fraternity, Dr. Ella Mae Simmons, Mr. Calvin R. Swinson, Joseph B. Williams, Mr. and Mrs. Alfred S. Wilsey, and the people of the San Francisco Bay Area, 1997.84. Photo Randy Dodson, Fine Arts Museums of San Francisco. © Heirs of Aaron Douglas/VAGA at ARS, NY and DACS, London

14 (below) Ronald Moody, *Midonz*, 1937. Elm, 69 × 38 × 39.5 (27¼ × 15 × 15⅝). Photo Tate. © The estate of Ronald Moody

15 Wifredo Lam, *The Jungle*, 1943. Gouache on paper mounted on canvas, 239.4 × 229.9 (94⅜ × 90⅝). The Museum of Modern Art, New York/Scala, Florence. © ADAGP, Paris and DACS, London 2022

16 Loïs Mailou Jones, *Moon Masque*, 1971. Oil and collage on canvas, 104.1 × 76.4 (41 × 30⅛). Smithsonian American Art Museum/Art Resource/Scala, Florence

17 Gerald Williams, *Portrait Y*, 1970. Acrylic on linen, 61 × 45.7 (24 × 18). Photo by John Lusis. Courtesy of Kavi Gupta. © Gerald Williams

18 (above left) James Phillips, *Howling Bebop Ghost*, 1977. Acrylic on canvas, 182.9 × 121.9 (72 × 48). Courtesy the artist and Kravets Wehby Gallery

18 (above right) Alma Woodsey Thomas, *Atmospheric Effects I*, 1970. Acrylic and pencil on paper, 56.3 × 77 (22⅛ × 30⅜). American Art Museum, Washington DC/Art Resource/Scala, Florence

18 (below right) Bob Thompson, *St. Matthew's Description of the End of the World*, 1964. Oil on canvas, 182.8 × 152.8 (6 ft × 60⅛). The Museum of Modern Art, New York/Scala, Florence. © Michael Rosenfeld Gallery LLC, New York

19 (above) Jeff Donaldson, *Patriot*, 1975. Mixed media, 61 × 50.8 (24 × 20). Courtesy Kravets Wehby Gallery and the Estate of Jeff Donaldson

19 (below) Octavia E. Butler, *Mind of My Mind*, 1977. Book cover artwork by Jan Esteves. Doubleday & Company, Inc. Photograph courtesy mostlydystopianbooks.com

20 Rahsaan Roland Kirk, *Prepare Thyself to Deal with a Miracle*, 1973. Album cover artwork by Stanislaw Zagorski. Atlantic Records

21 (left) Nick Cave, *Soundsuit*, 2014. Mixed media including fabric, buttons, antique sifter and wire, 211 × 60.5 × 67.5 (83⅛ × 23¾ × 26.5). Courtesy the artist and Jack Shainman Gallery, New York. © Nick Cave

21 (right) Nick Cave, *Soundsuit*, 2010. Mixed media, 248 × 115 × 45 (97⅝ × 45¼ × 17¾). Courtesy the artist and Jack Shainman Gallery, New York. © Nick Cave

22 (above) Hew Locke, *Harbinger*, 2007. From the series *How Do You Want Me?*. C-type photograph, 231 × 182 (90¹⁵/₁₆ × 71⅝). Courtesy the artist and Hales Gallery London

22 (below) Hew Locke, *Ambassador 1*, 2021. Mixed media – wood, resin, fabric, metal, plastic, 155 × 50 × 137 (61 × 19⅝ × 53⁹/₁₆). Photo Anna Arca. Courtesy the artist and Hales Gallery London

23 Rashaad Newsome, *Stop Playing in My Face!*, 2016. Single channel video with sound, 4:02 minutes. Courtesy Rashaad Newsome Studio

24 Sedrick Chisom, *The Fugitives of The Southern Cross Gathered With the Monstrous Races Beneath a Juniper Tree along the Outer Realm of the Savage South*, 2021. Oil, acrylic, spray paint and watercolour pencil on tiled sheets of paper glued to canvas, 167.6 × 209.6 (66 × 82½). Photo Christopher Burke. Courtesy the artist and Pilar Corrias, London

25 Kara Walker, *Prince McVeigh and the Turner Blasphemies*, 2021. Video, colour, sound: original score by Lady Midnight, 12:06 minutes. Courtesy Sikkema Jenkins & Co. and Sprüth Magers. © Kara Walker

27 Lina Iris Viktor, *Sixth*, 2018. Pure 24 karat gold, acrylic, ink, gouache, copolymer resin, print on cotton rag paper, 132.1 × 101.6 (52 × 40). © 2018. Courtesy the artist

29 Wangechi Mutu, *The End of eating Everything*, 2013. Video animation, 8:10 minutes. Courtesy the artist and Victoria Miro. © Wangechi Mutu

30 (left) Nick Cave, *Soundsuit 8:46*, 2020. Mixed media including textile and flowers, sequined appliqués, metal and mannequin, 248.9 × 78.7 × 55.9 (98 × 31 × 22) (without pedestal). Courtesy the artist and Jack Shainman Gallery, New York. © Nick Cave

30 (right) Nick Cave, *Unarmed*, 2016. Cast bronze, metal and vintage beaded flowers, 55.9 × 61 × 20.3 (22 × 24 × 8½). Courtesy the artist and Jack Shainman Gallery, New York. © Nick Cave

31 Nick Cave, *Chaplet*, 2020. Cast bronze and vintage tole flowers, 109 × 33 × 33 (43 × 13 × 13). Courtesy the artist and Jack Shainman Gallery, New York. © Nick Cave

32 Sedrick Chisom, *Medusa Wandered the Wetlands of the Capital Citadel Undisturbed by Two Confederate Drifters Preoccupied by Poisonous Vapors that Stirred in the Night Air*, 2021. Oil, acrylic, spray paint and watercolour pencil on tiled sheets of paper glued to canvas, 151.6 × 208.3 × 0.3 (59⅝ × 82 × ⅛). Photo Christopher Burke. Courtesy the artist and Pilar Corrias, London

33 Sedrick Chisom, *An Early Episode of The Empire's Preemptive Counterattack on The Monstrous Races in The Savage South*, 2019. Oil, acrylic, spray paint and watercolour pencil on tiled sheets of paper glued to canvas, 151.8 × 112.4 (59¾ × 44¼). Photo Damian Griffiths. Courtesy the artist and Pilar Corrias, London

34 Ellen Gallagher, *Watery Ecstatic*, 2021. Watercolour, varnish and cut paper on paper, 198 × 140 (78 × 55⅛). Photo Tony Nathan. Courtesy the artist and Hauser & Wirth. © Ellen Gallagher

35 Ellen Gallagher, *Ecstatic Draught of Fishes*, 2020. Oil, palladium leaf and paper on canvas, 249 × 202 × 4 (98 × 79½ × 1⅝). Photo Tony Nathan. Courtesy the artist and Hauser & Wirth. © Ellen Gallagher

36 Hew Locke, *Albion*, 2007. From the series *How Do You Want Me?*. C-type photograph, 231 × 182 (90¹⁵/₁₆ × 71⅝). Courtesy the artist and Hales Gallery London

37 Hew Locke, *Ambassador 3*, 2021. Mixed media – wood, resin, fabric, metal, plastic, 157 × 52 × 137 (61⅞ × 20⁷/₁₆ × 53⁹/₁₆). Photo Anna Arca. Courtesy the artist and Hales Gallery London

38 Wangechi Mutu, *Sentinel V*, 2021. Red soil, paper pulp, wood glue, emulsion paint, charcoal, ink, gourd, wood, horn, pumice stone, 207.5 × 61 × 56 (81¾ × 24⅛ × 22⅛). Courtesy the artist and Victoria Miro. © Wangechi Mutu

39 Wangechi Mutu, *The screamer island dreamer*, 2014. Collage painting on vinyl, 173.8 × 203.7 × 8.9 (68½ × 80¼ × 3½). Courtesy the artist and Victoria Miro. © Wangechi Mutu

40 Rashaad Newsome, *Isolation*, 2020. Collage on paper in custom mahogany and resin artist frame with automotive paint and crystals, 147.6 × 134.6 × 10.2 (58⅛ × 53 × 4). Courtesy Rashaad Newsome Studio

41 (above) Rashaad Newsome, *Stop Playing in My Face!*, 2016. Single channel video with sound, 4:02 minutes. Courtesy Rashaad Newsome Studio

41 (below) Rashaad Newsome, *Ansista*, 2019. African mahogany wood, silicone, leather, metal armature, textile, resin, paint, Swarovski crystal, 90.2 × 129.5 × 152.4 (35½ × 51 × 60). Installation view, *To Be Real*, Fort Mason Center for Arts & Culture, San Francisco. Courtesy Rashaad Newsome Studio and Jessica Silverman

42 Chris Ofili, *Odyssey 11*, 2019. Oil, gold leaf and graphite on linen, 309.9 × 200 (122 × 78¾). Courtesy the artist and David Zwirner. © Chris Ofili

43 (above) Chris Ofili, *Calypso (Green)*, 2019.

Oil, gold leaf and charcoal on linen, 200.3 × 310.5 (78⅞ × 122¼). Courtesy the artist and David Zwirner. © Chris Ofili

43 (below) Chris Ofili, *Annunciation*, 2006. Bronze, 200.7 × 213.4 × 119.4 (79 × 84 × 47). Edition 1 of 3. Courtesy the artist and David Zwirner. © Chris Ofili

44 (above) Tabita Rezaire, *Ultra Wet – Recapitulation*, 2017. Pyramid projection mapping installation, 11:18 minutes. Photo Villa Merkel, Esslingen am Neckar, Germany. Courtesy the artist and Goodman Gallery, South Africa

44 (below) Tabita Rezaire, *Ultra Wet – Recapitulation*, 2017. Pyramid projection mapping installation, 11:18 minutes. Photo Franz Wamhof. Courtesy the artist and Goodman Gallery, South Africa

45 Tabita Rezaire, *Ultra Wet – Recapitulation*, 2017. Pyramid projection mapping installation, 11:18 minutes. Photo Rob Battersby. Courtesy of the artist and Goodman Gallery, South Africa

46 (left) Cauleen Smith, *Back to Eden*, 2019. Gouache on paper, 30.5 × 22.9 (12 × 9). Photo Tom Van Eynde. Courtesy the artist and Corbett vs. Dempsey, Chicago. © Cauleen Smith

46 (right) Cauleen Smith, *Sula*, 2019. Gouache on paper, 30.5 × 22.9 (12 × 9). Photo Tom Van Eynde. Courtesy the artist and Corbett vs. Dempsey, Chicago. © Cauleen Smith

47 Cauleen Smith, *Epistrophy*, 2018. Installation view in *Cauleen Smith: Give It Or Leave It*, Los Angeles County Museum of Art, 2020–21. Photo Museum Associates/LACMA. Courtesy the artist and Corbett vs. Dempsey, Chicago. © Cauleen Smith

48 Lina Iris Viktor, *Second*, 2017–18. Pure 24 karat gold, acrylic, ink, gouache, copolymer resin, print on cotton rag paper, 132.1 × 101.6 (52 × 40). Courtesy the artist. © 2018

49 Lina Viktor, *Eleventh*, 2018. Pure 24 karat gold, acrylic, ink, copolymer resin, print on matte canvas, 165.1 × 127 (65 × 50). Courtesy the artist. © 2018

50–51 Kara Walker, *Prince McVeigh and the Turner Blasphemies*, 2021. Video, colour, sound: original score by Lady Midnight, 12:06 minutes. Courtesy Sikkema Jenkins & Co. and Sprüth Magers. © Kara Walker

52 Maïmouna Guerresi, *Rhokaya*, 2010. Lambda print on Dibond, 200 × 125 (78¾ × 49¼). Courtesy of Mariane Ibrahim

55 *Yeelen*, 1987. Director Souleymane Cissé. Films Cissé/Govt of Mali/Kobal/Shutterstock

56 (above) David Uzochukwu, *Uprising*, 2019. Digital photograph. Courtesy Galerie Number 8, Brussels

56 (below) Kristin-Lee Moolman, from the series *Baloji*, 2018. Courtesy the artist

57 David Uzochukwu, *Wildfire*, 2015. Digital photograph. Courtesy Galerie Number 8, Brussels

58 (above) Allison Janae Hamilton, *Floridawater II*, 2019. Archival pigment print, 61 × 91.4 (24 × 36). Edition of 5 plus 2 AP. Courtesy the artist and Marianne Boesky Gallery, New York and Aspen. © Allison Janae Hamilton

58 (below) *Get Out*, 2017. Director Jordan Peele. Universal Pictures. Moviestore/Shutterstock

59 Petite Noir, *La Vie Est Belle / Life Is Beautiful*, 2015. Digital photograph by Lina Iris Viktor. Artwork courtesy Lina Iris Viktor and Domino Recording Company Limited. Courtesy Petite Noir

60 William Villalongo, *Barack and Nefertiti in the Vela Supernova Remnant*, 2009. Hubble telescope poster, velour paper, mirrored Mylar, acrylic paint, 76.2 × 61 (30 × 24). Courtesy Villalongo Studio LLC and Susan Inglett Gallery, New York. © Villalongo Studio LLC

61 (left) Prince Gyasi, *Mental Slavery*, 2018. Photograph. Courtesy Prince Gyasi

61 (right) Prince Gyasi, *Restoration*, 2019. Photograph. Courtesy Prince Gyasi

62–63 Jean-Claude Moschetti, *Ouri #4*, 2010. Photograph, 70 × 105 (27⅝ × 41⅜). Courtesy Jean-Claude Moschetti

64–65 Zas Ieluhee, *Channeling*, 2018. Digital collage. Courtesy Zas Ieluhee

65 Flying Lotus, *You're Dead!*, 2014. Artwork by Shintaro Kago. Warp Records

66–67 Belkis Ayón, *La cena* (*The supper*), 1988. Collograph, 137 × 300 (54 × 118⅛). Photo José A. Figueroa. © Belkis Ayón Estate, Havana, Cuba

68 Fabiola Jean-Louis, *The Splitting of Cells*, 2018. Photograph, 104.1 × 74.3 (41 × 29¼). © Fabiola Jean-Louis

68–69 *Black Panther*, 2018. Director Ryan Coogler. Marvel Studios. Moviestore/Shutterstock

70 Allison Janae Hamilton, *Three girls in sabal palm forest II*, 2019. Archival pigment print, 61 × 91.4 (24 × 36). Edition of 5 plus 2 AP. Courtesy the artist and Marianne Boesky Gallery, New York and Aspen. © Allison Janae Hamilton

71 *Us*, 2019. Director Jordan Peele. Universal Pictures. C Barius/Universal/ILM/Kobal/Shutterstock

72–73 Kamasi Washington, *The Epic*, 2015. Photograph by Mike Park, artwork by Patrick Henry Johnson. Brainfeeder

73 *Ganja & Hess*, 1973. Director Bill Gunn. Kelly-Jordan Enterprises. Everett Collection, Inc./Alamy Stock Photo

74 (above) Kordae Jatafa Henry, *Earth Mother, Sky Father*, 2019. Film, 8 minutes. Courtesy Kordae Jatafa Henry

74 (below) *Atlantics*, 2019. Director Mati Diop. Cinekap/Netflix/Kobal/Shutterstock

75 Nnedi Okorafor, *Binti: The Complete Trilogy*, 2020. Artwork by Greg Ruth. Penguin Random House USA. Photo courtesy mostlydystopianbooks.com

76 Minnie Evans, *Untitled, c*, 1973. Pencil, crayon, and ink on paper, 30.2 × 22.8 (11⅞ × 9). The Museum of Modern Art, New York/Scala, Florence

76–77 Kristin-Lee Moolman, from the series *Baloji*, 2018. Courtesy the artist

78 (left) Raphaël Barontini, *Njinga*, 2021. Acrylic, ink and silkscreen on canvas, 220 × 160 (86⅝ × 63). Courtesy of Mariane Ibrahim

78 (right) Raphaël Barontini, *Queen Nanny*, 2021. Silkscreen and digital print on fabric, 140 × 100 (55⅛ × 39⅜). Courtesy of Mariane Ibrahim

79 Puleng Mongale, *Indlela Ibuzwa Kwabaphambili* (*Ask Those Who Have Gone Before*), 2020. Digital collage, 59.4 × 42 (23⅜ × 16½). Courtesy the artist, Doyle Wham and Latitudes. © Puleng Mongale

80 Ayana V. Jackson, *Consider the Sky and the Sea*, 2019. Archival pigment print on German etching paper, 119 × 109 (46⅞ × 42⅞). Courtesy of Mariane Ibrahim

81 (above) Aïda Muluneh, *Star shine, moon glow*, 2018. Photograph printed on Hahnemühle Photo Rag Bright White, 80 × 80 (31½ × 31½). *Water Life* collection by Aïda Muluneh commissioned by WaterAid and supported by H&M Foundation. WaterAid/Aïda Muluneh. Courtesy David Krut Projects, New York

81 (below) Aïda Muluneh, *Distant echoes of dreams*, 2018. Archival digital print, 80 × 80 (31½ × 31½). *Water Life* collection by Aïda Muluneh commissioned by WaterAid and supported by H&M Foundation. WaterAid/Aïda Muluneh. Courtesy David Krut Projects, New York

82 Jim Adams, *Royal Flypast (Horus flies over the artist's studio while Seth explodes in rage)*, 2019. Acrylic on canvas, hand-painted artist frame, 50.8 × 61 (20 × 24). Courtesy the artist and Luis De Jesus, Los Angeles

83 Kristin-Lee Moolman, from the series *Baloji*, 2018. Courtesy the artist

84–85 Miles Davis, *Bitches Brew*, 1970. Artwork by Abdul Mati Klarwein. Columbia Records. © ADAGP, Paris and DACS, London 2022

86 Jackie McLean, *Demon's Dance*, 1970. Artwork by Abdul Mati Klarwein, design by Bob Venosa. Blue Note Records. © ADAGP, Paris and DACS, London 2022

87 Leonce Raphael Agbodjelou, *Untitled*, 2011. From the series *Egungun*. C-print, 50 × 33 (19¹¹⁄₁₆ × 13). Edition of 10 plus 2 AP. Courtesy Jack Bell Gallery, London

88–97 Jim Adams, *Eternal Symbol*, 1996. Acrylic on canvas, hand-painted artist frame, 92.1 × 121.9 (36¼ × 48). Courtesy the artist and Luis De Jesus, Los Angeles

98–99 David Uzochukwu, *Shoulder*, 2019. Digital photograph. Courtesy Galerie Number 8, Brussels

100 Bob Thompson, *An Allegory*, 1964. Oil on linen, 121.9 × 121.9 (48 × 48). Whitney Museum of American Art/Licensed by Scala. © Michael Rosenfeld Gallery LLC, New York

101 Naudline Pierre, *Take Great Care*, 2019. Oil on canvas, 127 × 101.6 (50 × 40). Photo Paul Takeuchi. Courtesy the artist and James Cohan, New York

102 (above) Edouard Duval-Carrié, *La Traversée*, 2016. Mixed media on aluminium with artist's frame, 172.7 × 172.7 (68 × 68). Courtesy Lyle O. Reitzel Gallery, Santo Domingo, Dominican Republic

102 (below) Edouard Duval-Carrié, *Kongo Queen*, 2015. Mixed media on aluminium, 119.4 × 81.3 (47 × 32). Courtesy Lyle O. Reitzel Gallery, Santo Domingo, Dominican Republic

103 Miles Davis, *Live-Evil*, 1971. Artwork by Abdul Mati Klarwein, design by John Berg. Columbia Records. The Museum of Modern Art, New York/Scala, Florence. © ADAGP, Paris and DACS, London 2022

105 Namsa Leuba, *TranseA*, 2017. From the series *Weke*. Photograph, 50 × 33.3 (19¹¹⁄₁₆ × 13⅛). Courtesy Namsa Leuba

106, 106–7 (background) Hannsjörg Voth, *Stairway to Heaven*, 1980–87, Morocco. imageBROKER/Alamy Stock Photo

107 Rico Gatson, *Untitled (Universal Consciousness After Alice Coltrane)*, 2021. Acrylic paint on wood, 121.9 × 91.4 (48 × 36). Courtesy the artist and Miles McEnery Gallery, New York

108 Alex Jackson, *Basic Tools for Transmutation*, 2018. Oil on unstretched canvas, 205.7 × 238.8 (81 × 94). Courtesy Alex Jackson

109 Devan Shimoyama, *The Abduction of Ganymede*, 2019. Oil, colour pencil, dye, sequins, collage, glitter and jewelry on canvas, 213.4 × 182.9 (84 × 72). Courtesy the artist and De Buck Gallery, New York

110 Cristina de Middel, *Okowako*, 2014. Photograph, from the series *This is What Hatred Did*. © Cristina de Middel/Magnum Photos

111 (above) Cristina de Middel, *Arufin*, 2014. Photograph, from the series *This is What*

Hatred Did. © Cristina de Middel/Magnum Photos

111 (below) Sanford Biggers, *Ghettobird Tunic*, 2006. Bubble jacket and various bird feathers, 154.9 × 78.7 × 43.2 (61 × 31 × 17). Courtesy the artist

112 (left) Rotimi Fani-Kayode, *Nothing to lose XII*, 1989. Photograph. Courtesy Autograph, London

112 (right) Rotimi Fani-Kayode, *Adebiyi*, 1989. Photograph. Courtesy Autograph, London

113 Rotimi Fani-Kayode, *Every Mother's Son/ Children of Suffering*, 1989. Photograph. Courtesy Autograph, London

114 Zohra Opoku, *Re, cry out, let your heart be pleased by your beautiful truth of this day. Enter from the under-sky, go forth from the East, (you) whom the elders and the ancestors worship. Make your paths pleasant for me, broaden your roads for me (so that) I may cross the earth in the manner of (crossing) the sky, your sunlight upon me*, 2020. Screenprint on linen, thread, 255 × 156 (100⅜ × 61⅜). Courtesy of Mariane Ibrahim

115 Wole Lagunju, *Belle of the Hearth*, 2014. Acrylic on canvas, 175.3 × 123.2 (69 × 48½). Courtesy the artist and Ed Cross Fine Art

116 (above) Petite Noir, *La Maison Noir / The Black House*, 2018. Photograph by Kyle Weeks. Creative director Rochelle Nembhard. Courtesy Petite Noir

116–17 Adama Delphine Fawundu, *Aligned with Sopdet, Forest Upstate New York*, 2017. Archival pigment print on cotton fibre paper, 50.8 × 76.2 (20 × 30). Courtesy Adama Delphine Fawundu

117 Jean-Claude Moschetti, *Sirius Nommo 01*, 2017. Photograph, 125 × 160 (49⅕ × 63). Courtesy Jean-Claude Moschetti

118 (above) *Hyenas*, 1992. Director Djibril Diop Mambéty. © ADR Productions – Thelma Film AG/TCD/Prod.DB/Alamy Stock Photo

118 (below) *Touki Bouki*, 1973. Director Djibril Diop Mambéty. © Cinegrit – Studio Kankourama/TCD/Prod.DB/Alamy Stock Photo

118–19 (background), 119 BCEAO Tower, Bamako, Mali. Designed by Raymond Thomas Farah, 1994. Mauritius images GmbH/Alamy Stock Photo

120–21 Zina Saro-Wiwa, *Holy Star Boyz: Night Watch Men*, 2018. Lightbox, C-print on Duratrans, mounted on Plexi and framed, 50.8 × 76.2 (20 × 30). Courtesy the artist and Tiwani Contemporary

122 *Lovecraft Country*, Season 1, 2020. Bad Robot/HBO/Kobal/Shutterstock

123 Damon Davis, *Brave New World*, 2015. Digital collage. Courtesy the artist

124 Frida Orupabo, *Untitled*, 2019. Fine art print on Hahnemühle Photo Rag Baryta paper, framed, 145 × 102.5 (57⅛ × 40⅜). Edition of 3 plus 1 AP. Photo Gerhard Kassner, Berlin. Courtesy the artist and Galerie Nordenhake Berlin/Stockholm/Mexico City. © Frida Orupabo

125 Frida Orupabo, *Untitled*, 2019. Collage with paper pins mounted on aluminium, 54 × 29.5 (21¼ × 11¹⁄₁₆). Photo Gerhard Kassner, Berlin. Courtesy the artist and Galerie Nordenhake Berlin/Stockholm/Mexico City. © Frida Orupabo

126 OutKast, *ATLiens*, 1996. Artwork by Frank Gomez, art direction and creative concept by D. L. Warfield, design by Nigel Sawyer and Vince Robinson. LaFace Records

127 Kristin-Lee Moolman, from the series *Baloji*, 2018. Courtesy the artist

128 Kimathi Donkor, *Yaa Asantewaa Inspecting the Dispositions at Ejisu*, 2014. Oil and acrylic

on cotton canvas, 210 × 165 (82¹¹⁄₁₆ × 64¹⁵⁄₁₆). Courtesy Kimathi Donkor

128–29 Curtis Essel, *Allumuah*, 2020. Film. Courtesy Curtis Essel

130–31 Fabrice Monteiro, *Untitled #11 / Ogun*, 2016. From the series *The Prophecy*. Canson Infinity Platine Fibre Rag 310gr. Courtesy Galerie MAGNIN-A, Paris. © ADAGP, Paris and DACS, London 2022

132 Osibisa, *Happy Children*, 1973. Artwork by Jeffrey Schrier. Warner Bros Records

132–33 Markn, 'From dawn to dusk', 2018. *Document Journal*, November 2018. Stylist Louise Ford, model Bibi Abdulkadir. Courtesy Markn

134 *His House*, 2020. Director Remi Weekes. Netflix/Moviestore/Shutterstock

135 Ruby Okoro, *Untitled*, 2020. From the series *Days After Ascension*. Pigment inkjet print on fine art paper, 90 × 60 (35⁷⁄₁₆ × 23⅝). Courtesy the artist and Galerie Number 8, Brussels. © Ruby Okoro

136 Alison Saar, *Equinox Study*, 2008. Mixed media on paper, 171.5 × 94 (67½ × 37). Courtesy L.A. Louver, Venice, CA. © Alison Saar

141 *Daughters of the Dust*, 1991. Director Julie Dash. American Playhouse/Wmg/Geechee/ Kobal/Shutterstock

142 *Eve's Bayou*, 1997. Director Kasi Lemmons. Trimark/Kobal/Shutterstock

144 *Black Is King*, 2020. Director Beyoncé. Walt Disney Pictures/Kobal/Shutterstock

147 Larry Achiampong, *Pan African Flag for the Relic Travellers' Alliance*, 2017. © Larry Achiampong. All rights reserved, DACS/ Artimage 2022. Courtesy of the artist and Copperfield, London

148–49 Africa Pavilion, designed by Jacek Chyrosz and Stanisław Rymaszewski, International Trade Fair Centre, Accra, Ghana, 1962–67. Photograph Alexia Webster (2012)

149 (above) THEESatisfaction (Catherine Harris-White/SassyBlack and Stasia Irons/ Stas THEE Boss), *Earthee*, 2015. Courtesy THEESatisfaction (Catherine Harris-White/ SassyBlack and Stasia Irons/Stas THEE Boss) and Sub Pop Records

150 (above) GZA, *Liquid Swords*, 1995. Artwork by Denys Cowan. Geffen Records

150 (below) Idris Ackamoor & The Pyramids, *An Angel Fell*, 2018. Artwork by Lewis Heriz. Strut Records

151 (above) The Undisputed Truth, *Cosmic Truth*, 1975. Artwork by Robert Gleason, art direction by Katarina Pettersson. Gordy Records

151 (below) Ill Scholars, *Ill Scholars*, 2020. Artwork by Ill Scholars. Expanded Art Records. Courtesy Ill Scholars

152 (above left) Cristina de Middel, *Yinqaba*, 2011. From the series *The Afronauts*. © Cristina de Middel/Magnum Photos

152 (above right) Cristina de Middel, *Bambuit*, 2011. From the series *The Afronauts*. © Cristina de Middel/Magnum Photos

152 (below) Kandis Williams, *Cave before Cocytus*, 2018. Vinyl adhesive on mirror, 61 × 61 (24 × 24). Courtesy the artist and Night Gallery, Los Angeles

153 Djeneba Aduayom, *Within*, 2018. From the series *Capsulated*. Chromaluxe semi-matte metal print, 106 × 80 (41¾ × 31½). Courtesy the artist and Galerie Number 8, Brussels. © Djeneba Aduayom

154 Nuotama Bodomo, *Afronauts*, 2014. Film, 14 minutes. Courtesy Nuotama Bodomo/ Mothertongue

155 Djeneba Aduayom, *Alienation*, 2018. From

the series *Capsulated*. Chromaluxe semi-matte metal print, 106 × 80 (41¾ × 31½). Courtesy the artist and Galerie Number 8, Brussels. © Djeneba Aduayom

156 Zeitz MOCAA, Cape Town, 2011–17. Architect Thomas Heatherwick. Photograph Iwan Baan

157 Victoria Kovios, *Shabazz Palaces*, 2017. Photograph. Victoria Kovios, victoriakovios. com

158–59 Kerry James Marshall, *Keeping the Culture*, 2010. Oil on board, 75.2 × 121.9 (30 × 48). Courtesy the artist and Jack Shainman Gallery, New York. © Kerry James Marshall

160 Santana, *Abraxas*, 1970. Artwork by Abdul Mati Klarwein. Columbia Records. Records/ Alamy Stock Photo

161 Zas Ieluhee, *Forbidden Knowledge*, 2018. Digital collage. Courtesy Zas Ieluhee

162 Kiluanji Kia Henda, *Icarus 13, the First Journey to the Sun*, 2008. Photograph mounted on Plexiglas (methacrylate) frame. Courtesy the artist and Goodman Gallery, South Africa

162–63 Markn, 'From dawn to dusk', 2018. *Document Journal*, November 2018. Stylist Louise Ford, model Bibi Abdulkadir. Courtesy Markn

164–65 Tavares Strachan, *The Stranger*, 2018. Mylar, matte paper, pigment, enamel, vinyl, graphite, mounted on acrylic, 91.4 × 91.4 × 5.1 (36 × 36 × 2). Photo Brian Forrest. Courtesy Regen Projects, Los Angeles. © Tavares Strachan

165 Parliament, *The Clones of Dr. Funkenstein*, 1976. Photo by Ron Slenzak, graphics by Chris Whorf/Gribbitt!. Casablanca Records

166 (above) Temi Oh, *Do You Dream of Terra-Two?*, 2019. Cover photographs by Arcangel and Getty Images. Simon & Schuster

166 (below) Larry Achiampong, *Relic 1*, 2017. Film, 14 minutes. © Larry Achiampong. All rights reserved, DACS/Artimage 2022. Commissioned by PS/Y. Courtesy of the artist and Copperfield, London

167 Sun Ra, *Astro Black*, 1973. Artwork by Ed Scarisbrick. Impulse! Records

168 (above) Busta Rhymes, *Extinction Level Event – The Final World Front*, 1998. Artwork by Stu Maschwitz. Flipmode, Elektra Records

168 (below) GZA, *Beneath the Surface*, 1999. Artwork by Liquid Design Group. MCA Records

169 Edgar Arceneaux, *Myth, Nature, Man: an Advancement of Evolution*, 2009. Inkjet print on paper, 36.5 × 19.3 (14⅜ × 7⅝). Edition 1 of 3. Photo Lutz Bertram. Courtesy Vielmetter Los Angeles

170 Alison Saar, *Breach*, 2016. Wood, ceiling tin, found trunks, washtubs and miscellaneous objects, 393.7 × 152.4 × 129.5 (155 × 60 × 51). Collection of the Los Angeles County Museum of Art. Courtesy L.A. Louver, Venice, CA. © Alison Saar

171 Marc Asekhame and Daniel Obasi, untitled, 2020. From 'Chaos and creation in Lagos pre-lockdown', *The Face*, May 2020. Courtesy Marc Asekhame/Daniel Obasi

172 (above) Sun Ra, *The Nubians of Plutonia*, 1974. Artwork by John Lykes. Impulse! Records

172 (below) Osibisa, *Woyaya*, 1971. Painting and logo lettering by Roger Dean. © Roger Dean 1971, www.rogerdean.com

173 Black Kirby, *Mo'Blacktus*, 2012. Digital Collage. Courtesy the artists

174 (above) Saya Woolfalk, *Chimera*, 2013. Single channel colour video with sound, 2:49

minutes loop. Courtesy Leslie Tonkonow Artworks + Projects, New York. © Saya Woolfalk

174 (below) Herbie Hancock, *Thrust*, 1974. Artwork by Rob Springett. Columbia Records

175 Stacey Robinson, *Afrotopia I*, 2016. Digital collage. Courtesy the artist

176–77 Kiluanji Kia Henda, *Icarus 13, the First Journey to the Sun*, 2008. Photograph mounted on Plexiglas (methacrylate) frame. Courtesy the artist and Goodman Gallery, South Africa

178 (above) John Coltrane and Alice Coltrane, *Cosmic Music*, 1972. Photograph by Jim Marshall, artwork by Byron Goto. Impulse! Records

178 (below) Samuel R. Delany, *Stars in My Pocket like Grains of Sand*, 1984. Artwork by Luis Royo. Bantam Books Inc.

179 Yinka Shonibare, *Refugee Astronaut II*, 2016. Fibreglass mannequin, Dutch wax printed cotton textile, net, possessions, astronaut helmet, moon boots and steel baseplate, 210 × 90 × 103 (82¹¹/₁₆ × 35⁷/₁₆ × 40⁹/₁₆). Photo: Stephen White & Co. © Yinka Shonibare CBE. All Rights Reserved, DACS/Artimage 2022. Image courtesy James Cohan Gallery

180 Public Enemy, *Fear of a Black Planet*, 1990. Artwork by B. E. Johnson. Def Jam Recordings and Columbia Records. Photograph Robert Morris

181 Peter Williams, *He Was a Global Traveler*, 2020. Oil and graphite on canvas, 182.9 × 243.8 (72 × 96). Courtesy the artist and Luis De Jesus, Los Angeles

182–83 *District 9*, 2009. Director Neill Blomkamp. Tri-Star/Wingnut/Sony/Kobal/Shutterstock

184–93 John Akomfrah, *The Last Angel of History*, 1995. Single channel colour video, sound, 45:07 minutes. © Smoking Dogs Films, All Rights Reserved, DACS/Artimage 2022. Courtesy Lisson Gallery

194 Kerry James Marshall, *Dailies, 1999–2000*. Installation view. Courtesy the artist and Jack Shainman Gallery, New York. © Kerry James Marshall

195 Gordon Parks, *Invisible Man Retreat, Harlem, New York*, 1952. Photograph. Courtesy of and © The Gordon Parks Foundation

196 Keith Piper, *Go West Young Man*, 1987. 1 of 14 gelatin silver prints on paper mounted onto board, each 84 × 56 (33¹/₁₆ × 22¹/₁₆). Courtesy Keith Piper

197 *Top of the Heap*, 1972. Director Christopher St. John. Everett Collection Inc./Alamy Stock Photo

198 Imani Dennison, *Afrofuturism, a love story*, 2017. Photograph. Courtesy Imani Dennison

199 Ruby Okoro, *An Eye For An Eye*, 2020. Pigment inkjet print on fine art paper, 90 × 60 (35⁷/₁₆ × 23⅝). Courtesy the artist and Galerie Number 8, Brussels. © Ruby Okoro

200 Makoko Floating School Project, 2012. NLÉ. Photographs Iwan Baan

201 (above) Mohau Modisakeng, *Passage 8*, 2017. Inkjet print, 150 × 200 (59¹/₁₆ × 78¾). Courtesy Mohau Modisakeng Studio and Galerie Ron Mandos. © Mohau Modisakeng

201 (below) Mohau Modisakeng, *Passage 1*, 2017. Inkjet print, 150 × 200 (59¹/₁₆ × 78¾). Courtesy Mohau Modisakeng Studio and Galerie Ron Mandos. © Mohau Modisakeng

202 Tasha Orlova, 'Portal', 2017. *HUF Magazine*, March 2017. Photography and editing by Tasha Orlova, art direction and fashion design by Jenya Kartashova. Courtesy Tasha Orlova

203 Michael MacGarry, *Eulogia*, 2018. Polyurethane, steel, brass, found object,

14.8 × 21 × 34 (5¹³/₁₆ × 8¼ × 13⅜). Courtesy the artist

204 *Pumzi*, 2009. Director Wanuri Kahiu. Album/Alamy Stock Photo

205 Gerald Machona, *People from Far Away*, 2012. Video installation. Courtesy the artist and Goodman Gallery, South Africa

206 David Alabo, *Intergalactic Apostle of Funk*, 2018. Print, 40.6 × 50.8 (16 × 20). Courtesy David Alabo

207 Gerald Williams, *Message from a Giant – Garvey*, 1976–2017. Acrylic on canvas, 120.7 × 120.7 × 5.1 (47½ × 47½ × 2). Photo by John Lusis. Courtesy Kavi Gupta. © Gerald Williams

208 *Watchmen*, Season 1, 2019. DC/HBO/Sky Atlantic/Kobal/Shutterstock

209 Grand Puba, *Black from the Future*, 2016. Artwork by Ian Tait. Babygrande Records. Courtesy Ian Tait

210–11 *Space is the Place*, 1974. Director John Coney. North American Star System/Kobal/Shutterstock

212 Robert Pruitt, *Captain America*, 2015. Conte, charcoal and coffee wash on paper, 127 × 96.5 (50 × 38). Courtesy the artist and Salon 94, New York. © Robert Pruitt

213 Robert Pruitt, *I need a Vacation from this Vacation*, 2015. Conte, charcoal, pastel and coffee wash on paper, 127 × 96.5 (50 × 38). Courtesy the artist and Salon 94, New York. © Robert Pruitt

214–15 Grand Théatre de Rabat, Morocco, 2010–21. Zaha Hadid Architects. Render courtesy Zaha Hadid Architects

215 (above) Grace Jones, *Inside Story*, 1986. Artwork by Richard Bernstein. Manhattan Records

216 Juliana Huxtable, *Lil' Marvel*, 2015. Colour inkjet print, 101.6 × 76.2 (40 × 30). Edition 1 of 3. Courtesy the artist and JTT, New York

224 David Huffman, *Katrina, Katrina, Girl You're on My Mind*, 2006. From the series *Traumanauts*. Mixed media on wood panels, 203.2 × 274.3 × 5.1 (80 × 108 × 2). Collection of the Arizona State University Art Museum, Tempe; Purchased with funds provided by Herbert H. and Barbara C. Dow Foundation, Art Museum Acquisition Fund, Mikki and Stanley Weithorn, and the FUNd at Arizona State University Art Museum

227 Athi-Patra Ruga, *Night of the Long Knives I*, 2013. Archival inkjet print on PhotoRag Baryta, 150 × 190 (59¹/₁₆ × 74¹³/₁₆). Photo Hayden Phipps. Courtesy the artist and WHATIFTHEWORLD

228 (above) Alice Coltrane, *Journey in Satchidananda*, 1971. Photograph by Chuck Stewart. Impulse! Records

228–29 International Conference Center, Ouagadougou, Burkina Faso. Designed by Coldefy. 2009. Courtesy Coldefy

229 (above) Burkina Faso National Assembly & Memorial Park, Ouagadougou, Burkina Faso. Designed by Kéré Architecture. 2017. Courtesy Kéré Architecture

230 Yaoundé Olu, *Mother of Worlds*, 1975. Pen and ink on illustration board, 50.8 × 37.5 (20 × 14¾). The David and Alfred Smart Museum of Art, The University of Chicago; Purchase, The Paul and Miriam Kirkley Fund for Acquisitions. Photograph © 2022 courtesy The David and Alfred Smart Museum of Art, The University of Chicago

230–31 Hôtel Ivoire, Abidjan, Côte d'Ivoire, 1962–70. Architects Moshe Mayer, Heinz Fenchel and Thomas Leitersdorf (renovated by Pierre Fakhoury). Photograph Iwan Baan

232 *Sankofa*, 1993. Director Haile Gerima. Everett Collection Inc./Alamy Stock Photo

233 Cristina de Middel, *Idagiri*, 2014. From the series *This is What Hatred Did*. © Cristina de Middel/Magnum Photos

234 Robert Reed, *Galactic Journal: Antibes Vert (aka School Colors #2)*, 2004. Acrylic/oil marker on canvas, 228.6 × 205.7 (90 × 81). Courtesy Estate of Robert Reed and Pilar Corrias, London

235 Robert Reed, *Galactic Journal: Rose Hill Drive*, 2005. Acrylic/oil marker on canvas, 152.4 × 121.9 (60 × 48). Courtesy Estate of Robert Reed and Pilar Corrias, London

236 Kool & The Gang, *Spirit of the Boogie*, 1975. Artwork by Diane Nelson and Frank Daniel. De-Lite Records

237 Place des Cinéastes, Ouagadougou, Burkina Faso. Designed by Ali Fao and Ignace Sawadogo, 1986–87. Photo Hemis/Alamy Stock Photo

238–39 Hôtel du Lac, Tunis, Tunisia. Architect Raffaele Contigiani, 1970–73. Photo Christian Sappa/Gamma-Rapho via Getty Images

240 Radcliffe Bailey, *Between Sea and Space*, 2019. Mixed media, 157.5 × 119.4 × 20.3 (62 × 47 × 8). Photo Dave Bruel. © The artist, courtesy Maruani Mercier Gallery, Belgium

241 Lonnie Liston Smith & The Cosmic Echoes, *Expansions*, 1974. Artwork by Jack Martin. Flying Dutchman Records

242–43 (background) Hannsjörg Voth, *City of Orion*, Morocco, 1997–2003. Photo imageBROKER/Alamy Stock Photo

243 Fabrice Monteiro, *Untitled #6*, 2014. From the series *The Missing Link*. Canson Infinity Platine Fibre Rag 310gr. Courtesy Galerie MAGNIN-A, Paris. © ADAGP, Paris and DACS, London 2022

244 Loïs Mailou Jones, *Les Fétiches*, 1938. Oil on canvas, 64.8 × 54 (25½ × 21¼). Smithsonian American Art Museum/ArtResource/Scala, Florence

245 Erykah Badu, *New Amerykah Part Two (Return of the Ankh)*, 2010. Artwork by Emek. Universal Motown Records

246 Fabrice Monteiro, *Untitled #3*, 2014. From the series *The Missing Link*. Canson Infinity Platine Fibre Rag 310gr. Courtesy Galerie MAGNIN-A, Paris. © ADAGP, Paris and DACS, London 2022

246–47 La Pyramide, Abidjan, Côte d'Ivoire. Architect Rinaldo Olivieri, 1968–73. Photograph Iwan Baan

248–57 Memorial Thomas Sankara, Ouagadougou, Burkina Faso. Designed by Kéré Architecture. 2017–ongoing. Courtesy Kéré Architecture

258 Gustavo Nazareno, *The Birth of Exu*, 2020. Oil on canvas, 94 × 71.1 (37 × 28). Courtesy Gallery 1957, London. © The artist

258–59 *Black Panther*, 2018. Director Ryan Coogler. Marvel/Disney/Kobal/Shutterstock

260–61 FIDAK (Foire Internationale de Dakar), Dakar, Senegal. Designed by Jean François Lamoureux and Jean-Louis Marin, 1971–74. Photograph Iwan Baan

262 Wilfred Ukpong, *BC1-ND-FC: Strongly, We Believe In the Power of this Motile Thing That Will Take Us There #1*, 2017. From the series *Blazing Century 1: Niger-Delta/Future-Cosmos*. Mixed media, pigment print and acrylic on canvas in artist's frame (fabric, polystyrene and light steel rod), 150 × 200 × 0.5 (59¹/₁₆ × 78¾ × ³/₁₆). Courtesy Wilfred Ukpong and Blazing Century Studios, Nigeria

263 A Tribe Called Quest, *The Jam*, 1997. Artwork by Kwesi C. T. Ogbourne [Skam2?]. Jive Records

264 Afrika Bambaataa & Soul Sonic Force, *Renegades of Funk!*, 1983. Artwork by Bob

Camp. Tommy Boy, Warner Bros Records

265 Slave, *The Concept*, 1978. Cover illustration Daniel Maffia. Cover concept by Jeff Dixon and Stephen Washington, design by Lynn Dreese Breslin. Cotillion Records

266 (above) Mary Sibande, *Right Now!*, 2015. Archival digital print, 101.2 × 235.6 (39⁹⁄₁₆ × 92¾). Courtesy SMAC Gallery. © Mary Sibande

266 (below) Ishmael Reed, *Mumbo Jumbo*, 1972. Penguin Classics 2017 edition. Artwork © Ishmael Reed

267 Juliana Huxtable, *Untitled in the Rage (Nibiru Cataclysm)*, 2015. Colour inkjet print, 101.6 × 76.2 (40 × 30). Courtesy the artist and JTT, New York

269 Mickalene Thomas, *Untitled #3*, 2019. From the series *Orlando*. Chromogenic print, 146.7 × 109.9 (57¾ × 43¼). © Mickalene Thomas. © ARS, NY and DACS, London

270 Lorna Simpson, *Earth & Sky #64*, 2019. Found photograph and collage on paper, 28 × 21.6 (11 × 8½), framed: 31.8 × 25.4 × 3.8 (12½ × 10 × 1½). Photo James Wang. Courtesy the artist and Hauser & Wirth. © Lorna Simpson

271 (above) Lorna Simpson, *Earth & Sky #63*, 2019. Found photograph and collage

on paper, 28 × 21.6 (11 × 8½), framed: 31.8 × 25.4 × 3.8 (12½ × 10 × 1½). Photo James Wang. Courtesy the artist and Hauser & Wirth. © Lorna Simpson

271 (below) Lorna Simpson, *Earth & Sky #50*, 2018. Collage on paper, 27.9 × 21.6 (11 × 8½), framed: 31.8 × 25.4 × 3.8 (12½ × 10 × 1½). Courtesy the artist and Hauser & Wirth. © Lorna Simpson

272–73 Lauren Halsey. *thang*, 2020. Digital collage. Courtesy David Kordansky Gallery, Los Angeles

274 Weldon Irvine, *Cosmic Vortex (Justice Divine)*, 1974. Artwork by Dennis Pohl. RCA Records

275 *Black Is King*, 2020. Director Beyoncé. Walt Disney Pictures/Kobal/Shutterstock

276 Kristin-Lee Moolman, 'The Earthwise Issue', *i-D* magazine, no. 353, Fall 2018. Stylist Ibrahim Kamara. Courtesy the artist

277 Madvillain, *Madvillainy*, 2004. Photo by Eric Coleman. Stones Throw Records

278 Beddo, *Erykah – The Healer #1*, 2017. Pencil, ink and digital artwork, 41.9 × 27.9 (16½ × 11), (remix of *Silver Surfer #1* by John Buscema). Courtesy Beddo, BeddoArt.com

279 Umar Rashid (Frohawk Two Feathers), *New Axumite Stele, or, The Death of Ricky I of the*

Axumite Kingdom of Crenshaw. Codex of correlation between heat and sudden hood death syndrome. Try not to die if you can., 2018. Acrylic and ink on canvas, 121.9 × 91.4 (48 × 36). Courtesy the artist and Tiwani Contemporary

280–81 Flying Lotus, *Flamagra*, 2019. Artwork by Winston Hacking. Warp Records

281 (below right) Janelle Monáe, *Dirty Computer*, 2018. Artwork concept by Joe Perez. Wondaland Arts Society, Bad Boy Records and Atlantic Records

282 Kerry James Marshall, *Studies for Untitled Black Empire Suite*, 2015. Crayon and charcoal on paper, Triptych, left and right: 159 × 220 × 5 (62½ × 86½ × 2), centre: 220 × 159 × 5 (86½ × 62½ × 2). Courtesy the artist and Jack Shainman Gallery, New York. © Kerry James Marshall

283 Toyin Ojih Odutola, *A Parting Gift; Hers and Hers, Only*, 2019. Pastel, charcoal and chalk on board, 101.6 × 76.2 (40 × 30). Courtesy the artist and Jack Shainman Gallery, New York. © Toyin Ojih Odutola

287 Alisha B. Wormsley, *There Are Black People In The Future*, 2019. Billboard, 365.8 × 1079.5 (144 × 425). Photograph by Library Street Collective. Courtesy Alisha B. Wormsley

ACKNOWLEDGMENTS

AUTHOR ACKNOWLEDGMENTS

I wish to extend my profound thanks to the following individuals for their indispensable contribution to the creation of this project: Rush Jackson, Michelle Commander, Kameelah Martin, Ralph Rugoff, Thomas Sutton, Phoebe Cripps, Debbie Meniru, Nick Davies, Chloe Brooks, Alayo Akinkugbe, Andrew Sanigar, Nella Soušková, Ramon Pez, Jenny Wilson, Jo Walton and Sadie Butler. I would also like to thank the artists who brought their extraordinary talent and vision to the *In the Black Fantastic* exhibition: Nick Cave, Sedrick Chisom, Ellen Gallagher, Hew Locke, Wangechi Mutu, Rashaad Newsome, Chris Ofili, Tabita Rezaire, Cauleen Smith, Lina Iris Viktor and Kara Walker.

HAYWARD GALLERY ACKNOWLEDGMENTS

We wish to thank all the individuals, public galleries and museums who have lent artworks to *In the Black Fantastic*. Without their generosity, the exhibition would not have been possible.

We are extremely grateful for the crucial support provided for the realization of the exhibition by Gagosian and Jack Shainman Gallery. In addition, we would like to express our appreciation to all Hayward Gallery patrons who

have provided support towards this ambitious project.

We are also greatly indebted to the participating artists' studios and galleries. Our special thanks go to the following individuals for their collaboration and support:

Chris Berkery, Gagosian
Barbara Berlowicz, The National Museum of Denmark
Hayley Blackstone, Corbett vs. Dempsey
Carmen Blanco Santos, David Zwirner
Hakki Serhat Cacekli, Jessica Silverman Gallery
Angela Choon, David Zwirner
Caroline Currier, LGDR
Bob Faust, Nick Cave Studio
Jonathan Fraser, Wangechi Mutu Studio
Ali Giniger, Jack Shainman Gallery
Sasha Gomeniuk, Hales Gallery
Indra Khanna, Hew Locke Studio
Meg Malloy, Sikkema Jenkins & Co.
Erin Manns, Victoria Miro
Astrid Meek, Wangechi Mutu Studio
Al Morán, Morán Morán
Jessica Silverman, Jessica Silverman Gallery
Madeleine Stoddart, Pilar Corrias
Mar Sudac, Cauleen Smith Studio
Elif Temizkan, Tabita Rezaire Studio
Stefan Zebrowski-Rubin, Hauser & Wirth

Hayward Gallery Exhibition Credits

Ralph Rugoff, Director
Thomas Sutton, Assistant Curator
Phoebe Cripps, Assistant Curator
Debbie Meniru, Curatorial Assistant
Stephanie Busson, Exhibition Registrar
Alison Maun, Exhibition Bookings and Indemnity Coordinator
Chloe Brooks, Senior Technician
Nick Davies, Senior Technician
Juliane Heynert, Installation Manager
Urszula Kossakowska, General Manager
Leonie Warner, Senior Visitor Experience Manager
Lucy Biddle, Publications Manager
Alayo Akinkugbe, Curatorial Intern

Southbank Centre

We are grateful to all our collaborators across Southbank Centre, without whom this exhibition would not have been possible. In particular, we would like to acknowledge the contributions of our colleagues in Southbank Centre's Creative Learning, Design, Development, Digital, Health and Safety, Marketing, Press, Public Relations and Retail teams.

INDEX

Page numbers in *italic* refer to illustrations

Published by arrangement with Thames & Hudson Ltd, London,
by the MIT Press

The MIT Press
Massachusetts Institute of Technology
Cambridge, Massachusetts 02142
http://mitpress.mit.edu

ABOUT THE AUTHORS

Ekow Eshun is Chairman of the Fourth Plinth Commissioning Group,
overseeing the most prestigious public art programme in the UK, and
the former Director of the ICA, London. He is the author of *Africa State
of Mind*, nominated for the Lucie Photo Book Prize, and *Black Gold of the
Sun*, nominated for the Orwell Prize. He has contributed to monographs
and publications on artists including Mark Bradford, Chris Ofili, Kehinde
Wiley, John Akomfrah and Wangechi Mutu, as well as to books including
Masculinities: Liberation Through Photography, *Between Worlds: Voyagers
to Britain 1700–1850* and *Fashioning Masculinities: The Art of Menswear*.
His writing has appeared in publications including the *New York Times*,
Financial Times, *The Guardian*, *The Observer*, *The Independent*, *Granta*,
Esquire, *GQ Style*, *Aperture*, *Wired* and *L'uomo Vogue*. He is a Contributing
Editor at *Wallpaper* magazine and is a member of the Advisory Board of
Liquid Blackness journal. He is the recipient of an honorary doctorate from
London Metropolitan University.

Michelle D. Commander is Associate Director of the Schomburg Center
for Research in Black Culture in New York and the author of *Afro-Atlantic
Flight*.

Kameelah L. Martin is Director of the African American Studies Program
and Professor of African American Studies and English at the College
of Charleston.